BERENSON'S
ITALIAN PAINTERS
OF THE RENAISSANCE

VOLUME ONE

THE ITALIAN PAINTERS
OF THE RENAISSANCE

BY BERNARD BERENSON

VOLUME ONE

THE VENETIAN PAINTERS

THE NORTH ITALIAN PAINTERS

002718

WITH 191 ILLUSTRATIONS

PHAIDON · LONDON & NEW YORK

All rights in this edition reserved by Phaidon Press Ltd., 5 Cromwell Place, London SW7
First published 1952
Sixth impression 1967
First issued in two volumes 1968

Phaidon Publishers Inc., New York
Distributors in the United States: Frederick A. Praeger, Inc.
111 Fourth Avenue, New York, N.Y. 10003
Library of Congress Catalog Card Number: 68-18913

Volume 1: SBN 7148 1335 4
Volume 2: SBN 7148 1336 2

Made in Great Britain
Text printed by Tonbridge Printers Ltd., Tonbridge, Kent
Monochrome plates printed by Keliher, Hudson & Kearns Ltd., London
Colour plates printed by Hunt Barnard & Co. Ltd., Aylesbury, Buckinghamshire

CONTENTS

NOTE

Bernard Berenson's four essays on the Italian Painters of the Renaissance were originally published separately around the turn of the century. The Venetian Painters appeared in 1894, followed by the Florentine Painters (1896), the Central Italian Painters (1897), and the North Italian Painters and the Decline of Art (1907).

The large illustrated Phaidon edition, first published in 1952 by arrangement with the Clarendon Press, Oxford, and the Oxford University Press, New York, was produced in collaboration with the Samuel H. Kress Foundation as a tribute to Bernard Berenson and in appreciation of more than a quarter of a century of friendship and co-operation between Bernard Berenson and Samuel H. Kress in the field of Renaissance Painting.

The present paperback edition, which contains the same text and plates as the large Phaidon cloth-bound edition, consists of two self-contained volumes.

Volume I contains the Preface, the essays on the Venetian and North Italian Painters, and the Decline of Art.

Volume II contains the essays on the Florentine and Central Italian Painters.

PREFACE

MANY see pictures without knowing what to look at. They are asked to admire works of pretended art and they do not know enough to say, like the child in Andersen's tale, 'Look, the Emperor has nothing on'.

Vaguely the public feels that it is not being fed, perhaps taken in, possibly made fun of.

It is as if suddenly they were cut off from familiar food and told to eat dishes utterly unknown, with queer tastes, foreboding perhaps that they were poisonous.

In a long experience humanity has learnt what beasts of the field, what fowl of the air, what creeping things, what fishes, what vegetables and fruits it can feed on. In the course of thousands of years it has learnt how to cook them so as to appeal to smell, palate and teeth, to be toothsome.

In the same way some few of us have learnt in the course of ages what works of art, what paintings, what sculpture, what architecture feed the spirit.

Not many feel as convinced of what they are seeing as of what they are eating.

Just as all of us have learnt what is best as food, some of us think we have learnt what is best as art.

A person with convictions about his normal workaday food may enjoy highly savoured cookery for a change, or out of curiosity, but he will always return to the dishes he grew up on—as we Americans say, to 'mother's cooking'.

Art lacks the urgency of food, and little children are not taught what to look at as they are taught what to eat. And unless they are brought up in families of taste as well as of means, they are not likely to develop unconsciously a feeling for visual art, as they do, let us say, for language. Words and speech they pick up before they know what instruments they are learning to use. Later at school they are taught to practise and enjoy language as an art, as communicative speech and writing, chiefly through the reading of graduated passages from the best authors and through being taught how to understand and appreciate and enjoy them. In that way habits of liking and disliking are lodged in the mind. They guide us through life in encountering the not yet classified, the not yet consecrated, and in recognizing what is and what is not valuable and enjoyable or worth making the effort to

understand and enjoy. They end by giving us a sense of antecedent probability towards literature.

Why should we not try to implant such habits in a child's mind also for the visual arts?

Unhappily pictures cannot as yet be printed (so to speak) exactly as they are painted, in the way a writer's manuscript can be, without losing the quality of the original. The reproduction of a picture is still a makeshift, and may remain so for a long time, even if accurate and satisfactory colour reproductions should become available. The size of a composition has a certain effect on its quality, and colour clings to what is behind it. Thus a colour will, of course, not be the same on wood as on slate or marble or copper, and will vary from textile to textile on which it is applied, as for instance rough or ordinary canvas or fine linen.

On the whole therefore (despite the childish hanker today for colour reproductions, no matter how crude) the black and white, made from a photo that preserves tones and values, give the most satisfactory image of the original.

With that conviction in mind and with the idea of furnishing examples on which to educate the eye and the faculties that use the eye as an instrument, the present edition of *Italian Painters of the Renaissance* offers 400 illustrations representing all phases of Italian pictorial art during the three hundred years that begin a little before 1300 and end short of 1600.

For example: the Byzantine phase is represented by the greatest and completest master of that style anywhere in the world, namely, Duccio. The sturdy, severely tactile Romanesque mode by Giotto, its most creative and most accomplished master, and by his best followers, Andrea Orcagna and Nardo di Cione.

Then comes the fifteenth century and the struggle started by Masolino and Masaccio to emancipate painting from degenerate calligraphic Gothic affectation. Masaccio was a resurrected Giotto, with even increased power of communicating dignity, responsibility, spirituality by means of appropriate shapes, attitudes and grouping of figures. After his early death, Florentine painting, profiting by the great sculptors Donatello and Ghiberti and developed by artists like Fra Angelico, Fra Filippo Lippi, Pollaiuolo, Botticelli and Leonardo, culminated in Michelangelo, Andrea del Sarto and their immediate followers Pontormo and Bronzino. By that time the Florentines not only had recovered the indispensable mastery of the nude that the

Greeks cherished, but in the painting of landscape went beyond them, thanks to their better understanding of light and shade and perspective.

They handed on these achievements to Venice and to the rest of Italy, but to Venice particularly and later to France and Spain.

Venice and Umbria were sufficiently gifted to take advantage of what Florence could give them. They could throw away the scaffolding that the Florentines were too pious or too proud to cast off and produce painters like Perugino and Raphael at their most radiant best, and Giorgione, Titian and Tintoretto, with all their magic and colour, splendour of form and delight in placing the human figure in lordly surroundings and romantic scenery.

Excepting Paolo Veronese (who came, it is true, from Verona, but ended in Venice and was as Venetian as his only equals, namely, Titian and Tintoretto), the north of Italy produced only one artist of the highest mark, Andrea Mantegna of Padua. Milan to be sure had Foppa, Borgognone and Luini, the last valued by Ruskin as Italy's most communicative and convincing religious painter. Nowadays we care more for the energy and vehemence and fancy of the Ferrarese, Tura, Cossa and Ercole Roberti. They put to good use what they took from Donatello, Fra Filippo, Andrea Mantegna, as well as from Piero della Francesca.

Southern Italy during the centuries we are dealing with had no painter worth considering. Sicily had but one, Antonello da Messina, who never would have been the artist we admire without coming in touch first with Petrus Christus and then with Giovanni Bellini, the most creative, the most fascinating of fifteenth-century Venetians.

Visual language changes as much as spoken language. It takes deliberate training to understand the Saxon spoken by our ancestors till toward 1300. In painting that phase corresponds in Italy to Cimabue and Duccio and their close followers.

It takes a serious effort to learn to understand them. By the end of the fourteenth century there was Chaucer, and we can follow him with less difficulty as we can Giotto and Simone Martini and their successors well into the fifteenth century. In that, and in the next century, our ancestors, under various Latin impulses, were struggling towards a speech which approaches our own, and in the course of the struggle produced Marlowe, Shakespeare and Sidney, Milton, Donne, Herbert and Herrick, and a galaxy of minor poets, just as Italy in the same phase had Fra Angelico, Domenico Veneziano, Masaccio, Fra Filippo, Pollaiuolo, Mantegna and the Bellinis, Botticelli,

Leonardo and Michelangelo. With Dryden and Addison and Pope we come to current English and to their visual equivalents Titian and Veronese, Lotto and Tintoretto.

Happily visual language is easier to acquire than spoken language. One can learn to understand Giotto and Cimabue with less effort and in shorter time than Anglo-Saxon or even Middle English writers.

We therefore do not ask too much of the reader if we expect him to begin with looking at what is remotest from him instead of what is nearest, as would be the case with literature.

I am not an assiduous reader of my own writings. Decades have passed without my perusing the text of the *Italian Painters of the Renaissance* from cover to cover. In glancing through its pages now, I have tried to approach it as I would any other book that treated the same subject.

On the whole, it still seems to fulfil its purpose. It does not attempt to give an account of the painters' domestic lives or even of their specific techniques, but of what their pictures mean to us today as works of art, of what they can do for us as ever contemporary life-enhancing actualities. The text may help the reader to understand what the reproductions tell him, and may make him ask what he feels when he looks at them and try to account for his reactions while enjoying a work of visual art—in this instance, the paintings of the Italian Renaissance.

The quality of art remains the same, regardless of time and place and artist. Nevertheless, our feeling for it is conditioned by time and place and the personality of the artist. Acquaintance with these limitations is necessary for the enjoyment and understanding of the work of art. We are so made that we cannot help asking whence and whither, and we appreciate an object more when we know not only what it is intrinsically on its own merits, but also where it came from and what it led to.

Yet too much time should not be wasted in reading about pictures instead of looking at them. Reading will help little towards the enjoyment and appreciation and understanding of the work of art. It is enough to know when and where an artist was born and what older artist shaped and inspired him, rarely, as it happens, the master or teacher who first put pen, pencil and brush into his hands. Least profit is to be got from the writings of the metaphysical and psycho-analytical kind. If read one must, let it be the literature and history of the time and place to which the paintings belong.

We must look and look and look till we live the painting and for a fleeting moment become identified with it. If we do not succeed in loving what through the ages has been loved, it is useless to lie ourselves into believing that we do. A good rough test is whether we feel that it is reconciling us with life.

No artifact is a work of art if it does not help to humanize us. Without art, visual, verbal and musical, our world would have remained a jungle.

BERNARD BERENSON

I Tatti, Settignano, Florence

January, 1952

I. THE VENETIAN PAINTERS

I

AMONG the Italian schools of painting the Venetian has, for the majority of art-loving people, the strongest and most enduring attraction. In the course of the present brief account of the life of that school we shall perhaps discover some of the causes of our peculiar delight and interest in the Venetian painters, as we come to realize what tendencies of the human spirit their art embodied, and of what great consequence their example has been to the whole of European painting for the last three centuries.

The Venetians as a school were from the first endowed with exquisite tact in their use of colour. Seldom cold and rarely too warm, their colouring never seems an afterthought, as in many of the Florentine painters, nor is it always suggesting paint, as in some of the Veronese masters. When the eye has grown accustomed to make allowance for the darkening caused by time, for the dirt that lies in layers on so many pictures, and for unsuccessful attempts at restoration, the better Venetian paintings present such harmony of intention and execution as distinguishes the highest achievements of genuine poets. Their mastery over colour is the first thing that attracts most people to the painters of Venice. Their colouring not only gives direct pleasure to the eye, but acts like music upon the moods, stimulating thought and memory in much the same way as a work by a great composer.

The
Venetians'
use of
colour

II

The Church from the first took account of the influence of colour as well as of music upon the emotions. From the earliest times it employed mosaic and painting to enforce its dogmas and relate its legends, not merely because this was the only means of reaching people who could neither read nor write, but also because it instructed them in a way which, far from leading to critical inquiry, was peculiarly capable of being used as an indirect stimulus to moods of devotion and contrition. Next to the finest mosaics of the first centuries, the early works of Giovanni Bellini, the greatest Venetian master of the fifteenth century, best fulfil this religious intention. Painting had in his lifetime reached a point where the difficulties of technique no longer stood in the way of the expression of profound emotion. No one can look at

The Church
and painting

Pls. 18, 20 Bellini's pictures of the Dead Christ upheld by the Virgin or angels without being put into a mood of deep contrition, nor at his earlier Pl. 19 Madonnas without a thrill of awe and reverence. And Giovanni Bellini does not stand alone. His contemporaries, Gentile Bellini, the Vivarini, Crivelli, and Cima da Conegliano all began by painting in the same spirit, and produced almost the same effect.

The Church, however, thus having educated people to understand painting as a language and to look to it for the expression of their sincerest feelings, could not hope to keep it always confined to the channel of religious emotion. People began to feel the need of painting as something that entered into their everyday lives almost as much as we nowadays feel the need of the newspaper; nor was this unnatural, considering that, until the invention of printing, painting was the only way, apart from direct speech, of conveying ideas to the masses. At about the time when Bellini and his contemporaries were attaining maturity, the Renaissance had ceased to be a movement carried on by scholars and poets alone. It had become sufficiently widespread to seek popular as well as literary utterance, and thus, towards the end of the fifteenth century, it naturally turned to painting, a vehicle of expression which the Church, after a thousand years of use, had made familiar and beloved.

To understand the Renaissance at the time when its spirit began to find complete embodiment in painting, a brief survey of the movement of thought in Italy during its earlier period is necessary, because only when that movement had reached a certain point did painting come to be its most natural medium of expression.

III

The spirit of the Renaissance The thousand years that elapsed between the triumph of Christianity and the middle of the fourteenth century have been not inaptly compared to the first fifteen or sixteen years in the life of the individual. Whether full of sorrows or joys, of storms or peace, these early years are chiefly characterized by tutelage and unconsciousness of personality. But towards the end of the fourteenth century something happened in Europe that happens in the lives of all gifted individuals. There was an awakening to the sense of personality. Although it was felt to a greater or less degree everywhere, Italy felt the awakening earlier than the rest of Europe, and felt it far more strongly. Its first manifestation was a boundless and insatiable curiosity, urging people to find out all they could about the world and about man. They turned

eagerly to the study of classic literature and ancient monuments, because these gave the key to what seemed an immense storehouse of forgotten knowledge; they were in fact led to antiquity by the same impulse which, a little later, brought about the invention of the printing-press and the discovery of America.

The first consequence of a return to classical literature was the worship of human greatness. Roman literature, which the Italians naturally mastered much earlier than Greek, dealt chiefly with politics and war, seeming to give an altogether disproportionate place to the individual, because it treated only of such individuals as were concerned in great events. It is but a step from realizing the greatness of an event to believing that the persons concerned in it were equally great, and this belief, fostered by the somewhat rhetorical literature of Rome, met the new consciousness of personality more than half-way, and led to that unlimited admiration for human genius and achievement which was so prominent a feature of the early Renaissance. The two tendencies reacted upon each other. Roman literature stimulated the admiration for genius, and this admiration in turn reinforced the interest in that period of the world's history when genius was supposed to be the rule rather than the exception; that is to say, it reinforced the interest in antiquity.

Worship of greatness

The spirit of discovery, the never satisfied curiosity of this time, led to the study of ancient art as well as of ancient literature, and the love of antiquity led to the imitation of its buildings and statues as well as of its books and poems. Until comparatively recent times scarcely any ancient paintings were found, although buildings and statues were everywhere to be seen, the moment anyone seriously thought of looking at them. The result was that, while the architecture and sculpture of the Renaissance were directly and strongly influenced by antiquity, painting felt its influence only in so far as the study of antiquity in the other arts had conduced to better draughtsmanship and purer taste. The spirit of discovery could thus show itself only indirectly in painting—only in so far as it led painters to the gradual perfection of the technical means of their craft.

Study of ancient art

Unlimited admiration for genius and wonder that the personalities of antiquity should have survived with their great names in no way diminished, soon had two consequences. One was love of glory, and the other the patronage of those arts which were supposed to hand down a glorious name undiminished to posterity. The glory of old Rome had come down through poets and historians, architects and sculptors, and the Italians, feeling that the same means might be used

to hand down the achievements of their own time to as distant a
posterity, made a new religion of glory, with poets and artists for the
priests. At first the new priesthood was confined almost entirely to
writers, but in little more than a generation architects and sculptors
began to have their part. The passion for building is in itself one of the
most instinctive, and a man's name and armorial bearings, tastefully
but prominently displayed upon a church or palace, were as likely, it
was felt, to hand him down to posterity as the praise of poets or
historians. It was the passion for glory, in reality, rather than any love
of beauty, that gave the first impulse to the patronage of the arts in the
Renaissance. Beauty was the concern of the artists, although no doubt
their patrons were well aware that the more impressive a building was,
the more beautiful a monument, the more likely was it to be admired,
and the more likely were their names to reach posterity. Their instincts
did not mislead them, for where their real achievements would have
tempted only the specialist or antiquarian into a study of their career,
the buildings and monuments put up by them—by such princes as
Sigismondo Malatesta, Federico of Urbino, or Alfonso of Naples—
have made the whole intelligent public believe that they were really
as great as they wished posterity to believe them.

As painting had done nothing whatever to transmit the glory of the
great Romans, the earlier generations of the Renaissance expected
nothing from it, and did not give it that patronage which the Church,
for its own purposes, continued to hold out to it. The Renaissance
began to make especial use of painting only when its own spirit had
spread very widely, and when the love of knowledge, of power, and
of glory had ceased to be the only recognized passions, and when,
following the lead of the Church, people began to turn to painting for
the expression of deep emotion. The new religion, as I have called the
love of glory, is in its very essence a thing of this world, founded as it
is on human esteem. The boundless curiosity of the Renaissance led
back inevitably to an interest in life and to an acceptance of things for
what they were—for their intrinsic quality. The moment people
stopped looking fixedly towards heaven, their eyes fell upon the earth,
and they began to see much on its surface that was pleasant. Their own
faces and figures must have struck them as surprisingly interesting,
and, considering how little St. Bernard and other medieval saints and
doctors had led them to expect, singularly beautiful. A new feeling
arose that mere living was a big part of life, and with it came a new
passion, the passion for beauty, for grace, and for comeliness.

It has already been suggested that the Renaissance was a period in

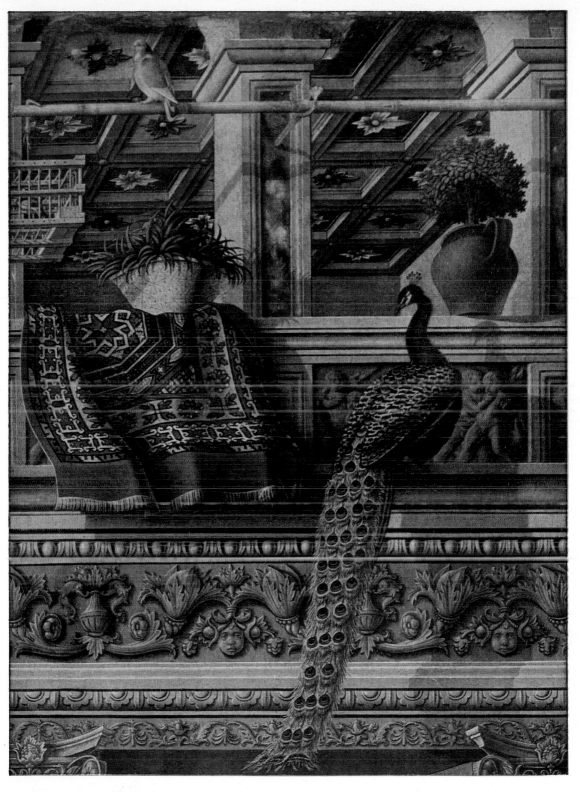

I. CARLO CRIVELLI: *Still Life with Peacock*. Detail of Plate 14

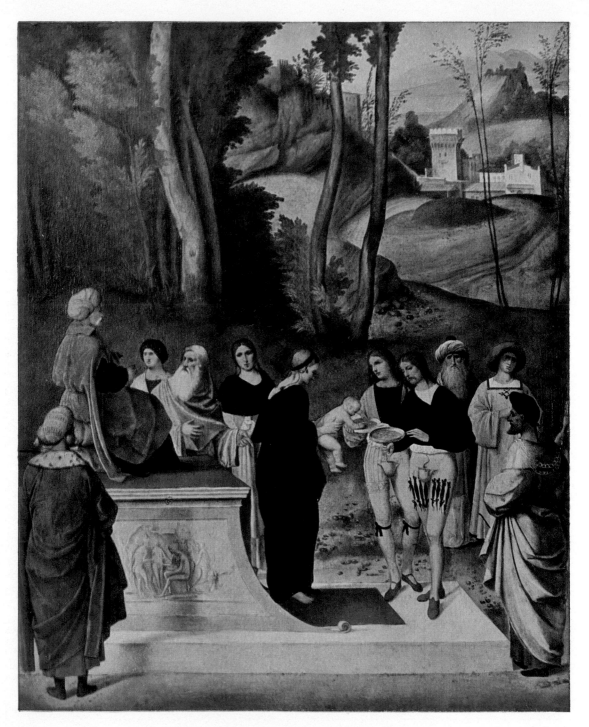

II. GIORGIONE: *The Trial of Moses*. Detail of Plate 36

the history of modern Europe comparable to youth in the life of the individual. It had all youth's love of finery and of play. The more people were imbued with the new spirit, the more they loved pageants. The pageant was an outlet for many of the dominant passions of the time, for there a man could display all the finery he pleased, satisfy his love of antiquity by masquerading as Caesar or Hannibal, his love of knowledge by finding out how the Romans dressed and rode in triumph, his love of glory by the display of wealth and skill in the management of the ceremony, and, above all, his love of feeling himself alive. Solemn writers have not disdained to describe to the minutest details many of the pageants which they witnessed.

We have seen that the earlier elements of the Renaissance, the passion for knowledge and glory, were not of the kind to give a new impulse to painting. Nor was the passion for antiquity at all so direct an inspiration to that art as it was to architecture and sculpture. The love of glory had, it is true, led such as could not afford to put up monumental buildings, to decorate chapels with frescoes in which their portraits were timidly introduced. But it was only when the Renaissance had attained to a full consciousness of its interest in life and enjoyment of the world that it naturally turned, and indeed was forced to turn, to painting; for it is obvious that painting is peculiarly fitted for rendering the appearances of things with a glow of light and richness of colour that correspond to warm human emotions.

IV

When it once more reached the point where its view of the world naturally sought expression in painting, as religious ideas had done before, the Renaissance found in Venice clearer utterance than elsewhere, and it is perhaps this fact which makes the most abiding interest of Venetian painting. It is at this point that we shall take it up.

The growing delight in life with the consequent love of health, beauty, and joy were felt more powerfully in Venice than anywhere else in Italy. The explanation of this may be found in the character of the Venetian government which was such that it gave little room for the satisfaction of the passion for personal glory, and kept its citizens so busy in duties of state that they had small leisure for learning. Some of the chief passions of the Renaissance thus finding no outlet in Venice, the other passions insisted all the more on being satisfied. Venice, moreover, was the only state in Italy which was enjoying, and for many generations had been enjoying, internal peace. This gave the

Venetians a love of comfort, of ease, and of splendour, a refinement of manner, and humaneness of feeling, which made them the first modern people in Europe. Since there was little room for personal glory in Venice, the perpetuators of glory, the Humanists, found at first scant encouragement there, and the Venetians were saved from that absorption in archaeology and pure science which overwhelmed Florence at an early date. This was not necessarily an advantage in itself, but it happened to suit Venice, where the conditions of life had for some time been such as to build up a love of beautiful things. As it was, the feeling for beauty was not hindered in its natural development. Archaeology would have tried to submit it to the good taste of the past, a proceeding which rarely promotes good taste in the present. Too much archaeology and too much science might have ended in making Venetian art academic, instead of letting it become what it did, the product of a natural ripening of interest in life and love of pleasure. In Florence, it is true, painting had developed almost simultaneously with the other arts, and it may be due to this cause that the Florentine painters never quite realized what a different task from the architect's and sculptor's was theirs. At the time, therefore, when the Renaissance was beginning to find its best expression in painting, the Florentines were already too much attached to classical ideals of form and composition, in other words, too academic, to give embodiment to the throbbing feeling for life and pleasure.

Thus it came to pass that in the Venetian pictures of the end of the fifteenth century we find neither the contrition nor the devotion of those earlier years when the Church alone employed painting as the interpreter of emotion, nor the learning which characterized the Florentines. The Venetian masters of this time, although nominally continuing to paint the Madonna and saints, were in reality painting handsome, healthy, sane people like themselves, people who wore their splendid robes with dignity, who found life worth the mere living and sought no metaphysical basis for it. In short, the Venetian pictures of the last decade of the century seemed intended not for devotion, as they had been, nor for admiration, as they then were in Florence, but for enjoyment.

The Church itself, as has been said, had educated its children to understand painting as a language. Now that the passions men dared to avow were no longer connected with happiness in some future state only, but mainly with life in the present, painting was expected to give voice to these more human aspirations and to desert the outgrown ideals of the Church. In Florence, the painters seemed unable or

unwilling to make their art really popular. Nor was it so necessary there, for Poliziano, Pulci, and Lorenzo dei Medici supplied the need of self-expression by addressing the Florentines in the language which their early enthusiasm for antiquity and their natural gifts had made them understand better than any other—the language of poetry. In Venice alone painting remained what it had been all over Italy in earlier times, the common tongue of the whole mass of the people. Venetian artists thus had the strongest inducements to perfect the processes which painters must employ to make pictures look real to their own generation; and their generation had an altogether firmer hold on reality than any that had been known since the triumph of Christianity. Here again the comparison of the Renaissance to youth must be borne in mind. The grasp that youth has on reality is not to be compared to that brought by age, and we must not expect to find in the Renaissance a passion for an acquaintance with things as they are such as we ourselves have; but still its grasp of facts was far firmer than that of the Middle Ages.

Painting as common tongue

Painting, in accommodating itself to the new ideas, found that it could not attain to satisfactory representation merely by form and colour, but that it required light and shadow and effects of space. Indeed, venial faults of drawing are perhaps the least disturbing, while faults of perspective, of spacing, and of colour completely spoil a picture for people who have an everyday acquaintance with painting such as the Venetians had. We find the Venetian painters, therefore, more and more intent upon giving the space they paint its real depth, upon giving solid objects the full effect of the round, upon keeping the different parts of a figure within the same plane, and upon compelling things to hold their proper places one behind the other. As early as the beginning of the sixteenth century a few of the greater Venetian painters had succeeded in making distant objects less and less distinct, as well as smaller and smaller, and had succeeded also in giving some appearance of reality to the atmosphere. These are a few of the special problems of painting, as distinct from sculpture for instance, and they are problems which, among the Italians, only the Venetians and the painters closely connected with them solved with any success.

V

The painters of the end of the fifteenth century who met with the greatest success in solving these problems were Giovanni and Gentile Bellini, Cima da Conegliano, and Carpaccio, and we find each of them

enjoyable to the degree that he was in touch with the life of his day. I have already spoken of pageants and of how characteristic they were of the Renaissance, forming as they did a sort of safety-valve for its chief passions. Venice, too, knew the love of glory, and the passion was perhaps only the more intense because it was all dedicated to the State. There was nothing the Venetians would not do to add to its greatness, glory, and splendour. It was this which led them to make of the city itself that wondrous monument to the love and awe they felt for their Republic, which still rouses more admiration and gives more pleasure than any other one achievement of the art-impulse in man. They were not content to make their city the most beautiful in the world; they performed ceremonies in its honour partaking of all the solemnity of religious rites. Processions and pageants by land and by sea, free from that gross element of improvisation which characterized them elsewhere in Italy, formed no less a part of the functions of the Venetian State than the High Mass in the Catholic Church. Such a function, with Doge and Senators arrayed in gorgeous costumes no less prescribed than the raiments of ecclesiastics, in the midst of the fairy-like architecture of the Piazza or canals, was the event most eagerly looked forward to, and the one that gave most satisfaction to the Venetian's love of his State, and to his love of splendour, beauty, and gaiety. He would have had them every day if it were possible, and, to make up for their rarity, he loved to have representations of them. So most Venetian pictures of the beginning of the sixteenth century tended to take the form of magnificent processions, if they did not actually represent them. They are processions in the Piazza, as in Gentile Bellini's 'Corpus Christi' picture, or on the water, as in Carpaccio's picture where St. Ursula leaves her home; or they represent what was a gorgeous but common sight in Venice, the reception or dismissal of ambassadors, as in several pictures of Carpaccio's St. Ursula series; or they show simply a collection of splendidly costumed people in the Piazza, as in Gentile's 'Preaching of St. Mark'. Not only the pleasure-loving Carpaccio, but the austere Cima, as he grew older, turned every biblical and saintly legend into an occasion for the picture of a pageant.

But there was a further reason for the popularity of such pictures. The decorations which were then being executed by the most reputed masters in the Hall of Great Council in the Doge's Palace, were, by the nature of the subject, required to represent pageants. The Venetian State encouraged painting as did the Church, in order to teach its subjects its own glory in a way that they could understand without

Marginal notes:

Venetians' passion for glory

Gorgeous functions

Pageant pictures

Pl. 3

Pl. 7

Pls. 4, 5

Pl. 29

State patronage in Venice

being led on to critical inquiry. Venice was not the only city, it is true, that used painting for political purposes; but the frescoes of Lorenzetti at Siena were admonitions to govern in accordance with the Cate- chism, while the pictures in the Great Hall of the Doge's Palace were of a nature to remind the Venetians of their glory and also of their state policy. These mural paintings represented such subjects as the Doge bringing about a reconciliation between the Pope and the Emperor Barbarossa, an event which marked the first entry of Venice into the field of Continental politics, and typified as well its unchanging policy, which was to gain its own ends by keeping a balance of power between the allies of the Pope and the allies of his opponents. The first edition, so to speak, of these works had been executed at the end of the fourteenth century and in the beginning of the fifteenth. Towards the end of that century it no longer satisfied the new feeling for reality and beauty, and thus had ceased to serve its purpose, which was to glorify the State. The Bellini, Alvise Vivarini, and Carpaccio were employed to make a second rendering of the very same subjects, and this gave the Venetians ample opportunity for finding out how much they liked pageant pictures.

It is curious to note here that at the same time Florence also commissioned its greatest painters to execute works for its Council Hall, but left them practically free to choose their own subjects. Michelangelo chose for his theme 'The Florentines while Bathing Surprised by the Pisans', and Leonardo 'The Battle of the Standard'. Neither of these was intended in the first place to glorify the Florentine Republic, but rather to give scope to the painter's genius, Michel- angelo's for the treatment of the nude, Leonardo's for movement and animation. Each, having given scope to his peculiar talents in his cartoon, had no further interest, and neither of the undertakings was ever completed. Nor do we hear that the Florentine councillors enjoyed the cartoons, which were instantly snatched up by students who turned the hall containing them into an academy.

State patronage in Florence

VI

It does not appear that the Hall of Great Council in Venice was turned into a students' academy, and, although the paintings there doubtless gave a decided incentive to artists, their effect upon the public, for whom they were designed, was even greater. The councillors were not allowed to be the only people to enjoy fascinating pictures of gorgeous pageants and ceremonials. The Mutual Aid Societies—the Schools, as

they were called—were not long in getting the masters who were employed in the Doge's Palace to execute for their own meeting-places pictures equally splendid. The Schools of San Giorgio, Sant' Ursula, and Santo Stefano, employed Carpaccio, the Schools of San Giovanni and San Marco, Gentile Bellini, and other Schools employed minor painters. The works carried out for these Schools are of peculiar importance, both because they are all that remain to throw light upon the pictures in the Doge's Palace destroyed in the fire of 1576, and because they form a transition to the art of a later day. Just as the State chose subjects that glorified itself and taught its own history and policy, so the Schools had pictures painted to glorify their patron saints, and to keep their deeds and example fresh. Many of these pictures—most in fact—took the form of pageants; but even in such, intended as they were for almost domestic purposes, the style of high ceremonial was relaxed, and elements taken directly from life were

Pl. 3 introduced. In his 'Corpus Christi', Gentile Bellini paints not only the solemn and dazzling procession in the Piazza, but the elegant young men who strut about in all their finery, the foreign loungers, and even the unfailing beggar by the portal of St. Mark's. In his 'Miracle of the

Pl. 6 True Cross', he introduces gondoliers, taking care to bring out all the beauty of their lithe, comely figures as they stand to ply the oar, and does not reject even such an episode as a serving-maid standing in a doorway watching a negro who is about to plunge into the canal. He treats this bit of the picture with all the charm and much of that delicate feeling for simple effects of light and colour that we find in such Dutch painters as Vermeer van Delft and Peter de Hoogh.

Episodes such as this in the works of the earliest great Venetian master must have acted on the public like a spark on tinder. They certainly found a sudden and assured popularity, for they play a more and more important part in the pictures executed for the Schools, many of the subjects of which were readily turned into studies of ordinary Venetian life. This was particularly true of the works of

Carpaccio Carpaccio. Much as he loved pageants, he loved homelier scenes as

Pl. 9 well. His 'Dream of St. Ursula' shows us a young girl asleep in a room filled with the quiet morning light. Indeed, it may be better described as the picture of a room with the light playing softly upon its walls, upon the flower-pots in the window, and upon the writing-table and the cupboards. A young girl happens to be asleep in the bed, but the picture is far from being a merely economic illustration to this episode in the life of the saint. Again, let us take the work in the same series

Pl. 8 where King Maure dismisses the ambassadors. Carpaccio has made

this a scene of a chancellery in which the most striking features are neither the king nor the ambassadors, but the effect of the light that streams through a side door on the left and a poor clerk labouring at his task. Or, again, take St. Jerome in his study, in the Scuola di San Giorgio. He is nothing but a Venetian scholar seated in his comfortable, bright *Pl. 10* library, in the midst of his books, with his little shelf of bric-à-brac running along the wall. There is nothing in his look or surroundings to speak of a life of self-denial or of arduous devotion to the problems of sin and redemption. Even the 'Presentation of the Virgin', which offered such a splendid chance for a pageant, Carpaccio, in one instance, turned into the picture of a simple girl going to her first communion. In other words, Carpaccio's quality is the quality of a painter of genre, of which he was the earliest Italian master. His genre differs from Dutch or French not in kind but in degree. Dutch genre is much more democratic, and, as painting, it is of a far finer quality, but it deals with its subject, as Carpaccio does, for the sake of its own pictorial capacities and for the sake of the effects of colour and of light and shade.

But happily art is too great and too vital a subject to be crowded into any single formula; and a formula that would, without distorting our entire view of Italian art in the fifteenth century, do full justice to such a painter as Carlo Crivelli, does not exist. He takes rank with the *Crivelli* most genuine artists of all times and countries, and does not weary even when 'great masters' grow tedious. He expresses with the free- *Pls. 12–15, I* dom and spirit of Japanese design a piety as wild and tender as Jacopo da Todi's, a sweetness of emotion as sincere and dainty as of a Virgin and Child carved in ivory by a French craftsman of the fourteenth century. The mystic beauty of Simone Martini, the agonized com- passion of the young Bellini, are embodied by Crivelli in forms which have the strength of line and the metallic lustre of old Satsuma or lacquer, and which are no less tempting to the touch. Crivelli must be treated by himself and as the product of stationary, if not reactionary, conditions. Having lived most of his life away from the main currents of culture, in a province where St. Bernardino had been spending his last energies in the endeavour to call the world back to the ideals of an infantile civilization, Crivelli does not belong to a movement of constant progress, and therefore is not within the scope of this work.

VII

At the beginning of the Renaissance, painting was almost wholly confined to the Church. From the Church it extended to the Council

Hall, and thence to the Schools. There it rapidly developed into an art which had no higher aim than painting the sumptuous life of the aristocracy. When it had reached this point, there was no reason whatever why it should not begin to grace the dwellings of all well-to-do people.

In the sixteenth century painting was not looked upon with the estranging reverence paid to it now. It was almost as cheap as printing has become since, and almost as much employed. When the Venetians had attained the point of culture where they were able to differentiate their sensations and distinguish pleasure from edification, they found that painting gave them decided pleasure. Why should they always have to go to the Doge's Palace or to some School to enjoy this pleasure? That would have been no less a hardship than for us never to hear music outside of a concert-room. There is no merely rhetorical comparison, for in the life of the Venetian of the sixteenth century painting took much the same place that music takes in ours. He no longer expected it to tell him stories or to teach him the Catechism. Printed books, which were beginning to grow common, amply satisfied both these needs. He had as a rule very little personal religion, and consequently did not care for pictures that moved him to contrition or devotion. He preferred to have some pleasantly coloured thing that would put him into a mood connected with the side of life he most enjoyed—with refined merrymaking, with country parties, or with the sweet dreams of youth. Venetian painting alone among Italian schools was ready to satisfy such a demand, and it thus became the first genuinely modern art: for the most vital difference that can be indicated between the arts in antiquity and modern times is this—that now the arts tend to address themselves more and more to the actual needs of men, while in olden times they were supposed to serve some more than human purpose.

The pictures required for a house were naturally of a different kind from those suited to the Council Hall or the School, where large paintings, which could be filled with many figures, were in place. For the house smaller pictures were necessary, such as could easily be carried about. The mere dimensions, therefore, excluded pageants, but, in any case, the pageant was too formal a subject to suit all moods —too much like a brass band always playing in the room. The easel picture had to be without too definite a subject, and could no more permit being translated into words than a sonata. Some of Giovanni Bellini's late works are already of this kind. They are full of that subtle, refined poetry which can be expressed in form and colour alone. But

Venetian culture

Easel pictures

they were a little too austere in form, a little too sober in colour, for the gay, care-free youth of the time. Carpaccio does not seem to have painted many easel pictures, although his brilliancy, his delightful fancy, his love of colour, and his gaiety of humour would have fitted him admirably for this kind of painting. But Giorgione, the follower of both these masters, starting with the qualities of both as his inheritance, combined the refined feeling and poetry of Bellini with Carpaccio's gaiety and love of beauty and colour. Stirred with the enthusiasms of his own generation as people who had lived through other phases of feeling could not be, Giorgione painted pictures so perfectly in touch with the ripened spirit of the Renaissance that they met with the success which those things only find that at the same moment wake us to the full sense of a need and satisfy it. *Giorgione*

Giorgione's life was short, and very few of his works—not a score in all—have escaped destruction. But these suffice to give us a glimpse into that brief moment when the Renaissance found its most genuine expression in painting. Its over-boisterous passions had quieted down into a sincere appreciation of beauty and of human relations. It would be really hard to say more about Giorgione than this, that his pictures are the perfect reflex of the Renaissance at its height. His works, as well as those of his contemporaries and followers, still continue to be appreciated most by people whose attitude of mind and spirit has most in common with the Renaissance, or by those who look upon Italian art not merely as art, but as the product of this period. For that is its greatest interest. Other schools have accomplished much more in mere painting than the Italian. A serious student of art will scarcely think of putting many of even the highest achievements of the Italians, considered purely as technique, beside the works of the great Dutchmen, the great Spaniard, or even the masters of today. Our real interest in Italian painting is at bottom an interest in that art which we almost instinctively feel to have been the fittest expression found by a period in the history of modern Europe which has much in common with youth. The Renaissance has the fascination of those years when we seemed so full of promise both to ourselves and to everybody else. *Pls. 32-8*

VIII

Giorgione created a demand which other painters were forced to supply at the risk of finding no favour. The older painters accommodated themselves as best they could. One of them indeed, turning towards the new in a way that is full of singular charm, gave his later *Catena*

Pl. 30

works all the beauty and softness of the first spring days in Italy. Upon hearing the title of one of Catena's works in the National Gallery, 'A Warrior Adoring the Infant Christ', who could imagine what a treat the picture itself had in store for him? It is a fragrant summer landscape enjoyed by a few quiet people, one of whom, in armour, with the glamour of the Orient about him, kneels at the Virgin's feet, while a romantic young page holds his horse's bridle. I mention this picture in particular because it is so accessible, and so good an instance of the Giorgionesque way of treating a subject; not for the story, nor for the display of skill, nor for the obvious feeling, but for the lovely landscape, for the effects of light and colour, and for the sweetness of

Pls. 32–5

human relations. Giorgione's altar-piece at Castelfranco is treated in precisely the same spirit, but with far more genius.

The young painters had no chance at all unless they undertook at once to furnish pictures in Giorgione's style. But before we can appreciate all that the younger men were called upon to do, we must turn to the consideration of that most wonderful product of the Renaissance and of the painter's craft—the Portrait.

<div align="center">IX</div>

The portrait

The longing for the perpetuation of one's fame, which has already been mentioned several times as one of the chief passions of the Renaissance, brought with it the more universal desire to hand down the memory of one's face and figure. The surest way to accomplish this end seemed to be the one which had proved successful in the case of the great Romans, whose effigies were growing more and more familiar as new busts and medals were dug up. The earlier generations of the Renaissance relied therefore on the sculptor and the medallist to

Sculpture and medals

hand down their features to an interested posterity. These artists were ready for their task. The mere materials gave them solidity, an effect so hard to get in painting. At the same time, nothing was expected from them except that they should mould the material into the desired shape. No setting was required and no colour. Their art on this account alone would naturally have been the earliest to reach fruition. But over and above this, sculptors and medallists had the direct inspiration of antique models, and through the study of these they were at an early date brought in contact with the tendencies of the Renaissance. The passion then prevailing for pronounced types, and the spirit of analysis this produced, forced them to such patient study of the face as would enable them to give the features that look of belonging to one con-

sistent whole which we call character. Thus, at a time when painters had not yet learned to distinguish between one face and another, Donatello was carving busts which remain unrivalled as studies of character, and Pisanello was casting bronze and silver medals which are among the greatest claims to renown of those whose effigies they bear.

Donatello's bust of Niccolo d'Uzzano shows clearly, nevertheless, that the Renaissance could not long remain satisfied with the sculptured portrait. It is coloured like nature, and succeeds so well in producing for an instant the effect of actual life as to seem uncanny the next moment. Donatello's contemporaries must have had the same impression, for busts of this kind are but few. Yet these few prove that the element of colour had to be included before the satisfactory portrait was found: in other words, that painting and not sculpture was to be the portrait-art of the Renaissance.

Donatello

The most creative sculptor of the earlier Renaissance was not the only artist who felt the need of colour in portraiture. Vittore Pisano, the greatest medallist of this or any age, felt it quite as keenly, and being a painter as well, he was among the first to turn this art to portraiture. In his day, however, painting was still too undeveloped an art for the portrait not to lose in character what it gained in a more life-like colouring, and the two of Pisanello's portraits which still exist are profiles much inferior to his best medals, seeming indeed to be enlargements of them rather than original studies from life.

Pisanello

It was only in the next generation, when the attention of painters themselves was powerfully concentrated upon the reproduction of strongly pronounced types of humanity, that they began to make portraits as full of life and energy as Donatello's busts of the previous period. Even then, however, the full face was rarely attempted, and it was only in the beginning of the sixteenth century that full-face portraits began to be common. The earliest striking achievement of this sort, Mantegna's head of Cardinal Scarampo (now in Berlin), was not the kind to find favour in Venice. The full-face likeness of this wolf in sheep's clothing brought out the workings of the self-seeking, cynical spirit within too clearly not to have revolted the Venetians, who looked upon all such qualities as impious in the individual because they were the strict monopoly of the State. In the portraits of Doges which decorated the frieze of its great Council Hall, Venice wanted the effigies of functionaries entirely devoted to the State, and not of great personalities, and the profile lent itself more readily to the omission of purely individual traits.

The new portraiture

It is significant that Venice was the first state which made a business

of preserving the portraits of its chief rulers. Those which Gentile and

Pls. 23, 24

Giovanni Bellini executed for this end must have had no less influence on portraiture than their mural paintings in the same Hall had on other branches of the art. But the State was not satisfied with leaving records of its glory in the Ducal Palace alone. The Church and the saints were impressed for the same purpose—happily for us, for while the portraits in the Great Hall have perished, several altar-pieces still preserve to us the likenesses of some of the Doges.

Early in the sixteenth century, when people began to want pictures in their own homes as well as in their public halls, personal and

Choice of
subjects

religious motives combined to dictate the choice of subjects. In the minds of many, painting, although a very familiar art, was too much connected with solemn religious rites and with state ceremonies to be used at once for ends of personal pleasure. So landscape had to slide

Pl. 28

in under the patronage of St. Jerome; while romantic biblical episodes,

Pls. 36, II

like the 'Finding of Moses', or the 'Judgement of Solomon', gave an excuse for genre, and the portrait crept in half hidden under the mantle of a patron saint. Its position once secure, however, the portrait took no time to cast off all tutelage, and to declare itself one of the most attractive subjects possible. Over and above the obvious satisfaction afforded by a likeness, the portrait had to give pleasure to the eye, and to produce those agreeable moods which were expected from all other paintings in Giorgione's time. Portraits like that of Scarampo are scarcely less hard to live with than such a person himself must have been. They tyrannize rather than soothe and please. But Giorgione and his immediate followers painted men and women whose very look leads one to think of sympathetic friends, people whose features are pleasantly rounded, whose raiment seems soft to touch, whose surroundings call up the memory of sweet landscapes and refreshing breezes. In fact, in these portraits the least apparent object was the likeness, the real purpose being to please the eye and to turn the mind toward pleasant themes. This no doubt helps to account for the great popularity of portraits in Venice during the sixteenth century. Their number, as we shall see, only grows larger as the century advances.

X

Giorgione's
followers

Giorgione's followers had only to exploit the vein their master hit upon to find ample remuneration. Each, to be sure, brought a distinct personality into play, but the demand for the Giorgionesque article, if one may be allowed the phrase, was too strong to permit of much

deviation. It no longer mattered what the picture was to represent or where it was going to be placed; the treatment had to be always bright, romantic, and joyous. Many artists still confined themselves to painting ecclesiastical subjects chiefly, but even among these, such painters as Lotto and Palma, for example, are fully as Giorgionesque as Titian, Bonifazio, or Paris Bordone.

Titian, in spite of a sturdier, less refined nature, did nothing for a generation after Giorgione's death but work on his lines. A difference in quality between the two masters shows itself from the first, but the spirit that animated each is identical. The pictures Titian was painting ten years after his companion's death have not only many of the qualities of Giorgione's, but something more, as if done by an older Giorgione, with better possession of himself, and with a larger and firmer hold on the world. At the same time, they show no diminution of spontaneous joy of life, and even an increased sense of its value and dignity. What an array of masterpieces might be brought to witness! In the 'Assumption', for example, the Virgin soars heavenward, not helpless in the arms of angels, but borne up by the fullness of life within her, and by the feeling that the universe is naturally her own, and that nothing can check her course. The angels seem to be there only to sing the victory of a human being over his environment. They are embodied joys, acting on our nerves like the rapturous outburst of the orchestra at the end of 'Parsifal'. Or look at the 'Bacchanals' in Madrid, or at the 'Bacchus and Ariadne' in the National Gallery. How brim-full they are of exuberant joy! you see no sign of a struggle of inner and outer conditions, but life so free, so strong, so glowing, that it almost intoxicates. They are truly Dionysiac, Bacchanalian triumphs —the triumph of life over the ghosts that love the gloom and chill and hate the sun.

The portraits Titian painted in these years show no less feeling of freedom from sordid cares, and no less mastery over life. Think of 'The Man with the Glove' in the Louvre, of the 'Concert' and 'Young Englishman' in Florence, and of the Pesaro family in their altarpiece in the Frari at Venice—call up these portraits, and you will see that they are true children of the Renaissance whom life has taught no meannesses and no fears.

Titian

The Assunta
Pls. 40–2

Pls. 43–5

Pls. 50, III, 48
51, 47

XI

But even while such pictures were being painted, the spirit of the Italian Renaissance was proving inadequate to life. This was not the

fault of the spirit, which was the spirit of youth. But youth cannot last more than a certain length of time. No matter how it is spent, manhood and middle age will come. Life began to show a sterner and more sober face than for a brief moment it had seemed to wear. Men became conscious that the passions for knowledge, for glory, and for personal advancement were not at the bottom of all the problems that life presented. Florence and Rome discovered this suddenly, and with a shock. In the presence of Michelangelo's sculptures in San Lorenzo, or of his 'Last Judgement', we still hear the cry of anguish that went up as the inexorable truth dawned upon them. But Venice, although humiliated by the League of Cambrai, impoverished by the Turk, and by the change in the routes of commerce, was not crushed, as was the rest of Italy, under the heels of Spanish infantry, nor so drained of resource as not to have some wealth still flowing into her coffers. Life grew soberer and sterner, but it was still amply worth the living, although the relish of a little stoicism and of earnest thought no longer seemed out of place. The spirit of the Renaissance had found its way to Venice slowly; it was even more slow to depart.

We therefore find that towards the middle of the sixteenth century, when elsewhere in Italy painting was trying to adapt itself to the hypocrisy of a Church whose chief reason for surviving as an institution was that it helped Spain to subject the world to tyranny, and when portraits were already exhibiting the fascinating youths of an earlier generation turned into obsequious and elegant courtiers—in Venice painting kept true to the ripened and more reflective spirit which succeeded to the most glowing decades of the Renaissance. This led men to take themselves more seriously, to act with more consideration of consequences, and to think of life with less hope and exultation. Quieter joys were sought, the pleasures of friendship and of the affections. Life not having proved the endless holiday it had promised to be, earnest people began to question whether under the gross mask of the official religion there was not something to console them for departed youth and for the failure of hopes. Thus religion began to revive in Italy, this time not ethnic nor political, but personal—an answer to the real needs of the human soul.

XII

Lotto

It is scarcely to be wondered at that the Venetian artist, in whom we first find the expression of the new feelings, should have been one who by wide travel had been brought in contact with the miseries of Italy

in a way not possible for those who remained sheltered in Venice. Lorenzo Lotto, when he is most himself, does not paint the triumph of man over his environment, but in his altar-pieces, and even more Pls. 54–7 in his portraits, he shows us people in want of the consolations of religion, of sober thought, of friendship and affection. They look out from his canvases as if begging for sympathy.

But real expression for the new order of things was not to be found by one like Lotto, sensitive of feeling and born in the heyday of the Renaissance, to whom the new must have come as a disappointment. It had to come from one who had not been brought in personal contact with the woes of the rest of Italy, from one less conscious of his environment, one like Titian who was readier to receive the patronage of the new master than to feel an oppression which did not touch him personally; or it had to come from one like Tintoretto, born to the new order of things and not having to outlive a disappointment before adapting himself to it.

<div align="center">XIII</div>

It is as impossible to keep untouched by what happens to your neighbours as to have a bright sky over your own house when it is Spread of Spanish influence stormy everywhere else. Spain did not directly dominate Venice, but the new fashions of life and thought inaugurated by her nearly universal triumph could not be kept out. Her victims, among whom the Italian scholars must be reckoned, flocked to Venice for shelter, persecuted by a rule that cherished the Inquisition. Now for the first time Venetian painters were brought in contact with men of letters. As they were already, fortunately for themselves, too well acquainted with the business of their own art to be taken in tow by learning or even by poetry, the relation of the man of letters to the painter became on the whole a stimulating and at any rate a profitable one, as in the instance of two of the greatest, where it took the form of a partnership for mutual advantage. It is not to our purpose to speak of Aretino's gain, but Titian would scarcely have acquired such fame in his lifetime if that founder of modern journalism, Pietro Aretino, had not been at his side, eager to trumpet his praises and to advise him whom to court.

The overwhelming triumph of Spain entailed still another consequence. It brought home to all Italians, even to the Venetians, the The Triumph of Spain sense of the individual's helplessness before organized power—a sense which, as we have seen, the early Renaissance, with its belief in the

omnipotence of the individual, totally lacked. This was not without a decided influence on art. In the last three decades of his long career,

Titian

Titian did not paint man as if he were as free from care and as fitted to his environment as a lark on an April morning. Rather did he represent man as acting on his environment and suffering from his reactions. He made the faces and figures show clearly what life had done to them.

Pl. 61
Pl. 58

The great 'Ecce Homo' and the 'Crowning with Thorns' are imbued with this feeling no less than the equestrian portrait of Charles the Fifth. In the 'Ecce Homo' we see a man with a godlike personality, humbled by the imperial majesty, broken by the imperial power, and utterly unable to hold out against them. In the 'Crowning with Thorns' we have the same godlike being almost brutalized by pain and suffering. In the portrait of the Emperor we behold a man whom life has enfeebled, one who has to meet a foe who may crush him.

Yet Titian became neither soured nor a pessimist. Many of his late portraits are even more energetic than those of his early maturity. He shows himself a wise man of the world. 'Do not be a grovelling syco-phant,' some of them seem to say, 'but remember that courtly manners and tempered elegance can do you no harm.' Titian, then, was ever ready to change with the times, and on the whole the change was towards a firmer grasp of reality, necessitating yet another advance in

Titian's greatness

the painter's mastery of his craft. Titian's real greatness consists in the fact that he was as able to produce an impression of greater reality as he was ready to appreciate the need of a firmer hold on life. In painting, as has been said, a greater effect of reality is chiefly a matter of light and shadow, to be obtained only by considering the canvas as an enclosed space, filled with light and air, through which the objects are seen. There is more than one way of getting this effect, but Titian attains it by the almost total suppression of outlines, by the har-monizing of his colours, and by the largeness and vigour of his

The old Titian

brushwork. In fact, the old Titian was, in his way of painting, remark-ably like some of the best French masters at the end of the nineteenth century. This makes him only the more attractive, particularly when with handling of this kind he combined the power of creating forms of beauty such as he has given us in the 'Wisdom' of the Venetian

Pls. 59, 63

Library of San Marco, or in the 'Shepherd and Nymph' of Vienna. The difference between the old Titian, author of these works, and the young Titian, painter of the 'Assumption', and of the 'Bacchus and Ariadne', is the difference between the Shakespeare of the *Midsummer-Night's Dream* and the Shakespeare of the *Tempest*. Titian and Shakespeare begin and end so much in the same way by no mere

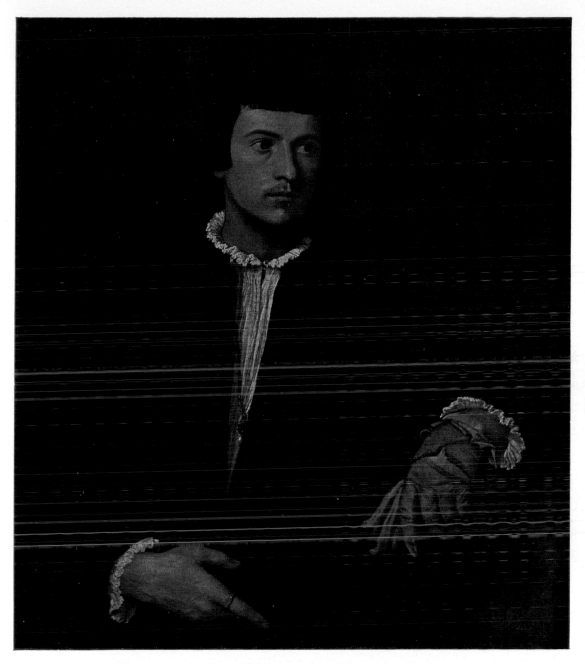

III. TITIAN: '*L'homme au gant*'. Cf. Plate 50

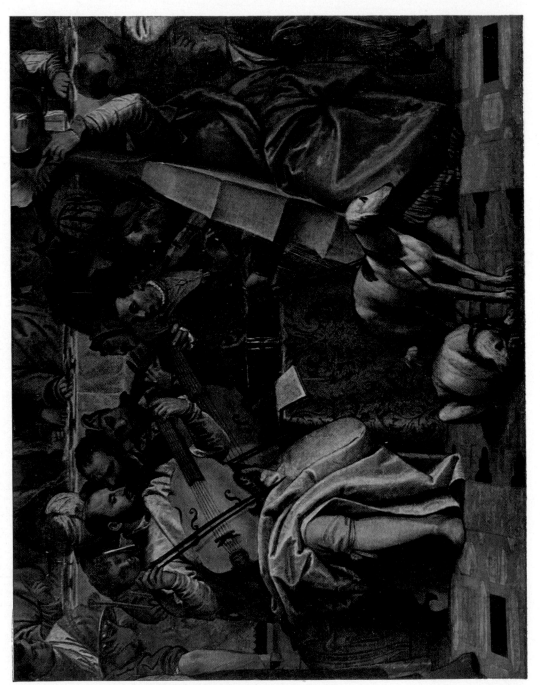

IV. Paolo Veronese: *An Orchestra of Venetian Painters*. Cf. Plate 83

accident. They were both products of the Renaissance, they underwent similar changes, and each was the highest and completest expression of his own age. This is not the place to elaborate the comparison, but I have dwelt so long on Titian, because, historically considered, he is the only painter who expressed nearly all of the Renaissance that could find expression in painting. It is this which makes him even more interesting than Tintoretto, an artist who in many ways was deeper, finer, and even more brilliant.

XIV

Tintoretto grew to manhood when the fruit of the Renaissance was ripe on every bough. The Renaissance had resulted in the emancipation of the individual, in making him feel that the universe had no other purpose than his happiness. This brought an entirely new answer to the question, 'Why should I do this or that?' It used to be, 'Because self-instituted authority commands you.' The answer now was, 'Because it is good for men.' In this lies our greatest debt to the Renaissance, that it instituted the welfare of man as the end of all action. The Renaissance did not bring this idea to practical issue, but our debt to it is endless on account of the results the idea has produced in our own days. This alone would have made the Renaissance a period of peculiar interest, even if it had had no art whatever. But when ideas are fresh and strong, they are almost sure to find artistic embodiment, as indeed this whole epoch found in painting, and this particular period in the works of Tintoretto.

Tintoretto

XV

The emancipation of the individual had a direct effect on the painter in freeing him from his guild. It now occurred to him that possibly he might become more proficient and have greater success if he deserted the influences he was under by the accident of birth and residence, and placed himself in the school that seemed best adapted to foster his talents. This led to the unfortunate experiment of Eclecticism which checked the purely organic development of the separate schools. It brought about their fusion into an art which no longer appealed to the Italian people, as did the art which sprang naturally from the soil, but to the small class of dilettanti who considered a knowledge of art as one of the birthrights of their social position. Venice, however, suffered little from Eclecticism, perhaps because a strong sense of

The experiment of Eclecticism

individuality was late in getting there, and by that time the painters were already well enough educated in their craft to know that they had little to learn elsewhere. The one Venetian who became an Eclectic Pls. 64-7 remained in spite of it a great painter. Sebastiano del Piombo fell under the influence of Michelangelo, but while this influence was pernicious in most cases, the hand that had learned to paint under Bellini, Cima, and Giorgione never wholly lost its command of colour and tone.

XVI

Tintoretto Tintoretto stayed at home, but he felt in his own person a craving for something that Titian could not teach him. The Venice he was born in was not the Venice of Titian's early youth, and his own adolescence fell in the period when Spain was rapidly making herself mistress of Italy. The haunting sense of powers almost irresistible gave a terrible fascination to Michelangelo's works, which are swayed by that sense as by a demonic presence. Tintoretto felt this fascination because he was in sympathy with the spirit which took form in colossal torsos and limbs. To him these were not, as they were to Michelangelo's enrolled followers, merely new patterns after which to model the nude.

But beside this sense of overwhelming power and gigantic force, Tintoretto had to an even greater degree the feeling that whatever existed was for mankind and with reference to man. In his youth people were once more turning to religion, and in Venice poetry was making its way more than it had previously done, not only because Venice had become the refuge of men of letters, but also because of the diffusion of printed books. Tintoretto took to the new feeling for religion and poetry as to his birthright. Yet whether classic fable or Biblical episode were the subject of his art, Tintoretto coloured it with his feeling for the human life at the heart of the story. His sense of power did not express itself in colossal nudes so much as in the immense energy, in the glowing health of the figures he painted, and more still in his effects of light, which he rendered as if he had it in his hands to brighten or darken the heavens at will and subdue them to his own moods.

Light and shadow He could not have accomplished this, we may be sure, if he had not had even greater skill than Titian in the treatment of light and shadow and of atmosphere. It was this which enabled him to give such living versions of Biblical stories and saintly legends. For, granting that an effect of reality were attainable in painting without an adequate treatment of light and atmosphere, even then the reality would look

hideous, as it does in many modern painters who attempt to paint people of today in their everyday dress and among their usual surroundings. It is not 'Realism' which makes such pictures hideous, but the want of that toning down which the atmosphere gives to things in life, and of that harmonizing to which the light subjects all colours.

It was a great mastery of light and shadow which enabled Tintoretto to put into his pictures all the poetry there was in his soul without once tempting us to think that he might have found better expression in words. The poetry which quickens most of his works in the Scuola di San Rocco is almost entirely a matter of light and colour. What is it but the light that changes the solitudes in which the Magdalen and St. Mary of Egypt are sitting, into dreamlands seen by poets in their moments of happiest inspiration? What but light and colour, the gloom and chill of evening, with the white-stoled figure standing resignedly before the judge, that give the 'Christ before Pilate' its sublime magic? What, again, but light, colour, and the star-procession of cherubs that imbue the realism of the 'Annunciation' with music which thrills us through and through? Pl. 68 Pl. 69 Pl. 70

Religion and poetry did not exist for Tintoretto because the love and cultivation of the Muses was a duty prescribed by the Greeks and Romans, and because the love of God and the saints was prescribed by the Church; but rather, as was the case with the best people of his time, because both poetry and religion were useful to man. They helped him to forget what was mean and sordid in life, they braced him to his task, and consoled him for his disappointments. Religion answered to an ever-living need of the human heart. The Bible was no longer a mere document wherewith to justify Christian dogma. It was rather a series of parables and symbols pointing at all times to the path that led to a finer and nobler life. Why then continue to picture Christ and the Apostles, the Patriarchs and Prophets, as persons living under Roman rule, wearing the Roman toga, and walking about in the landscape of a Roman bas-relief? Christ and the Apostles, the Patriarchs and Prophets, were the embodiment of living principles and of living ideals. Tintoretto felt this so vividly that he could not think of them otherwise than as people of his own kind, living under conditions easily intelligible to himself and to his fellow men. Indeed, the more intelligible and the more familiar the look and garb and surroundings of Biblical and saintly personages, the more would they drive home the principles and ideas they incarnated. So Tintoretto did not hesitate to turn every Biblical episode into a picture of what the scene would Tintoretto's religious sense Pls. 70-1, 73-4

look like had it taken place under his own eyes, nor to tinge it with his own mood.

His conception of the human form was, it is true, colossal, although the slender elegance that was then coming into fashion, as if in protest against physical force and organization, influenced him considerably in his construction of the female figure; but the effect which he must always have produced upon his contemporaries, which most of his works still produce, is one of astounding reality as well as of wide sweep and power. Thus, in the 'Discovery of the Body of St. Mark', in the Brera, and in the 'Storm Rising while the Corpse is being Carried through the Streets of Alexandria', in the Academy at Venice, the figures, although colossal, are so energetic and so easy in movement, and the effects of perspective and of light and atmosphere are so on a level with the gigantic figures, that the eye at once adapts itself to the scale, and you feel as if you too partook of the strength and health of heroes.

Conception of the human form

Pl. 78

Pl. 79

XVII

That feeling for reality which made the great painters look upon a picture as the representation of a cubic content of atmosphere enveloping all the objects depicted, made them also consider the fact that the given quantity of atmosphere is sure to contain other objects than those the artist wants for his purpose. He is free to leave them out, of course, but in so far as he does, so far is he from producing an effect of reality. The eye does not see everything, but all the eye would naturally see along with the principal objects must be painted, or the picture will not look true to life. This incorporation of small episodes running parallel with the subject rather than forming part of it, is one of the chief characteristics of modern as distinguished from ancient art. It is this which makes the Elizabethan drama so different from the Greek. It is this again which already separates the works of Duccio and Giotto from the plastic arts of Antiquity. Painting lends itself willingly to the consideration of minor episodes, and for that reason is almost as well fitted to be in touch with modern life as the novel itself. Such a treatment saves a picture from looking prepared and cold, just as light and atmosphere save it from rigidity and crudeness.

Value of minor episodes

No better illustration of this can be found among Italian masters than Tintoretto's 'Crucifixion' in the Scuola di San Rocco. The scene is a vast one, and although Christ is on the Cross, life does not stop. To most of the people gathered there, what takes place is no more than

Tintoretto's 'Crucifixion'

a common execution. Many of them are attending to it as to a tedious
duty. Others work away at some menial task more or less connected
with the Crucifixion, as unconcerned as cobblers humming over their
last. Most of the people in the huge canvas are represented, as no
doubt they were in life, without much personal feeling about Christ.
His own friends are painted with all their grief and despair, but the
others are allowed to feel as they please. The painter does not try to
give them the proper emotions. If one of the great modern novelists,
if Tolstoy, for instance, were describing the Crucifixion, his account
would read as if it were a description of Tintoretto's picture. But
Tintoretto's fairness went even farther than letting all the spectators
feel as they pleased about what he himself believed to be the greatest
event that ever took place. Among this multitude he allowed the light
of heaven to shine upon the wicked as well as upon the good, and the
air to refresh them all equally. In other words, this enormous canvas
is a great sea of air and light at the bottom of which the scene takes
place. Without the atmosphere and the just distribution of light, it
would look as lifeless and desolate, in spite of the crowd and animation,
as if it were the bottom of a dried-up sea.

XVIII

While all these advances were being made, the art of portraiture had
not stood still. Its popularity had only increased as the years went on. Tintoretto's
portraits
Titian was too busy with commissions for foreign princes to supply
the great demand there was in Venice alone. Tintoretto painted por-
traits not only with much of the air of good breeding of Titian's
likenesses, but with even greater splendour, and with an astonishing Pls. 75-7
rapidity of execution. The Venetian portrait, it will be remembered,
was expected to be more than a likeness. It was expected to give
pleasure to the eye, and to stimulate the emotions. Tintoretto was
ready to give ample satisfaction to all such expectations. His portraits,
although they are not so individualized as Lotto's, nor such close
studies of character as Titian's, always render the man at his best, in
glowing health, full of life and determination. They give us the sen-
suous pleasure we get from jewels, and at the same time they make us
look back with amazement to a State where the human plant was in
such vigour as to produce old men of the kind represented in most of
Tintoretto's portraits.

With Tintoretto ends the universal interest the Venetian school
arouses; for although painting does not deteriorate in a day any more

than it grows to maturity in the same brief moment, the story of the decay has none of the fascination of the growth. But several artists remain to be considered who were not of the Venetian school in the strict sense of the term, yet have always been included within it.

XIX

The Venetian provinces were held together not merely by force of rule. In language and feeling no less than in government, they formed a distinct unit within the Italian peninsula. Painting being so truly a product of the soil as it was in Italy during the Renaissance, the art of the provinces could not help holding the same close relation to the art of Venice that their language and modes of feeling held. But a difference must be made at once between towns like Verona, with a school of at least as long a growth and with as independent an evolution as the school of Venice itself, and towns like Vicenza and Brescia whose chief painters never developed quite independently of Venice or Verona. What makes Romanino and Moretto of Brescia, or even the powerful Montagna of Vicenza, except when they are at their very best, so much less enjoyable as a rule than the Venetians—that is to say, the painters wholly educated in Venice—is something they have in common with the Eclectics of a later day. They are ill at ease about their art, which is no longer the utterly unpremeditated outcome of a natural impulse. They saw greater painting than their own in Venice and Verona, and not unfrequently their own works show an uncouth attempt to adopt that greatness, which comes out in exaggeration of colour even more than of form, and speaks for that want of taste which is the indelible stamp of provincialism. But there were Venetian towns without the traditions even of the schools of Vicenza and Brescia, where, if you wanted to learn painting, you had to apprentice yourself to somebody who had been taught by somebody who had been a pupil of one of Giovanni Bellini's pupils. This was particularly true of the towns in that long stretch of plain between the Julian Alps and the sea, known as Friuli. Friuli produced one painter of remarkable

Pl. 80 talents and great force, Giovanni Antonio Pordenone, but neither his talents nor his force, nor even later study in Venice, could erase from his works that stamp of provincialism which he inherited from his first provincial master.

Such artists as these, however, never gained great favour in the capital. Those whom Venice drew to herself when her own strength was waning and when, like Rome in her decline, she began to absorb

into herself the talent of the provinces, were rather painters such as Paolo Veronese whose art, although of independent growth, was sufficiently like her own to be readily understood, or painters with an entirely new vein, such as the Bassani.

XX

Paolo was the product of four or five generations of Veronese painters, the first two or three of which had spoken the language of the whole mass of the people in a way that few other artists had ever done. Consequently, in the early Renaissance, there were no painters in the North of Italy, and few even in Florence, who were not touched by the influence of the Veronese. But Paolo's own immediate predecessors were no longer able to speak the language of the whole mass of the people. There was one class they left out entirely, the class to whom Titian and Tintoretto appealed so strongly, the class that ruled, and that thought in the new way. Verona, being a dependency of Venice, did no ruling, and certainly not at all so much thinking as Venice, and life there continued healthful, simple, unconscious, untroubled by the approaching storm in the world's feelings. But although thought and feeling may be slow in invading a town, fashion comes there quickly. Spanish fashions in dress, and Spanish ceremonial in manners, reached Verona soon enough, and in Paolo Caliari we find all these fashions reflected, but health, simplicity, and unconsciousness as well. This combination of seemingly opposite qualities forms his great charm for us today, and it must have proved as great an attraction to many of the Venetians of his own time, for they were already far enough removed from simplicity to appreciate to the full his singularly happy combination of ceremony and splendour with an almost childlike naturalness of feeling. Perhaps among his strongest admirers were the very men who most appreciated Titian's distinction and Tintoretto's poetry. But it is curious to note that Paolo's chief employers were the monasteries. His cheerfulness, and his frank and joyous worldliness, the qualities, in short, which we find in his huge pictures of feasts, seem to have been particularly welcome to those who were expected to make their meat and drink of the very opposite qualities. This is no small comment on the times, and shows how thorough had been the permeation of the spirit of the Renaissance when even the religious orders gave up their pretence to asceticism and piety.

Paolo
Veronese

Life in
Verona

Pls. 81-6, IV

Pls. 83-4

XXI

Love of the
countryside

Venetian painting would not have been the complete expression of the riper Renaissance if it had entirely neglected the country. City people have a natural love of the country, but when it was a matter of doubt whether a man would return if he ventured out of the town gates, as was the case in the Middle Ages, this love had no chance of showing itself. It had to wait until the country itself was safe for wayfarers, a state of things which came about in Italy with the gradual submission of the country to the rule of the neighbouring cities and with the general advance of civilization. During the Renaissance the love of the country and its pleasures received an immense impulse from Latin authors. What the great Romans without exception recommended, an Italian was not slow to adopt, particularly when, as in this case, it harmonized with natural inclination and with an already common practice. It was the usual thing with those who could afford to do so to retire to the villa for a part of the year. Classic poets helped such Italians to appreciate the simplicity of the country and to feel a little of its beauty. Many took so much delight in country life that they wished to have reminders of it in town. It may have been in response

Palma
Vecchio
Pl. 88
Bonifazio
Veronese

Pl. 90

to some such half-formulated wish that Palma began to paint his 'Sante Conversazioni'—groups of saintly personages gathered under pleasant trees in pretty landscapes. His pupil, Bonifazio, continued the same line, gradually, however, discarding the traditional group of Madonna and saints, and, under such titles as 'The Rich Man's Feast' or 'The Finding of Moses', painting all the scenes of fashionable country life, music on the terrace of a villa, hunting parties, and picnics in the forest.

Jacopo
Bassano

Bonifazio's pupil, Jacopo Bassano, no less fond of painting country scenes, did not, however, confine himself to representing city people in their parks. His pictures were for the inhabitants of the small market-town from which he takes his name, where inside the gates you still see men and women in rustic garb crouching over their many-coloured wares; and where, just outside the walls, you may see all the ordinary occupations connected with farming and grazing. Inspired, although unawares, by the new idea of giving perfectly modern versions of

Pls. 92-5

Biblical stories, Bassano introduced into nearly every picture he painted episodes from the life in the streets of Bassano, and in the country just outside the gates. Even Orpheus in his hands becomes a farmer's lad fiddling to the barn-yard fowls.

Pls. 96-7

Bassano's pictures and those of his two sons, who followed him

very closely, found great favour in Venice and elsewhere, because they were such unconscious renderings of simple country life, a kind of life whose charm seemed greater and greater the more fashionable and ceremonious private life in the city became. But this was far from being their only charm. Just as the Church had educated people to under-stand painting as a language, so the love of all the pleasant things that painting suggested led in time to the love of this art for its own sake, serving no obvious purpose either of decoration or suggestion, but giving pleasure by the skilful management of light and shadow, and by the intrinsic beauty of the colours. The third quarter of the six-teenth century thus saw the rise of the picture-fancier, and the success of the Bassani was so great because they appealed to this class in a special way. In Venice there had long been a love of objects for their sensuous beauty. At an early date the Venetians had perfected an art in which there is scarcely any intellectual content whatever, and in which colour, jewel-like or opaline, is almost everything. Venetian glass was at the same time an outcome of the Venetians' love of sensuous beauty and a continual stimulant to it. Pope Paul II, for example, who was a Venetian, took such a delight in the colour and glow of jewels, that he was always looking at them and always handling them. When painting, accordingly, had reached the point where it was no longer dependent upon the Church, nor even expected to be decorative, but when it was used purely for pleasure, the day could not be far distant when people would expect painting to give them the same enjoyment they received from jewels and glass. In Bassano's works this taste found full satisfaction. Most of his pictures seem at first as dazzling, then as cooling and soothing, as the best kind of stained glass; while the colouring of details, particularly of those under high lights, is jewel-like, as clear and deep and satisfying as rubies and emeralds.

It need scarcely be added after all that has been said about light and atmosphere in connexion with Titian and Tintoretto, and their handling of real life, that Bassano's treatment of both was even more masterly. If this were not so, neither picture-fanciers of his own time, nor we nowadays, should care for his works as we do. They represent life in far more humble phases than even the pictures of Tintoretto, and, without recompensing effects of light and atmo-sphere, they would not be more enjoyable than the cheap work of the smaller Dutch masters. It must be added, too, that without his jewel-like colouring Bassano would often be no more delightful than Teniers.

Pl. 92
Bassano's
treatment of
light

Pls. 92–4
The first
modern
landscapes

Another thing Bassano could not fail to do, working as he did in the country, and for country people, was to paint landscape. He had to paint the real country, and his skill in the treatment of light and atmosphere was great enough to enable him to do it well. Bassano was in fact the first modern landscape painter. Titian and Tintoretto and Giorgione, and even Bellini and Cima before them, had painted beautiful landscapes, but they were seldom direct studies from nature. They were decorative backgrounds, or fine harmonizing accompaniments to the religious or human elements of the picture. They never failed to get grand and effective lines—a setting worthy of the subject. Bassano did not need such setting for his country versions of Bible stories, and he needed them even less in his studies of rural life. For pictures of this kind the country itself naturally seemed the best background and the best accompaniment possible—indeed, the only kind desirable. Without knowing it, therefore, and without intending it, Bassano was the first Italian who tried to paint the country as it is, and not arranged to look like scenery.

XXII

The
Venetians and
Velaspuez

Had Bassano's qualities, however, been of the kind that appealed only to the collectors of his time, he would scarcely rouse the strong interest we take in him. We care for him chiefly because he has so many of the more essential qualities of great art—truth to life, and spontaneity. He has another interest still, in that he began to beat out the path which ended at last in Velazquez. Indeed, one of the attractions of the Venetian school of painting is that, more than all others, it went to form that great Spanish master. He began as a sort of follower of Bassano, but his style was not fixed before he had given years of study to Veronese, to Tintoretto, and to Titian.

XXIII

Bassano appealed to collectors by mere accident. He certainly did not work for them. The painters who came after him and after Tintoretto no longer worked unconsciously, as Veronese did, nor for the whole intelligent class, as Titian and Tintoretto had done, but for people who prided themselves on their connoisseurship.

Pl. 98
The Epigoni

Palma the Younger and Domenico Tintoretto began well enough as natural followers of Tintoretto, but before long they became aware

of their inferiority to the masters who had preceded them, and, feeling no longer the strength to go beyond them, fell back upon painting variations of those pictures of Tintoretto and Titian which had proved most popular. So their works recall the great masters, but only to bring out their own weakness. Padovanino, Liberi, and Pietro della Vecchia went even lower down and shamelessly manufactured pictures which, in the distant markets for which they were intended, passed for works of Titian, Veronese, and Giorgione. Nor are these pictures altogether unenjoyable. There are airs by the great composers we so love that we enjoy them even when woven into the compositions of some third-rate master.

XXIV

But Venetian painting was not destined to die unnoticed. In the eighteenth century, before the Republic entirely disappeared, Venice produced three or four painters who deserve at the least a place with the best painters of that century. The constitution of the Venetian State had remained unchanged. Magnificent ceremonies still took place, Venice was still the most splendid and the most luxurious city in the world. If the splendour and luxury were hollow, they were not more so than elsewhere in Europe. The eighteenth century had the strength which comes from great self-confidence and profound satisfaction with one's surroundings. It was so self-satisfied that it could not dream of striving to be much better than it was. Everything was just right; there seemed to be no great issues, no problems arising that human intelligence untrammelled by superstition could not instantly solve. Everybody was therefore in holiday mood, and the gaiety and frivolity of the century were of almost as much account as its politics and culture. There was no room for great distinctions. Hairdressers and tailors found as much consideration as philosophers and statesmen at a lady's levee. People were delighted with their own occupations, their whole lives; and whatever people delight in, that they will have represented in art. The love for pictures was by no means dead in Venice, and Longhi painted for the picture-loving Venetians their own lives in all their ordinary domestic and fashionable phases. In the hairdressing scenes we hear the gossip of the periwigged barber; in the dressmaking scenes, the chatter of the maid; in the dancing-school, the pleasant music of the violin. There is no tragic note anywhere. Everybody dresses, dances, makes bows, takes coffee, as if there were nothing else in the world that wanted doing. A tone of high courtesy,

The later Venice

Longhi

Pl. 99

of great refinement, coupled with an all-pervading cheerfulness, distinguishes Longhi's pictures from the works of Hogarth, at once so brutal and so full of presage of change.

XXV

Venice herself had not grown less beautiful in her decline. Indeed, the building which occupies the centre of the picture Venice leaves in the mind, the Salute, was not built until the seventeenth century. This was the picture that the Venetian himself loved to have painted for him, Canaletto and that the stranger wanted to carry away. Canale painted Venice with a feeling for space and atmosphere, with a mastery over the Pl. 100 delicate effects of mist peculiar to the city, that make his views of the Salute, the Grand Canal, and the Piazzetta still seem more like Venice than all the pictures of them that have been painted since. Later in the Guardi century Canale was followed by Guardi, who executed smaller views Pl. 102 with more of an eye for the picturesque, and for what may be called instantaneous effects, thus anticipating both the Romantic and the Impressionist painters of the nineteenth century.

XXVI

Yet delightful as Longhi, Canale, and Guardi are, and imbued with the spirit of their own century, they lack the quality of force, without which there can be no impressive style. This quality their contem-Tiepolo porary Tiepolo possessed to the utmost. His energy, his feeling for splendour, his mastery over his craft, place him almost on a level with the great Venetians of the sixteenth century, although he never allows one to forget what he owes to them, particularly to Veronese. The grand scenes he paints differ from those of his predecessor not so much in inferiority of workmanship, as in a lack of that simplicity and candour which never failed Paolo, no matter how proud the event he Pls. 103–4 might be portraying. Tiepolo's people are haughty, as if they felt that to keep a firm hold on their dignity they could not for a moment relax their faces and figures from a monumental look and bearing. They evidently feel themselves so superior that they are not pleasant to live with, although they carry themselves so well, and are dressed with such splendour, that once in a while it is a great pleasure to look at them. It was Tiepolo's vision of the world that was at fault, and his vision of the world was at fault only because the world itself was at fault. Paolo saw a world barely touched by the fashions of the Spanish

Court, while Tiepolo lived among people whose very hearts had been vitiated by its measureless haughtiness.

But Tiepolo's feeling for strength, for movement, and for colour was great enough to give a new impulse to art. At times he seems not so much the last of the old masters as the first of the new. The works he left in Spain do more than a little to explain the revival of painting in that country under Goya; and Goya, in his turn, had a great influence upon many of the best French artists of recent times.

XXVII

Thus, Venetian painting before it wholly died, flickered up again strong enough to light the torch that is burning so steadily now. Indeed, not the least attraction of the Venetian masters is their note of modernity, by which I mean the feeling they give us that they were on the high road to the art of today. We have seen how on two separate occasions Venetian painters gave an impulse to Spaniards, who in turn have had an extraordinary influence on modern painting. It would be easy, too, although it is not my purpose, to show how much other schools of the seventeenth and eighteenth centuries, such as the Flemish, led by Rubens, and the English, led by Reynolds, owed to the Venetians. My endeavour has been to explain some of the attractions of the school, and particularly to show its close dependence upon the thought and feeling of the Renaissance. This is perhaps its greatest interest, for being such a complete expression of the riper spirit of the Renaissance, it helps us to a larger understanding of a period which has in itself the fascination of youth, and remains particularly attractive to us, because the spirit that animates us is singularly like the better spirit of that epoch. We, too, are possessed of boundless curiosity. We, too, have an almost intoxicating sense of human capacity. We, too, believe in a great future for humanity, and nothing has yet happened to check our delight in discovery or our faith in life.

(N.B.—Written in 1894!)

The death of Venetian painting

II. THE NORTH ITALIAN PAINTERS

I

PAINTING in Northern Italy had its share in the successes and failures of medieval Italian art. It was lit up by the Byzantine glow radiating from Duccio, and quickened, as in the rest of the peninsula, by the genius of Giotto. Many an unknown shrine in the Milanese, the Veronese, and the Paduan territories retains to this day frescoes of no less interest than the average of contemporary mural decoration in Florence or Siena. But no imposing artistic personality appeared in the vast region between the Alps, the Apennines, and the sea, until, in the second half of the fourteenth century, Altichiero Altichieri of Verona began to practise his art.[1]

The only considerable fragment of his which remains in his native town, the fresco in S. Anastasia, where three gentlemen of the Cavalli family are presented by their patron saints to the Madonna, is certainly one of the few great works of art of the later years of the Trecento. The large simplicity of the design, the heraldic pageantry of the costumes, the grandeur of the Saints, the impressiveness of the Virgin, the comely faces of the angels, give their painter a place among Giotto's followers second to none in Florence itself, not even to Orcagna, whom Altichiero so unexpectedly resembles. Giotto's seed, we are tempted to think, has found here a richer soil. But enthusiasm grows somewhat cooler before the frescoes at Padua. It is true that as regards colour they have every advantage of Florentine painting during the same years: they are more gorgeous, better fused, and altogether more harmonious. In design, too, excepting always Orcagna's, no work of a contemporary Tuscan has their excellence. Yet with all their merits they are disappointing in the comparison, for nothing Tuscan great enough to have their qualities would have had their faults.

Their qualities, in so far as they have not already been pointed out in the description of the Verona fresco, consist in clearness of narration, effective massing, and fine distances. The compositions and facial

Altichiero

The frescoes
at Padua
Pl. 105

[1] Unfortunately the bulk of his authenticated work at home has perished and his share in the two cycles of frescoes at Padua is uncertain. His countryman d'Avanzi worked with him, and many futile attempts have been made to assign this bit to one and that to the other. There are slight differences of quality, no doubt, but the inspiring and guiding mind is one, and surely Altichiero's. For our present purpose, the paintings in the Santo and in the contiguous chapel of St. George may count as his.

types are so fresh and memorable that they left their mark upon Veronese painting as long as it remained worthy of being called an art, and supplied Padua and even Venice with some of the most admirable motives of their respective schools. Architecture is handled with the loving precision of a Canaletto, and perspective, although naïve and unmathematical, is seldom wanting. The portrait heads, besides being vigorous, straightforward, and dignified, are individualized to the utmost limits permitted by form in that day, while to this gift of direct observation is added a power of rendering the thing seen, surpassed by Giotto alone.

Altichiero's faults

But with these qualities Altichiero combines many faults of those later Trecento painters who never came near him in other ways. He has their exaggerated love of costume and finery, their delight in trivial detail, their preoccupation with local colour. He lacks distinction, he fails to be impressive, he misses spiritual significance. The accessories absorb him, so that the humorous trivialities which life foists upon the sublimest events, at his hands sometimes receive more tender care than the principal figures. Thus, while he masses well, he is too eager for detail not to overcrowd his compositions. Not a single one has that happy emptiness which makes you breathe more lightly and freely before the best compositions of a Giotto, a Simone Martini, or an Orcagna. Altichiero reduces the Crucifixion to something not far removed from a market scene, and the spectator is in danger of forgetting the Figure on the Cross by having his attention drawn to a dog lapping water from a ditch, a handsome matron leading a wilful child, or an old woman wiping her nose. The artist is so little heedful of the highest artistic economy that he constantly abandons it for the passing fashions of the day. One of these fashions was a delight in contemporary costume, and Altichiero clothes his figures accordingly, bartering impressiveness for frippery; although, as if to prove that he really knew better, he scarcely ever fails to drape his protagonists, whether they be St. George, St. Lucy, or St. Catherine, with the amplitude, simplicity, and sweep of Giotto's grandest manner. Another of the fashions of the day was what might be called 'local colour', an attention to some of the obvious characteristics of time and place. As nearly all sacred and much of legendary story has the Orient for a background, Altichiero misses no chance of introducing the Calmuck faces and pigtails of the most prominent Orientals of his time, the Tartar conquerors. Had the Inquisition been as meddlesome then as it became two hundred years later, the first great Veronese painter might have had to answer before its tribunal to charges as

many and as well founded as were brought against the last great master of that school. Paolo Caliari, it will be remembered, was put on trial for filling his 'Feast in the House of Levi'—a much less solemn theme than that treated by Altichiero—with dwarfs, parrots, and Germans.

Altichiero's faults, I repeat, might easily be matched in Tuscany, but not in combination with his qualities. It is worth while to insist on this point, because we shall discover it to be highly characteristic of most North Italian painters. They are apt to be out of tone spiritually; they find it difficult to keep to one moral and emotional atmosphere; they are more active with their hands than with their heads. One would almost think that with the mass of them, as indeed with all Northern peoples, painting was rather a matter of reflex action than of the eliminating, transubstantiating intellect. And it goes some way to confirm the truth of this generalization that there would be no difficulty in supposing that, had Altichiero and Paolo changed places, we should never have known the difference: in other words, that Altichiero in the sixteenth century would have been a Paolo, and Paolo in the fourteenth an Altichiero.

II

Altichiero had scarcely ceased covering wall spaces with the pomp and circumstance of medieval life, when his task was taken up by his better-known Renaissance follower, Vittorio Pisanello. The larger part of this artist's work, in fact all his decoration of great houses and public palaces, has perished. Even now, after earnest efforts to gather together the strewn limbs of his art, only six or seven paintings of his can be discovered: two frescoes, two sacred subjects, and two or three portraits. His renown as a painter has therefore been eclipsed by his fame as a medallist. And, in truth, never since the days when Greek craftsmen modelled coins for proud city states, has there been such a moulder of subtle reliefs in miniature. Yet Pisanello himself never signed his name without the addition of the word PICTOR, and it was as a painter that he received the stipends of princes and the adulation of poets.

Although he was much more modern than his ancestor, there was nothing in his paintings to startle princes and poets, or even less distinguished persons, whose education in art consisted then, no doubt, as it does now, in confirming a fondness for the kind of picture to which their eyes had grown accustomed during childhood and youth.

Pisanello

Pls. 106–8

Pisanello, although counting as one of the great geniuses of the Renaissance, by no means broke with the past. He went, it is true, as far beyond Altichiero as Altichiero had gone beyond his immediate precursors, but he betrays no essential difference of intention or spirit. Some advance was inevitable, for the hard-won position of one genius is only the starting-point of the next. Altichiero had observed the appearance of objects, Pisanello observed more closely; Altichiero could characterize and individualize, Pisanello did the same, but more subtly; Altichiero could render distances fairly well, Pisanello rendered them with even better effect. But far from betraying the clumsy struggles of innovators, he has the refinement, the daintiness of the last scion of a noble lineage. In him, art-evolution produced a painter most happily fitted to hold up an idealizing mirror to a parallel product of social evolution, the sunset of Chivalry. No wonder that he was employed along with the kindred Gentile da Fabriano by the rich and noble, and that he was chosen to continue the courtly Umbrian's tasks.

Pisanello's surviving paintings

Of Pisanello's seven paintings, six are distinctly court pictures, and their subjects bear witness to his interest in the courtier's mode of life. The fresco at S. Anastasia in Verona is first and foremost a knightly pageant; the little St. Hubert is the knight as huntsman: and in the other picture in the National Gallery the prominent figure is the cavalier St. George standing in gala costume beside his proud steed. His Leonello d'Este is of course a great gentleman, and the female portraits, if less commanding, are still great ladies. The only work which is not distinctly courtly in tone is an Annunciation, and the time was still far off when Michelangelo's followers so broke loose from tradition as to transform the meek Judean maiden into a haughty princess. But even this composition is crowned by the knightly figures of St. George and St. Michael, the favourite saints of chivalry.

A further examination of his works will reveal how far he was from feeling the inspiration of the real Italian Renaissance. In the S. Fermo fresco that we have just glanced at, the Virgin, with her folded hands resting on her lap, is neither in type nor pose nor silhouette obviously Italian, although nothing could be more in accordance with medieval Italian tradition than the obeisance of the announcing Angel, with the grand sweep of his gathered wings, his streaming hair, and his long trailing robes. The Virgin's chamber, with its elaborate Gothic pendentives, its tapestries and stuffs, recalls the contemporary paintings of far-away Bruges. St. George and St. Michael hark back to Altichiero.

Pl. 106

At S. Anastasia the fresco is on both sides of a Gothic arch, at such a height that only figures much above the ordinary size would convey

their effect to a spectator on the floor. Not only are the figures them-
selves much too small for this purpose, but no attempt has been made
to divide them into lucid groups, or to detach them clearly from their
background. No thought of composition entered the artist's head, no
idea of extracting the significance of the noble deed. What arrange-
ment there is, is due to a desire to introduce stock material, regardless
of the requirements of the subject. Nothing in the part on the right
(which never had any integral relation to the other part, now almost
invisible) betrays that the subject is the story of St. George and the
Princess of Trebizond. We see a knight getting ready to mount his
horse. Between this beast, seen from the back, in order to display the
master's command of foreshortening, and his squire's horse, seen for
similar reasons nearly full face, stands a lady in profile, expressionless,
immobile, in a dress with a long train. She is there as a stock figure of
the great lady, the head being a portrait. The dogs in the foreground
are not inappropriate, but the presence of a ram in an equally con-
spicuous position can only be explained on the ground that Pisanello
yielded to an irresistible desire to show how well he could paint him.
A low knoll in the middle distance half hides the stone lacework of a
group of wedding-cake Gothic palaces, such as even the Venetians of
that time might have hesitated to erect along their canals. From the
gate issues a procession of knights on horseback, one of whom, in
profile, is manifestly a portrait, while the others are, like the archi-
tecture and the head of St. George, but Altichiero's inventions
brought up to date. Over these horsemen, on a high gallows-tree,
swing two rogues, and beyond rises a tall cliff, beneath the shelter of
which a ship under full sail is running to shore. A piece of water
bounded by a hilly coast stretches across the pointed arch over which
the fresco is painted. In the foreground on the other side of the arch
lies a dead dragon in the midst of a multitude of creeping things. Now
almost wholly effaced, and never visible to the normal eye from the
floor below, these creatures are yet painted with the exactness of a
naturalist, and with the detailed care of the miniaturist. Indeed, this
wonderful fresco is a miniaturist's work, executed with no thought of
the spectator on the floor of the church, but as an illuminator might
cover the page of a missal.

We shall find the same advanced medieval traits in Pisanello's two
works in the National Gallery, both, as it happens, little more than
miniatures in size. In the one, St. Hubert, nobly clad and mounted
on a richly caparisoned hunter, in the midst of his dogs and hounds,
encounters a stag, who stands still displaying between his antlers the

'St. George
and the
Princess'

'The Vision
of St. Hubert'

Pl. 108

image of our Lord on His Cross. The merry huntsman lifts his hand, but betrays no other sign of emotion: there is more appropriate expression in the eye of the stag. Around and about them spreads a marvellous scene, rocks and trees, every flower and every beast of the field, every bird of the air and stream, each and all painted with the naturalist's accuracy of observation and the miniaturist's daintiness of touch. The beauty of detail is infinite, the form and structure of each individual bird or beast being rendered only less admirably than its characteristic movements. The eye could dwell on them for ever, captivated by the artist's feeling that his one 'vocation was endless imitation'. If that were indeed the whole of art, this were supreme art.

<div style="margin-left:2em">The Madonna with two Saints</div>

<div style="margin-left:2em">Pl. 107, V</div>

The other picture in the National Gallery represents the Madonna appearing against the sun in the midst of a radiance of glory, over a darkling wood, before which stand St. George and St. Anthony Abbot. The effect, which is noble and inspiring, is produced by the extreme simplicity of the composition and by the light; but here, once more, our attention is chiefly directed to the silver armour of the knight, to the amazing detail and texture of his straw hat, and to the fierce energy of the boar and the heraldic coils of the dragon.

Pisanello's portraits tell no different tale. No doubt the 'Leonello' of the Morelli Collection at Bergamo and the 'Este Princess' of the Louvre are ably and adequately characterized, one as born and bred to command, and the other as an amiable maiden of high lineage; but in both panels the patterns on the dresses and the texture and tissue of the flowers that decorate the backgrounds were evidently of prime import to the artist.

Of intellectuality, of spiritual significance, of the greatest qualities of the illustrator, Pisanello had even less than Altichiero, but in the rendering of single objects, whether in the animal kingdom or in nature, he was perhaps not inferior to any of his own contemporaries the world over. Indeed, he painted birds as only the Japanese have painted them, and his dogs and hounds and stags have not been surpassed by the Van Eycks themselves. Yet his place is somewhere between the late medieval Franco-Flemish miniaturists, such as the Limburgs, on the one hand and the Van Eycks on the other—much nearer to the first than to the second—rather than with Masaccio, Uccello, or even Fra Angelico. He draws more accurately, he paints more delightfully than his Florentine contemporaries. Why then are they yet actually greater as artists, and the forerunners of a new movement, the begetters of artists as great as themselves, or even greater, while he remains essentially medieval, a little master, and his art dies with him?

The proper answer to this question would require for its adequate development many times more space than is allotted for the whole of this small book, and would involve important problems of aesthetics as well as of history. The detailed answer is not to be thought of here; but I may venture to hint at it, warning the reader that my suggestions will be of little avail if he has not read the other essays in this work.

III

It is conceivable that but for the influence of Florence, and to a minor degree of the Antique, the art of Pisanello would not have disappeared as it did without effect. As drawing, it was on a level with the Van Eycks, and as painting, but little inferior. What it lacked in intellectuality might have been, in such an age of progress as the Renaissance peculiarly was, more than made up by the next great painter. The successor of Pisanello in North Italian painting would naturally have been a Van Eyck; or, if not a Van Eyck, then, considering the Veronese master's love of birds and beasts, his feeling for line, and the supreme daintiness of his touch, his next successor, taking up these elements, might conceivably have initiated an evolution destined to end in a Hokusai. That Mantegna bears no resemblance to Pisanello, and has no likeness to the Van Eycks and their followers,[1] or to Hokusai and his precursors, is due to Florence and the Antique.

Comparison with Flemish art

The art of Pisanello, like that of the early Flemings, was too naïve. In their delight in nature they were like children who, on making the first spring excursion into the neighbouring meadow and wood, pluck

[1] The Van Eycks make me think of their greatest Italian follower, Antonello da Messina. What is left to us of his works confirms the tradition that he was formed under the influence of the Van Eycks or of their immediate follower Petrus Christus. He learnt from them not only the secrets of their superior technique, but inherited their preference for linear perspective and for pyramidal and conical shapes and masses. At the end of his relatively brief career Antonello spent some time in Venice and got more from Giovanni Bellini than he gave him and the other Venetians. His latest works are Venetian in spirit and between his and Giovanni Bellini's portraits the differences are slight.

As an illustrator this solitary impersonal artist seems to approach Piero della Francesca. His sense of space is scenic, and in one of his two larger pictures, the Saint Sebastian of the Dresden Gallery (the other being the Siracusa Annunciation) the architectural proportions are sumptuous and impressive. But his tactile values are not to be compared with those of a Piero della Francesca or of a Cézanne, nor are they superior to those of Giovanni Bellini. *Pl. 111*

He is appreciated above all for his portraits, although they seem on the whole less fascinating as works of art than his Munich and Palermo Virgins or his noble Benson Madonna, now in the National Gallery of Washington. This last is a creation not less striking than Vermeer's head of a girl at the Hague, which recalls Piero della Francesca while anticipating Cézanne. *Pls. 110, 112*

all the wild flowers, trap all the birds, hug all the trees, and make friends with all the gay-coloured creeping things in the grass. Everything is on the same plane of interest, and everything that can be carried off they bring home in triumph. To this pleasure in the mere appearance of things, the greatest of the early Flemings, the Van Eycks, joined, it is true, high gifts of the spirit and rare powers of characterization. They had, as all the world knows, a technique far beyond any dreamt of in Tuscany. And yet the bulk, if not the whole, of Flemish painting, to the extent that it is not touched by Florentine influences, is important only as Imitation and Illustration. That is perhaps why, as art, it steadily declined until, only a century after Pisanello's death, it perished in its turn, leaving nothing behind it but its marvellous technique. This is all of his heritage that Rubens, the next great Fleming after the Van Eycks, took up. In every other respect he was an Italian: and, after Michelangelo, to say Italian was practically to say Florentine.

It would be an interesting digression to speculate on what might have happened to the Low Countries if they had been situated nearer to Tuscany, and to conceive a Rubens coming, not after the Caracci, when the fight had been fought out, but, like Mantegna, almost at its beginning. But our present task is to try to discover what were the elements destined to conquer Europe, which Northern art in the fifteenth century lacked and Florentine art possessed.

The trouble with Northern painting was that, with all its qualities, it was not founded upon any specifically artistic ideas. If it was more than just adequate to the illustrative purpose, then, owing no doubt to joy in its own technique, it overflowed into such rudimentarily decorative devices as gorgeous stuffs and spreading, splendidly painted draperies. It may be questioned whether there exists north of the Apennines a single picture uninspired by Florentine influence, in which the design is determined by specifically artistic motices: that is to say, motives dictated by the demands of Form and Movement.

In the other essays in this book I have stated or implied that the human figure must furnish the principal material out of which the graphic and plastic arts are constructed. Every other visible thing should be subordinated to man and submitted to his standards. The standards concerned are, however, not primarily moral and utilitarian, although ultimately in close connexion with ordinary human values. Primarily they are standards of happiness, not the happiness of the figure portrayed, but of us who look on and perceive. This feeling of happiness is produced by the way the human figure is presented to

us, and it must be presented in such a way that, instead of merely recognizing it as meant for a human being of a given type, we shall be forced by its construction and modelling to dwell upon it, until it arouses in ourselves ideated sensations that shall make us experience the diffused sense of happiness which results upon our becoming aware of an unexpectedly intensified, facilitated activity. The figures must be presented in such a way that all their movements are readily ideated, with none of the fatigue yet something of the glow of physical exertion. And, finally, each figure must be presented in such a relation to every other figure in the composition that it shall not diminish but increase the effect of the whole, and in such relation to the space allotted that we feel neither lost in a void nor jammed in a crowd: we must, on the contrary, have the kind of space in which our ideated sensations of breathing and moving, while increasing rather than diminishing our confidence in the earth's stability, shall almost seem to emancipate us from the tyranny of burdensome matter.

To these three ways of presenting the human figure—which are at bottom but one—I have in the last two essays of this work given the names of 'Tactile Values', 'Movement', and 'Space-Composition'. If what was said there, and what is said now, be true, it follows that it is not enough to paint naïvely what we see, or even what fancy evokes. As a matter of fact, we see much more with our mind than with our eye, and the naïve person is the unsuspecting dupe of a mind which is only saved from being a bundle of inflexible conventialities by sporadic irruptions of anarchy. The larger part of human progress consists in exchanging naïve conventionality for conscious law; and it is not otherwise with art. Instead of painting indiscriminately everything that appeals to him, the great artist, as if with deliberate intention, selects from among the mass of visual impressions only those elements that combine to produce a picture in which each part of the design conveys tactile values, communicates movement, and uplifts with space-composition.

The essential in the Figure arts

Not every figure is suited for conveying tactile values, not every attitude is fitted for communicating movement, and not every space is uplifting. It may even be doubted whether the requisites out of which the work of art is to be constructed exist originally in nature. The 'noble' savage, who may seem to offer a fit subject for the painter, is not by any means a primeval being, but moulded through immemorial ages by the ennobling arts of the chase, of the dance and the mime, of war and oratory. And even he, just as he stood, would seldom have lent himself to great artistic treatment.

Originally not to be found ready-made in nature, rarely met with in our own proud times, these figures had to be constructed by the artist, these attitudes discovered, these spaces invented. How he went to work with these ends in view are matters I have touched upon already in preceding books, too briefly, yet more fully than I shall in this place.

The credit of the achievement in modern Europe was due to Florence. There alone the task was understood in all its bearings, and there alone was found a succession of men able to take it over, one from the other, until it was completed. It is true that many, weary with cutting roads through forbidding forests, turned for repose into the first glade that offered immediate sunshine, caressing breezes, and wild fruits. But the sufficing few kept on conquering chaos all the way to their goal.

IV

Without Florence, then, painting in Northern Italy might have differed but slightly from contemporary painting in the Low Countries or in Germany. But Pisanello was still living when his native town was invaded by Florentine sculptors. Although of no high order, they travelled as missionaries of the art of Donatello. The mighty innovator himself came to Padua years before Pisanello's death, and worked there for a decade. He was preceded and followed by such of his fellows as Paolo Uccello and Fra Filippo, and always accompanied by a host of his townsmen as assistants. A tide of influence like this was not to be resisted. Yet it might have produced only quaint or ingenuously unintelligent imitations, if at Padua there had not then existed talents greater than were allotted to most of Squarcione's pupils. Happily these years were the apprentice years of a prince in the domain of art—Andrea Mantegna.

Mantegna At little more than ten years of age, Mantegna was adopted by a contractor named Squarcione. How much of a painter Squarcione was we do not know; but we do know that he undertook designing and painting to be executed by people in his employ. He was also a dealer in antiquities, and his shop was frequented by the distinguished people who passed through Padua, and by the Humanists teaching in the famous University. It happened to be a moment when in Italy Antiquity was a religion, nay, more, a mystical passion, causing wise men to brood over fragments of Roman statuary as if they were sacred relics, and to yearn for ecstatic union with the glorified past.

To complete the spell, this glorified past happened to be the past of their own country.

Reared among fragments of ancient art, in a shop haunted by Professors—great persons in any town overshadowed by a University, and at that time regarded as hierophants of the cult of the national past—a lad of genius could not help growing up an inspired devotee of Antiquity. A path of light spread before him, at the end of which, far away but not inaccessible, stood the city of his dreams, his longings, his desires. Throughout his whole life Imperial Rome was to Mantegna what the New Jerusalem was to the Puritan or the old Jerusalem to the Jew. To revive it in the fullness of its splendour must have seemed a task that could be achieved only by the unflagging labours of many generations, but meanwhile it could be reconstructed in the mind's eye, and the vision recorded in a form that would be at once a prophecy, an incentive, and a goal.

Mantegna and antiquity

Antiquity was thus to Mantegna a different affair both from what it was to his artist contemporaries in Florence, and from what it is to us now. If ever there be a just occasion for applying the word 'Romantic' —and it means, I take it, a longing for a state of things based not upon facts but upon the evocations of art and literature—then that word should be applied to Mantegna's attitude towards Antiquity. He entirely lacked our intimate and matter-of-fact acquaintance with it. He knew it visually from a small number of coins and medals, from a few statues and bas-reliefs, and from several arches and temples, mostly Roman. He knew it orally from the Paduan Humanists, who fired him with their love of the Latin poets and historians. That the first of Roman poets was a Mantuan and the first of Roman historians a Paduan, sons of his own soil, must have given no slight stimulus to his retrospective patriotism. No wonder Rome filled his horizon and stood to him for the whole of Antiquity.

Not only was he romantic in his feeling for Italy's glorious past, but naïvely romantic. His visual acquaintance with it being confined to a few plastic representations, he naïvely forgot that Romans were creatures of flesh and blood, and he painted them as if they had never been anything but marble, never other than statuesque in pose, processional in gait, and godlike in look and gesture. Very likely, if he had been quite free to choose, he would never have touched a subject not taken from Roman history or poetry; and in the last twenty years of his life he came near to having his way, for, thanks in no small degree to his own influence, the Romanization of his employers had advanced to a point where they also preferred Roman themes, such

Mantegna's Romanticism

themes as the 'Triumph of Caesar', the 'Triumph of Scipio', or 'Mucius Scaevola'. But no subject at any time, unless indeed it was a portrait, escaped his Romanizing process. Consequently, although he was Court Painter for nearly half a century, he never reveals the fact except in the portraits of the *Camera degli Sposi*; and although a painter of Christian mysteries, he betrays little Christian feeling.

It scarcely matters what 'religious pictures' we select as examples. In all, the old men are proud, even haughty Senators, the young are handsome and soldierlike, the women stately or gracious. They walk in streets lined with temples, palaces, and triumphal arches, or in the mineral landscapes of bas-reliefs. I shall not cite such works as the frescoes in the Eremitani, which readily lent themselves to Antique treatment, but call attention to subjects which Christians find most awe-inspiring.

We are somewhat surprised at the start to discover how few subjects of this kind Mantegna seems to have treated. At a time when his brother-in-law, the young Bellini, and his fellow-pupil, Carlo Crivelli, were inspired by the echoes of S. Bernardino's revival to paint scenes and symbols of the Passion full of the deepest contrition, most tender pity, and mystical devotion, Mantegna apparently remained aloof and untouched. The only 'Pietà' from his earlier years holds a subordinate place in the Brera polyptych, and is not to be compared as interpretation to any of Bellini's handlings of the same theme. Each of these artists happens to have in the National Gallery an 'Agony in the Garden'. The hush, the solemnity, the sense of infinite import conveyed by the one finds no echo in the other, with its rock-born giant kneeling in sight of Rome, in the midst of a world of flint, praying to several momentarily saddened cupids. We may love this panel too, but not for its Christian spirit.

Subjects like the Crucifixion, the Circumcision, the Ascension, which again offer rare opportunities for the expression of specifically Christian feeling, Mantegna treated as fitting occasions for the reproduction of the Antique world. The priceless Crucifixion of the Louvre is, in the first place, a study of the Roman soldier. The Ascension in the Uffizi is the apotheosis of a Roman athlete. The Circumcision on the companion panel represents the interior of a Roman temple, with its sumptuous marbles, incrustations, and gildings. Placed beside Ambrogio Lorenzetti's panel in the Uffizi at Florence, where the same theme is handled, it would quickly reveal the difference between a Christian and a pagan artist.

And Mantegna did not grow more Christian with years. On the

Pl. 115

Pl. 113, VI

Pl. 116

Romanized
Christianity

contrary, he lived to deserve even better than Goethe the surname of 'Old Pagan'. In mid-career he painted a picture, now at Copenhagen, with a wailing, half-nude Christ supported on a sarcophagus by two mourning angels with wings widespread. If you can forget the inane expression on the Saviour's face, and the perfunctory grimaces of the angels, you will be free to enjoy a design that sweeps you from earth to heaven, but not on the pinions of Faith! Or take the mystic subject belonging to Lord Melchett[1] which Mantegna painted when he was no longer young. Few things even in ancient art have more of the Roman and imperial air than this infant Caesar whom Mantegna has seen fit to pose there as the infant Christ. From his later years we have such negations of Christianity as the distinctly Roman figures meant to represent Christ between Longinus and Andrew, or those in the other engraving of a sublimely pagan Entombment.

Mantegna deserves no blame for Romanizing Christianity, any more than Raphael for Hellenizing Hebraism. Indeed, they both did their work so well that the majority of Europeans at this day still visualize their Bible story in forms derived from these two Renaissance masters. And Mantegna should incur the less reproach because it is probable that the Christian spirit cannot easily find embodiment in the visual arts. The purpose of the last few paragraphs was not to find fault but to show that, as an Illustrator, he intended to be wholly Roman.

Had he succeeded, we might perhaps afford to forget him, in spite of the three centuries of admiration bestowed upon him by an over-Latinized Europe. We do not any longer need his reconstructions. We know almost scientifically the aspect and character of the Rome which cast her glamour over his fancy. Besides, we no longer stop at Rome, but have gone back to her fountain-head, Athens. If Mantegna is still inspiring as an Illustrator, it is because he failed of his object, and conveyed, instead of an archaeologically correct transcript of ancient Rome, a creation of his own romantic mood, the Rome of his dreams, his vision of a noble humanity living nobly in noble surroundings.

Thus Mantegna's attitude towards Antiquity, unlike our own, was romantic; and it was equally remote from the attitude of his artist contemporaries in Tuscany. His aim was to resuscitate the ancient world; his method was the imitation of the Antique. Little as they shared his purpose, they shared his methods less.

There are different uses to which one may put the art of the past. One may use it as a child uses blocks. They enable him to build up his toy town, but, though he may forget the fact or be either too giddy or

[1] Now in the National Gallery, London.

too stupid to be aware of it, the scheme is predetermined. He can do only what may be done with the given blocks, and it is doubtful whether they can teach him to produce another toy town without blocks but with the pencil or brush or even clay. This use of ancient art may be called archaistic, and it was the way in which Roman fragments were employed again and again in the Middle Ages, notably in the thirteenth century at Rheims, at Capua, and by the greatest Italian sculptor before the Renaissance, Niccolò Pisano. On the other hand, the art of the past may be used as vintners nowadays use the ferment of a choice vintage, to improve the flavour of a liquid pressed from an ordinary grape. This is the most constant use to which it has been put, and, to a limited degree, it is a profitable use. The most profitable of all, however, is neither to imitate the past nor to seek merely to be refined and ennobled by it, but to detect the secret of its commerce with nature, so that we may become equally fruitful.

Florentine painting and the Antique 　While Mantegna chiefly put the art of Rome to the first of these uses, his Florentine contemporaries cared to profit by the last only. So carefully did they abstain in the serious figure arts from any direct imitation of the Antique, that we can seldom trace its influence upon Quattrocento sculpture and even less upon Quattrocento painting in Tuscany. The utmost that would appear is that these arts benefited by the cult of physical beauty exemplified in ancient marbles and by the study of Greco-Roman proportions. Many of the Tuscan painters illustrated themes taken as directly from Latin poetry as any of Mantegna's, but they used their own visual imagery, their own forms, and their own accent. If we place Pollaiuolo's paintings of the Hercules myth, Botticelli's 'Spring' and 'Birth of Venus', and Signorelli's 'Pan' alongside of Mantegna's 'Parnassus', we shall have to acknowledge that his alone is painted, so to speak, in Latin, while the others are in pure Tuscan. Nor was there any diminution in the aloofness of Florentine sculpture and painting from any direct imitation of the Antique. Michelangelo seems more antique only because he so nearly reconquered the position of Antiquity. For the pursuit of tactile values and of movement, followed strenuously, and unhampered by the requirements of Illustration, tends to create not only the type of figure but the cast of features known as Classic.

In spite of these differences in purpose and method between Mantegna and the Florentines, the former labouring to reconstruct the world as seen by an imperial Roman, and to reconstruct it in that Roman's visual language, the latter toiling to master form and action, and design based upon form and action, Mantegna nevertheless owed

to Donatello and to Donatello's countrymen more than he owed to the Antique. He owed to them the knowledge and skill that it took to differ from them and to try to be antique.

We have already had occasion to note that in the thirteenth century at Rheims, at Capua, at Ravello, and at Pisa, Greco-Roman sculpture had found deliberate imitators. But they were sterile, and Giovanni Pisano, the son of the ablest and most conscious of them, turned his face towards France to become all but the greatest of Gothic statuaries. In the fourteenth century the tide of Humanism began to run. Petrarch, its mightiest adept, who, it may be remembered, spent his last years worshipped like a present deity within the sound of Padua's bells, composed in Latin an epic intended at the same time to revive the memories of old Rome and to create a passionate longing for its glorious restoration. He was not indifferent to the fine arts, and he must have used his gifts of persuasion to induce his artist friends to follow his example and to share his task. It is clear that he failed, as he was bound to fail. The painter who before Donatello ventured to imitate the ancients was in the position of Petrarch attempting to learn Greek. A Calabrian monk read Homer to him and gave him a general sense of the narrative, but could not teach him to read for himself, because the monk lacked the analytical, articulated, grammatical knowledge of the language. A modern scholar of equal genius, in Petrarch's place, would be able to master a language to which he had far less of a clue, because he is the heir to a philological training of many generations.

Before he could profit by the Antique, the artist had to have some appreciation of its artistic superiority. It was not enough that he should revere it as the achievement of a glorious past. Nor was it enough that he should admire it for its handsomer faces and more impressive poses (if indeed, as is questionable, the Gothic sculptor or painter did in fact find the faces in Greco-Roman art more handsome and the poses more impressive than in his own). When the living traditions of a great art have been destroyed, the archaistic imitation of its products will lead no farther towards creation than the naïve imitation of nature. A reviving art must begin at the beginning, and endeavour to penetrate step by step into the secrets of art construction. At every step it takes it will discover in the Antique an indication of how the next step is to be taken. The progress of an art which revives under these conditions will be almost as rapid as that of the individual who in a few decades learns what humanity needed a thousand centuries to acquire. But the Antique, in order to produce this effect, must be

The rise of Humanism

Stimulus of the Antique

accessible in sufficient examples of its best work, and it must encounter men of so vigorous an independence that its masterpieces will not lure them into imitation.

Donatello and Brunellesco, Uccello and Masaccio may have had the independence of mind to resist the allurements of Antiquity, but they were not severely tested, for, in their earlier days, at all events, ancient works of art were scanty and of a low order of merit. They were obliged to recover most of the secrets of art-creation for themselves. Had it been otherwise, it is possible that they would have been saved much waste, much affectation, and much bad taste. One must not dwell on the thought of all that might have happened had Donatello known Pheidian or—still more fascinating speculation!—Greek Archaic art! But as he and his countrymen had never seen the Elgin marbles, the Aeginetan and Olympian pediments, or the Delphian bas-reliefs, it is to their lasting glory that they at least knew better than to imitate the specimens of debased Greco-Roman sculpture which alone were accessible to them, and that they dared to be archaic for themselves.

Archaic and archaistic art

For no art can hope to become classic that has not been archaic first. The distinction between archaistic imitation and archaic reconstruction, simple as it is, must be clearly borne in mind. An art that its merely adopting the ready-made models handed down from an earlier time is archaistic, while an art that is going through the process of learning to construct the figures and discover the attitudes required for the presentation of tactile values and movement, is archaic. On the other hand, an art which has completed the process is classic. Thus, while Niccolò Pisano may be ranked as archaistic, Giotto and his

'Classic' art

school are classic and not archaic, as also the Van Eycks and their followers, the French sculptors of the thirteenth century, and the Chinese and Japanese artists since many centuries. Merely primitive or even savage art is not necessarily archaic. There is, for instance, little of the archaic in most Egyptian art, and as little in Aztec carvings or Alaskan totem-poles. On the contrary, a painter of the nineteenth century, Degas, may boast of being archaic. And of course most

Definition of archaic art

Florentine artists of the fifteenth century were archaic, for they were making for a goal which none of them could hope to touch. That goal was an art compounded of nothing but specifically artistic motives.

This definition gives even more than it promised, for it clearly suggests the reason why we care so much for genuinely archaic art. It is because such art is necessarily the product of the striving for form and movement. It may fail to realize them completely; it will by definition fail to realize them in proper combination, for then it would

already be classic; it may exaggerate any one tendency to the extreme of caricature, as indeed it frequently does: but through its presentation of form, or of movement, or of both, it never fails of being life-enhancing.

The same definition further suggests the chief reasons why Quattrocento Italian art was inferior to the Greek art of more than twenty centuries earlier, and why it led to no such great results. Renaissance art, although it had no acquaintance with the best products of Antiquity, was yet not frankly enough archaic. It may in a sense be called somewhat archaistic, seeing that it never completely emancipated itself from the art of the past, its own immediate past, if not the remoter past of Rome. Thus, in the allegorical figures on his 'Tomb of Sixtus IV', even so advanced and original a genius as Pollaiuolo never wholly abandoned the vapid elegance of the Romance of the Rose period. There was, moreover, the further difficulty of the subject-matter imposed upon the artists from the outside, for extra-artistic reasons, a subject-matter whose resistance no one could sufficiently overcome. The Greek archaic artist was more fortunate, enjoying the inestimable advantage of a free hand in the making of his own gods. Thanks to a hundred causes, the Greek artist of the pre-Pheidian time was the dictator of theologians and not their slave. The aspects and actions of his gods, being the creation of a specifically visual imagination, were necessarily perfect material for the sculptor and painter. Not so the gods of Christendom, who were fashioned by ascetics, mystics, philosophers, logicians, and priests, and not by sculptors or painters. The Greeks had the further advantage, that they could believe their gods to be present in the most strictly plastic work, while the Christians, before they could believe that their gods were so much as represented by an image, had to prove it by values current, not in the world of visual beauty but in the realms of mysticism or in those of dogmatic theology and canon law. Small wonder that, with such convictions, Michelangelo did not equal Pheidias, or that the precursors of the one did not dedicate themselves so entirely to pure art as the forerunners of the other.

Hampered then, as were the great Florentines, by too much rever- *Reverence* ence for the past and by the necessity they were under of representing *for the past* personages and scenes which owed their origin to theology instead of to art, they were nevertheless working mainly in the right spirit, and were genuinely and hopefully archaic; and, for all his humanistic ardour, Mantegna, without the severe studies in the rendering of form and movement to which he was subjected by the tradition if not by

the personal stimulus of Donatello, would never have been able to record in any adequate semblance his vision of Antiquity. He must, at an age surprisingly precocious for even that century of early maturing genius, have become as well aware of his means as of his end, for as a mere lad he absorbed all that his Florentine teachers had to give him. But although he was gifted for whatever is essential in the figure arts as perhaps were none of their pupils at home, and endowed besides with a pictorial faculty that was unknown in Tuscany, Mantegna, in his earliest extant works, already betrays the subordination of the one and the suppression of the other. The suppression of his native impulse towards the pictorial was so complete that, but for two or three drawings, dashed off without effort, we should scarcely have suspected its existence. As for form and movement, he seems to have acquired before he was five and twenty nearly all he was destined to master. What progress he made later was brought about by mere force of momentum, for he never again gave them the first place in his thought. That place was taken by his Illustrator's purpose of reconstructing the Ancient World.

Mantegna's passion for antiquity There is no need to quarrel with Mantegna for preferring pagan to Christian subject-matter. Indeed, it was but his duty as an artist. We can readily sympathize with his passion for Antiquity, and love his vision of a perfected humanity, for among the many dreams of Perfection that have been dreamt, his is surely one of the healthiest and noblest. But we may well quarrel with him for the uncritical attitude he adopted towards the Antique, and deplore its result. Even had the Antique he was acquainted with been of the best, he should have endeavoured to fathom the secret of its craft rather than to copy its shapes and attitudes. Thus, and thus only, could he have drawn clear profit from it. But the Antique that he knew was, with the rarest exceptions, of a debased kind, a product of the successive copying of many generations. In types and poses these works did, it is true, retain something of their primitive beauty, but in every other respect they were listless, lifeless, and mechanical. Englamoured and undiscriminating as only an Italian Humanist could be, Mantegna was blinded to the fact that his models were, in everything but conception, inferior to the work of his own peers and contemporaries. If he had to put the art of the past to the use of a ferment, it was certainly unfortunate that he drew from a cask broached so long ago that all its flavour had evaporated. He was saved from insipidity only by the vigour and incorruptibility of genius. Quality of touch is a gift that nothing but physical decrepitude can take away, and, although he

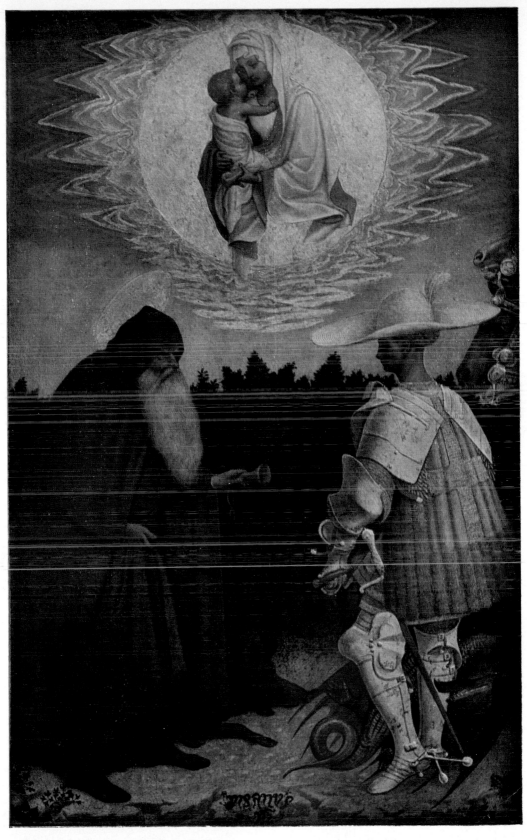

V. Pisanello: *Madonna and Child with two Saints*. Cf. Plate 107

VI. ANDREA MANTEGNA: *Landscape*. Detail of Plate 113

doubtless wasted much of his talent upon the monstrous effort to assimilate an execution inferior to his own, he received no fatal injury.

The effort, however, did not advance him. Perhaps but for this waste of energy, his zealous quest of line would have been crowned with far greater success. Not only did he fail of the triumphs of Botticelli, but he never quite reached the full use of contour, of functional line, stopping short in his development at the outline, at the line that circumscribes but does not model.

Another factor of kindred origin contributed to his shortcomings with regard to line in contour. In his effort to assimilate the precise touch of his antique models, it is not surprising that, instead of waiting to evolve a canon of the human figure out of his own experience of form and movement, he attempted to adopt the one created by the Ancients. He succeeded only too well; but it could not end there. Active people cannot stand still. If not deliberately, then all the more certainly, do they speed forward on the path they have taken. Well for them if it is a genuine highway and not a blind alley. In each art there are a few things, and only a few, capable of intensification; and fruitful activity consists in taking hold of at least one of these things and working upon it. There are many other things, alluring and specious, which seem to promise profitable returns for outlay. Nor are their promises brusquely falsified. It is part of their wickedness that they do seem to pay: only, like other gifts of evil spirits—so our ancestors used to believe—like the luscious fruit that moulders to dust, or the ruby wine that changes into wind at the touch of the lip, these profits turn quickly to dross. To take another metaphor, they not only bring no interest upon investment, but show a capital so diminished that a few successive operations dwindle it away to nothing. In the figure arts it is an almost irresistible temptation to take over shapes and attitudes already evolved. By their means one seems so quickly to acquire charm, beauty, and dignity. Unfortunately shapes and attitudes are among the things that do not admit of intensification, but only of schematization; and Mantegna, in the measure that he took them over from the Antique as a canon ready made, tended to reduce them, despite obvious appearances to the contrary, to mere calligraphy. For contour, being line in function, line that renders the form and gives the pulse of life, cannot be found by travelling in the opposite direction!

The facility and accomplishment which mark the first steps of decay are apt to be mistaken for symptoms of the contrary process, especially when these steps are taken by an artist in such apparent rude health as

Dangers of the Antique.

Mantegna. But other faults resulting from the imitation of the Antique may be brought home to him more easily. We have noted already how he tended to paint people as if they were made of coloured marble rather than of flesh and blood, and remarked that this may have been due to his naïvely thinking of the Ancients—those Ancients whose resurrection was his chief aim—as having had in real life the only aspect in which he knew them, the aspect of marbles in the round or in relief. We may well admire and like these beings when they are endowed, as they not infrequently are in Mantegna's earlier works, with all the splendour and grace and even tenderness of human beings, but built of a more insensible, more incorruptible material. Human qualities in such creatures have something more poignantly touching, just as the expression of tenderness is so much more appealing in a poetry like the Latin, because nothing has led one to expect it of the Roman and his hard lapidary language. We should find no fault with Mantegna on this score if, at other times, and more often, he did not betray the coarse and even vulgar inspiration of post-Augustan sculpture. But it is carrying things too far to confine one's attention so closely to men and women in marble as never to look at life—life, the only inexhaustible field for study, for experiment, for suggestion. One would be tempted to doubt whether Mantegna had ever seen with his own eyes—for I venture to believe that a man may be an artist of high, almost exalted rank, and yet never see with his own

Pl. 115 eyes—if, in his portraits in the Camera degli Sposi and elsewhere, we did not find proof that he possessed an almost unrivalled power of direct observation. It is unfortunate that he put it aside, prodigally blinding himself to all light that was not reflected from Roman bas-reliefs.

The Roman
bas-relief The Roman bas-relief took greater and greater hold upon him. There he found the forms, there the substances, there the arrangement of his ideal world, and he seems to have ended by seeing not in three dimensions but in the exquisitely artificial space-relations of low relief. In his last years, casting variety of tint like a vain thing from him, he painted more and more in monochrome, ending with such stone-coloured canvases as his London 'Triumph of Scipio', the Louvre

Pl. 117 'Judgement of Solomon', or the Dublin 'Judith'. It should be added that these final performances come dangerously near to being repro-ductions of Antonine bas-reliefs. But from this ignominy he was saved to some extent by his genius, and even more by the nervous silhouetting he had learned from Donatello.

Too great devotion to the Antique thus hampered Mantegna in all

his movements, checking in every direction his free development, and curbing the natural course of his genius. This, however, was so prodigious that despite the mummy-cloths that he wrapped about him, he burst through them and walked more freely than most others not so self-handicapped. There is but one more addition to make to the inventory of his errors, and this relates to the subjects of which he made choice. His Florentine rivals, seldom forgetting that the real triumphs of art are reserved for those who exploit the elemental, eternal, inexhaustible resources of Form and Movement, rarely failed to seize an opportunity to compose accordingly, or to create an opportunity if one did not present itself. Botticelli, even where the subject was given him, as it doubtless was in the 'Spring' and the 'Birth of Venus', produced creations of so purely decorative an order that the merely illustrative material is completely consumed away. Even more is this the case with Pollaiuolo. He also loved the Antique. But note what subjects he chose to illustrate: 'Combats of Gladiators' and the 'Deeds of Hercules'. He selected themes which dissolve themselves without residue into values of form and movement, creating of themselves their necessary shapes, attitudes, and relations. But Mantegna, here again, was tied hand and foot. Determined to revive Antiquity, he did not sufficiently consider whether a given subject, given shapes, and given attitudes were those calculated to produce the really great work of art. The humanist in him was always killing the artist. Consequently, although he is magnificent and inspiring, he never produced a composition approaching the 'Combat of Gladiators', nor a painting to rival the 'Spring'. His 'Combat of Virtue and Vice' is choked with unconsumed illustrative material, and even his 'Parnassus' fritters away one's attention on various archaeological side-shows, for thus they may irreverently be called, seeing that they are artistically unrelated to the main composition of the picture.

Choice of antique subjects

This, in brief, is what I have to say of Mantegna, whom so much of me loves and worships. Perhaps it will help my readers to understand my view of him if they are told that in essentials, although on a much grander scale, he seems to have been not unlike a great artist of our own day. Like Burne-Jones, he was archaistic rather than archaic in his intention and romantic in his attitude towards the past, and, like Burne-Jones, he substituted a schematic vision for a remarkable native gift of observation.

It is a pity that so highly gifted a genius went astray. Had Mantegna devoted all his talents to the real problems of painting as a figure art, he might, besides creating masterpieces intrinsically finer, have

transmitted such a feeling for serious construction as would have uplifted all the schools of Northern Italy, and prevented Correggio from being so boneless, and Veronese so ill-articulated. As it was, he accomplished little more than to help bring about a change in visualizing, and to bequeath a passion for the Antique. It was in no slight degree due to him that the region where he lived, fostered or employed the most archaizing sculptors, bronze-workers, and architects of the Renaissance. But he left no direct heirs, and it was only as an Illustrator that his influence on the art of painting perpetuated itself. His cult of Paganism prepared the way for Giorgione's 'Fête Champêtre' and Titian's Bacchanals.

V

Past and present views on art

At this point, the eighteenth-century critic, who was apt to be both shrewd and rational, would have turned his attention first to Leonardo and then to Correggio. I confess I envy the giant strides which enabled the writers of old to pass from peak to peak, unconscious of all that lay between! Any picture that interested them, they set down to some well-known master; and if the picture chanced to be of Lombard origin, it had to be a Mantegna, a Leonardo, or a Correggio. Their attributions were more frequently wrong than not, but their attitude was, in the main, right. To the objections of us latter-day connoisseurs they could have replied that Art formed no exception to the rest of their interests, which were always intellectual, and that, intellectually, there was little or nothing calling for attention in painters whose works might be easily assimilated to those of their more famous peers. Perhaps theirs was too rationalistic and lofty an attitude, but it stands in refreshing contrast to the microscopic outlook and groping methods from which we suffer. If we could return to it, we might devote the resulting leisure to the study of Art.

The study of art, as distinct from art-fancying, and from the biography of artists, should be, in the first place, a study of the specific ideas embodied in works of art. From this point of view, there is nothing to be said about the North Italian contemporaries of Mantegna that has not already been said about him: he subsumes them all. Their purpose, when they had one, was not different from his. Most of them followed him. A few walked and some stumbled or staggered independently, but all took his road. It would be difficult to find among them a single idea—by which I mean, in the figure arts, a motive exploiting the possibilities of form and movement—which

Mantegna had not used better. The student of art might well ignore these minor men, but of the small number for whom art, as art, has any meaning, few are students. The rest are fanciers or pedants, and it is to them, and as one of them, that I shall speak of the Quattrocentists of the valley of the Po.

VI

Among the North Italians who were young in the third quarter of the fifteenth century, there is no painter of mark who did not study at Padua or under someone fresh from her studios. At first, it seems mysterious that one town, and that by no means the largest or most convenient, should have exerted such an influence; but on closer inspection it appears that the whole country had been carefully prepared to join the new movement, for the Humanists, during three generations, had been preaching the emancipation from the canons and symbols of the Middle Ages, in favour of a return to the Antique. Northern Italy was therefore, like Tuscany, intellectually ready to take the new step, and there lacked nothing but initiative and a practical acquaintance with the means. These were furnished by Donatello at Padua, and when you add to this the emulation aroused by the successes of the adolescent Mantegna, and the seductive advertisement supplied by the applauding Humanists, it is easy to understand why all the young and gifted flocked to Squarcione's workshop. There each acquired what his energy enabled him to graft upon his own gifts, as these had been already modified by his previous training at home under a local teacher. Thence they brought away even more than they had bargained for, since, along with an enthusiasm for Antiquity, they caught the contagion of an ardent, if sometimes short-lived, realism. When they returned home, they radiated the new knowledge, and before the greater number of them had died, the revolution was complete. Excepting in remote upland valleys, no painters remained who visualized and rendered in the old way.

The Paduan school

Of the young men who flocked to Padua, none brought greater gifts, none drank deeper of Donatello's art, and none had a more remarkable destiny than Cosimo Tura. He founded a line of painters which flourished not only in his native town of Ferrara, but throughout the dominions of its Este lords and the adjacent country from Cremona to Bologna. It was destined that from him should descend both Raphael and Correggio.

Tura

Yet nothing could be more opposed to the noble grace of the one,

Pls. 119–20

or the ecstatic sensuousness of the other, than the style of their Patriarch. His figures are of flint, as haughty and immobile as Pharaohs, or as convulsed with suppressed energy as the gnarled knots in the olive tree. Their faces are seldom lit up with tenderness, and their smiles are apt to turn into archaic grimaces. Their claw-like hands express the manner of their contact. Tura's architecture is piled up and baroque, not as architecture frequently is in painters of the earlier Renaissance, but almost as in the proud palaces built for the Medes and Persians. His landscapes are of a world which has these many ages seen no flower or green leaf, for there is no earth, no mould, no sod, only the inhospitable rock everywhere. He seldom finds place even for the dry cornel tree which other artists, trained at Padua, loved to paint.

There is a perfect harmony in all this. His rock-born men could not fitly inhabit a world less crystal-hard, and would be out of place among architectural forms less burdensomely massive. Being of adamant, they must take such shapes as that substance will permit, of things either petrified, or contorted with the effort at articulation. And where the effort at movement produces such results, expression must freeze into grimace before it has reached its conclusion.

Where there is harmony there is necessarily purpose, and Tura's purpose is clear. It is to realize substance with almost maniac ferocity. He will have nothing in his world which will not firmly resist his conquering embrace. Nothing soft, nothing yielding, nothing vague. His world is an anvil, his perception is a hammer, and nothing must muffle the sound of the stroke. Naught more tender than flint and adamant could furnish the material for such an artist.

Tura had drunk too deeply, perhaps, of Donatello's art, and had his vision too much englamoured by Mantegna's earliest achievements. And who knows what flower-like, ghost-like medieval painting he was violently revolting from, to lead him to exaggerate so passionately the only principle he seems to have grasped at Padua? Hokusai, in his extreme old age, used to sign himself 'The Man-mad-about-Drawing', and with equal fitness, Tura, all his life, might have signed, 'The Man-mad-about-Tactile-Values'.

To this one principle he sacrificed the whole of a genius kindred and perhaps not inferior to Pollaiuolo's. With no conspicuous mental training and lacking, like all provincials, the intelligent criticism of serious rivals, he was never driven out of his narrow formula into a more intellectual pursuit of his art. He ranks, consequently, not with his Florentine peers, but with another product of the Paduan school, Carlo Crivelli. The one exaggerates definition as the other exaggerates

precision, and like all born artists who lack adequate intellectual purpose, both ended in the grotesque.

Not so evil a fate this, when all is said and done! Next to Giotto and Masaccio, to Leonardo and Michelangelo, and their glorious company the world over, we must place the artists who, with an infinite gift for quality of touch, never passed beyond the point of creating designs that demand the utmost vitality in every detail. Now a design inspired by delight in nothing but life-enhancing detail is bound to turn into the grotesque, and the makers of these designs are always masters of this art, as the Japanese, for example. To them we must not give our highest esteem, but it is difficult not to love them as much as the best, for to love is to have life enhanced by the object loved.

And so Tura is much loved, for he was a great master of the grotesque, and of the heraldic grotesque, which is its finest form. His works abound not only in the unconscious, but in the deliberate grotesque. He revels in strange sea things and stranger land things. He loves symbolic beasts, and when he paints a horse, as in his 'St. George and the Pl. 119 Dragon', he gives him, as an armourer would, a proudly heraldic head.

Another reading of Tura is possible. It may be that his purpose was merely illustrative, and that he loved this arid, stony world of his, inhabited by rock-born berserkers, as others love the desert, or glaciers, or the Arctic regions. These are inspiringly tonic to some temperaments, and, in aesthetic form, to all of us. The illustrator who communicates ideated sensations which compel us to identify ourselves with such virility, with such proud insensibility, with such energy and endurance, is an artist indeed. Which is the right interpretation of Tura is of no consequence, for in him, as in every complete artist—and Tura was complete though narrow—Illustration and Decoration are perfectly fused.

VII

It would take no considerable changes to make these paragraphs on Cossa Tura apply to his slightly younger townsman, Cossa. They form a double star, each so resembling the other, and of such equal magnitude, that it is not easy to keep them apart, nor to decide which revolved round the other. Prolonged acquaintance, however, reveals differences of purpose and quality, due partly to a difference in orbit. Tura veers towards Padua, while Cossa is attracted by the more specifically pictorial influence of Piero della Francesca, the mighty Tuscan, who worked for a time at Ferrara.

Pls. 121-2

Cossa took over Tura's world bodily, and, when possible, exaggerated it. His landscapes are as sublimely sterile as Tura's, and, to deepen the desolation, his architecture is shattered to ruins. His figures are no less convulsed with energy, and if they are less haughty, it is only because they condescend to be insolent. He took over, as well, Tura's violent realization, but he was saved from the consequence of intensifying it to the utmost by the example of Piero's large planes and quiet surfaces. Thanks to these, he learned to broaden to a boss what in Tura would have remained a knob. To Piero again, Cossa owed his interest and consequent eminence in the treatment of diffused light; but to his own genius alone did he owe his command of movement.

His distinguishing characteristics are due to this. Where he departs in type from Tura, it is largely owing to greater mobility and more detailed articulation. Like all artists with unusual feeling for movement, he understood functional line, and the contours of his figures gain thereby a correspondence to tactual impression as convincing as it is in Pollaiuolo or the young Botticelli. Even the insolence of most of his figures may be due to his putting them in motion, for insolence is only haughtiness in action.

To the same source may be traced his unexpected rendering of the holiday life of his time that we find in the 'Schifanoia'. He paints a race between slim horses and men and women runners, each with an individual movement, yet all together making a continuous pattern. They are watched with evident delight by onlookers, among them elegant court ladies, stretching their lovely necks from balconies. Line cannot be too ductile to convey action so quick and contours so delicate. No Greek bas-relief or vase can show a design more swift.

Pl. 121

It required faculties of all but the most exalted rank to create a figure like his 'Autumn' at Berlin. She is as powerfully built, as sturdy and firm on her feet, as if she had been painted by Piero himself; but in atmospheric effect and in expression she reminds us of Millet and Cézanne.

The artist who had this range and this touch might have left who knows what, had he but added intellectual purpose, and had he while still young migrated to Florence instead of to Bologna.

VIII

Ercole
Roberti

Tura's and Cossa's austere vision of vehement primeval beings in a severely mineral world suffered a certain change as it passed into the eyes of their ablest follower, Ercole Roberti. While remaining, at all

events in his earlier years, an artist of a high order, he was much more given to Illustration than to Decoration. He was thus keenly Pl. 123–6 alive to the 'literary' qualities in the works of his predecessors, and used them with full consciousness of their emotional effect. But this exact effect could, if he had but known it, only be produced by its own causes, and not by using itself as building material; for then it became a new cause, bound to have another result. The fresh product would very likely appeal even more vividly to a poetical mood, and yet it must end in a mirage, standing for nothing.

It seldom came to this with Ercole, thanks to certain compensating qualities he possessed. Either because he lacked his masters' feeling for substance, or because they themselves were not intellectual enough to teach it, his works never produce anything like the conviction that theirs inspire. His pattern tends to be calligraphic, as it must be when composed of figures that have more volume than bulk, with limbs at times little more than silhouettes, with feet that seldom press the ground, and hands that never grasp. Before his Dresden 'Betrayal' and 'Procession to Calvary', if you stop to think of the substance in the Pl. 125 figures represented, you must conclude that they consist of nothing solid, but of some subtle material out of which they were beaten, like repoussé work, having no backs at all, or with hollow insides. But, on the other hand, he had enough feeling for functional line to enable him, if not to communicate movement, to present action so that he succeeded in conveying a sense of things really happening. Then, he understood almost as well as his Umbrian contemporaries, or as Millet among moderns, the solemnity of the sky line, and the sense of profound significance it can impart to figures towering above it, as we see in his Berlin 'Baptist'. Moreover, in his best pictures, such as the Dresden *predelle*, the figures are so sharply silhouetted, and so frankly treated like repoussé work, that, far from taking them amiss, one is bewitched by their singularity. Finally, his colour has the soothing harmonies of late autumn tints.

Yet none of these qualities and faults, nor all of them together, explain the fascination of the man, which is to be looked for rather in his gifts as an Illustrator. These gifts were of the intensest type, although narrow in range. There is in the works already mentioned, in the Liverpool 'Pietà', in the Cook 'Medea', and in the mono- Pl. 124 chrome decorations in the Brera altar-piece, a vehemence so passionate, an unrestraint so superhuman, that we surrender to them as we do to every noble violence, happy to identify ourselves with their more vividly realized life. If ever man had 'wrinkled lip and sneer of cold

command', it is Herod in the ferocious scene in the Brera painting representing the 'Massacre of the Innocents'. But the treatment as a bas-relief adorning a throne takes away all possible literalness, and leaves nothing but that delight in the absence of human sensibility which we get in the Icelandic Sagas, or, better still, in the flint-hearted last days of the Nibelungen Not.

Even as an Illustrator, Ercole recalls his masters, Tura and Cossa, as this description will have revealed. But in him the effect is deliberately aimed at, while with them it may have been but the unsolicited result of their style. Therefore, as Illustration, his work has the advantage of set purpose; yet nothing shows more clearly how small a part even the most fascinating illustration plays in art. At his best, Ercole Roberti is but a variation played by the gods on the much grander theme they had invented in Tura; and at his worst, as in his Modena 'Lucretia', he is fit subject for a sermon on the text that no Illustrator, who is not also a master of form and movement, retains any excellence whatever after he has worn out the motives he took over from some other artist who had had these essentials at his command.

IX

If miserable decline was the lot of Ercole, who had come in contact with reality at second hand and with intellect at third hand, we may
Costa know what to expect from his pupil, Lorenzo Costa, whose contact with life and thought was only at third and fourth hand. He began with paintings, like the Bentivoglio portraits and the 'Triumphs' in San Giacomo at Bologna, which differ from Ercole's later works only in increased feebleness of touch and tameness of conception. He ended with such pictures as the one in S. Andrea at Mantua, where there remains only the remote semblance of a formula that once had had a meaning. Between his earliest and his latest years, however, he had happy moments. Despite his predilection for types vividly suggesting the American Red Indian, an altar-piece like the one in San Petronio at Bologna has not only the refulgent colour of a well-tempered mosaic, but a certain solemnity and even dignity in the figures. But in the greater number of his works, the figures have no real existence. Usually they are heads screwed on—not always at the proper angle— to cross-poles hung about with clothes. Yet, even thus, his narration is so gay, his arrangement so pleasant, his colour so clean and sweet, that one is often captivated, as, notably, by the Louvre picture repre-
Pl. 127 senting 'Isabella d'Este in the Garden of the Muses'. Here, however,

as in most instances where Costa pleases, it is chiefly by his landscapes, which, without being in any sense serious studies, are among the loveliest painted in his day. Their shimmering hazes, their basking rivers running silver under diffused sunshine, their clumps of fine-stemmed trees with feathery foliage, their suggestion of delicious life out of doors, make one not only forget how poor an artist Costa was, but even place him among those of whom one thinks with affection.

Naturally the masters I have mentioned are the tallest trees in the little wood of Ferrarese art. There are many others growing under their branches, some of them clinging, like the mistletoe, to the boughs of the sturdiest oaks. In places the trunks and branches are so tangled and intertwined that as yet many a one has not been traced down to its roots. Bianchi, for instance, if he painted the impressive 'St. John' Bianchi at Bergamo and M. Dreyfus's Portraits of the Bentivoglios,[1] would deserve a high rank in the school. But a still higher place belongs to the author of the Louvre altar-piece ascribed to him. Its severely Pl. 128 virginal Madonna, its earnest yet sweet young warrior saint, its angels, so intent upon their music, the large simplicity of its arrangement, the quiet landscape seen through slender columns, the motionless sky, all affect one like a calm sunset, when one is subdued, as by ritual, into harmony with one's surroundings.

Before leaving, for the present, the school of Ferrara, a word will be in place about Francesco Francia and Timoteo Viti. Francia, whom meticulous finish, gracious angel faces, and quietistic feeling render Francia popular, was, from the point of view of universal art, a painter of small importance. Trained as a goldsmith, he became a painter only in his maturity, and thus he missed the necessary education in the essentials of the figure arts. But his feeling, before it grew exaggerated (when it anticipated his townsmen of a century later), was, in its quietism, at least as fine as Perugino's. No work by the Umbrian master is more solemnly gracious, tender, yet hushed with awe, than Francia's Munich picture of the Virgin stooping, with hands rever- Pl. 129 ently crossed on her breast, to worship the Holy Child lying within the mystic rose-hedge. Perugino, without his magical command of space effects, could never have moved us thus; and even Francia owes much of his modest triumph to his landscapes. Many of us have felt their dainty loveliness, and been soothed by such silent pools—*sine labe lacus sine murmure rivos*—such deep green banks, such horizontal sky-lines as give charm to his altar-piece in S. Vitale at Bologna.

[1] Now in the National Gallery of Art, Washington.

Viti
Pl. 130

Timoteo Viti has left two pictures—the 'Magdalen', at Bologna, and the 'Annunciation', at Milan, which, as figure art, are perhaps as good as any of Francia's. It is not these, however, that earn him mention here. His importance is due to the fact that it was he who first taught Raphael, and that it was through him that the boy genius inherited many of the traditions which, in however enfeebled a form, had been handed down from the grand patriarch, Tura. It need scarcely be said that, in the condition in which it reached Raphael, it was a heritage he might have done well not to take up. At all events, it would have stood him in no stead if he had not added to it the wealth of Florence.

X

The School
of Verona

We return to Verona, this time not as to a capital of the arts, mistress of Italy between the Alps and the Apennines, but as to a provincial town, whose proud memories served only to prevent her taking the new departure at the most profitable moment and in the most fruitful way. Few of her young men seem to have frequented Padua while Donatello was there and while the revolution started by his presence was in full strength. Most of them stayed at home, sullenly waiting for its flood to sweep up to their gates.

The visit of Mantegna, in the flush of his early maturity, was a visit of conquest, and the altar-piece which he left behind at San Zeno remained, like a triumphal arch, a constant witness to his genius. From the neighbouring Mantua, where he established his reign, he kept Verona, for two generations and more, a fascinated captive at his feet.

In some ways this was unfortunate. As the Veronese painters had not known Donatello, nor been brought into contact with reality through a direct acquaintance with his sculptures, they could not understand the ultimate source of Mantegna's inspiration, and could only imitate its final results. These were by no means the inevitable outcome of Florentine ideals—which, as we recollect, were to base design on form and movement and space—but were more frequently the offspring of a desire to present his vision of the Ancient World in the accent of that world itself; and if this touch of a dead hand did not entirely paralyse his own, happily too vital and resistant, it did nevertheless succeed in relaxing his contours to a slackness more readily found in Roman bas-reliefs than in the works of his fellow-pupils, Bellini and Tura. This over-schematized but very seductive product gave no monition to strive for understanding, but held out every

incentive to imitation. Although it will be granted that the first imitations retained something of the excellence of the originals, successive copying could not fail soon to have the usual consequences, decay and death. If Veronese painting was saved from these disasters, and lived to boast of a Paolo Caliari, it had to thank the solid heritage of naïve observation, colour feeling, and sound technique handed down from Altichiero and Pisanello, which, as was hinted earlier in this essay, formed part of that fund of merit held by Verona in common with the rest of Northern Europe.

XI

The Quattrocento painters of Verona betray two fairly distinct tendencies. One of these, manifested most clearly and potently in Domenico Morone, was to admit nothing of the old spirit in adopting the new imagery and the new attitudes introduced by Mantegna. The other, headed by Liberale, was inclined to retain the old types and such of the old ways as would make a compromise with the new vision. So tenacious was this party of ancient traditions that it succeeded in transmitting them to the Cinquecento school which resulted from the fusion of the two movements.

Domenico Morone is known to us in his last phase only. In his one important work now extant, the amusing Crespi canvas, now in the Palace at Mantua, representing the expulsion of the Buonaccolsi by the Gonzagas, we have one of those Renaissance battles that partook more of a spirited dress-parade than of a field of carnage. Refined cavaliers on deftly-groomed horses are making elegant thrusts at one another, and at times even bending over each other as if with ungentle intention. But it is clear that they will do no harm; they are only taking poses that will show to best advantage their own graceful carriage and lithe limbs, and the mettle of their steeds. And charmingly indeed do they group in the midst of the broad city square, surrounded by its quaint façades, and backed by the distant mountains.

The man who ended thus must have begun as a strenuous workman, for in art, as in love, 'none but the brave deserve the fair'. Indeed, at San Bernardino there exist ruined frescoes which betray no preoccupation with elegance and grace, but show every sign of having been done under the stress of an ambition to master form and movement. They also make one question whether their author had not studied in Padua. Faint echoes of his earlier struggles reach one from the works of his pupils, and further proof of a certain intellectual endeavour may be

Domenico Morone

Pl. 132

Pl. 131

Pl. 134

discovered in the fact that these pupils comprised the best, with the one exception of Caroto, of their generation. But Mantegna's influence upon Morone ran contrary to intimacy with reality, and swept him away towards schematization and towards that kind of elegance which, in happy circumstances, is the first as well as the finest product of this kind of intensification.

Little remained to be accomplished by his son, Francesco, and his other followers, Girolamo dai Libri and Cavazzola. Being his imitators, they were by so much farther removed from the source, and, lacking his relatively serious training, they could not attain his gracefully vivid action. It is to their credit that they seem to have made no futile attempts, and that they confined themselves to spreading abroad unambitious, honest, and frequently delightful imitations and recombinations of the style and motives of their master. As serious figure art, their work ranks no higher than that of the Umbrians; and if they have not the compensating space harmonies of those artists, they please and tarnquillize one almost as much with their poetical landscape backgrounds and soft diffused lights. Their arrangement is as restfully simple, while their grouping is perhaps larger. Their types are frequently as quiescent and even as ecstatic, although they exhale at the same time the well-being that turns each picture of their descendant, Paolo Veronese, into a temple of health. Then they have a radiance which they shared with the Venetians only, due to the treatment of colour as substance, as the material out of which the visible world is made, not as if it were only an application on the surface of matter, as colour was regarded elsewhere in Italy. For these reasons one may rank the school of Domenico Morone on a level with Perugino's, provided one first excluded Raphael. It is excluding much, but the Umbrian remainder is almost as inferior to the Veronese average as he is above it.

One can speak of Domenico's followers thus together, because their resemblances are so much more striking than their differences. Nevertheless, each introduced the newness his temperament could not avoid.

Francesco Morone was the severest of them, as if educated while his father was still in his more archaic and more earnest humour. Indeed, his 'Crucifixion' at San Bernardino in Verona, with its cross towering gigantic over the low horizon, and its firm figures, must count among the most inspired renderings of the sublime theme. He declined from this strenuous mood, but without losing his poetical feeling, which expressed itself chiefly in skies filled with cloudlets, purpled and bronzed with transfiguring sunrise or sunset lights. He had an almost

Giorgionesque gift for fusing landscape and figures into romantic significance. His 'Samson and Delilah' at Milan transports one to a world of sweet yearnings, of desires one would not have fulfilled, into a lyric atmosphere which tempers existence as music does. Pl. 133

Girolamo dai Libri was perhaps the most talented of Domenico's pupils, and certainly the most admirable in achievement. He not only had greater solidity and better action, but he attained to fuller realization in landscape. And of landscape he was, if not a master, at least a magician. What views of grand and beautiful yet humanized nature, full of comforting and even poetical evocations, all bathed in warm tranquil light! What distances, too, as in the 'Madonna with Peter and Paul' of the Verona Gallery, where the three figures frame in, like an arch, harmonious expanses of flood and field, of mountain and meadow! Girolamo just failed of being a great space-composer, another Perugino. Girolamo dai Libri / Pl. 135

Cavazzola, the youngest of the group, the least at ease in its traditions, but lacking the genius to react against them fruitfully, is, except in portraits and in landscapes, somewhat distasteful. But at times, as in the portrait at Dresden, he attains to an almost Durer-like intensity, while keeping to the large handling of his school. And in a landscape like the background of his Verona 'Deposition', he anticipates the quiet effects of Canaletto. Cavazzola / Pl. 139

XII

At the head of the rival group of Veronese painters stood Liberale. He was trained as a miniaturist, and it is perhaps owing to this—for traditions last on longest in the minor arts—that in his types and colour-schemes he retained through life such a close connexion with the old school. But he did not escape the influence of the new art. Whether through coming in contact in Siena with Girolamo da Cremona, the most intellectual, imaginative, and accomplished of Italian miniaturists; or whether, on his return, through falling under the attraction of the grand sculptor Rizzo; or whether through having glimpses of Mantegna's and even Bellini's earlier masterpieces; or whether, as is indeed more probable, through all these in combination, he found ample opportunity of becoming acquainted with the products of the new movement. Unfortunately he never seems to have fully comprehended its springs of action, and hence his inferiority. Endowed by nature with an unusual if not deep sense for form and structure, and with a certain poetical feeling as well, Liberale, had he Liberale / Girolamo da Cremona

enjoyed the education of a Florentine or even a Paduan, would not have been satisfied with the few remarkable works that were the accidental fruit of his talent, but would have learnt to exploit his gifts systematically, as the scientific miner delves for precious metals, and would not have been contented, like a thoughtless barbarian, with what he had the luck to find on or near the surface. Nor would he have painted, when inspiration failed, the feeble and contemptible pictures of his prolonged old age.

His beginnings were brilliant, for he was scarcely out of his teens when he commenced those illuminations which, although inferior to Girolamo da Cremona's, are still among the finest of Italian miniatures. They have alertness of action and extraordinary vigour of colour, while at times they all but attain the rare heights of Imaginative Design. Few who have seen them in the Library of the Cathedral at Siena will forget the blue-bodied Boreas blowing, or the white-turbanned, Klingsor-like priest at an altar, or the vision of the Castle St. Angelo. Not long after completing them he must have painted, under the influence perhaps of Bellini and certainly of Rizzo, his most intellectual and most admirable work, the Munich 'Pietà'. Despite its over-sinuous contours, betraying the miniaturist, and despite its draperies taken heedlessly from sculpture, in which art they are intelligible if not beautiful, this 'Pietà' is impressive in feeling and convincing in effect. It does not occur to one to question the existence of the figures, the reality of their action, or the genuine pathos of their expression. Still under Rizzo's impulse, he painted two Sebastians, one now in Berlin and one in Milan, which are among the most comely if not the most fully realized nudes of their day, figures which, for their shortcomings as well as for their virtues, may be compared with Perugino's Sebastian in the Louvre. The Milan example has for background one of the best presentments in existence of a Venetian canal with its sumptuous palaces and out-of-door life. Even greater delight in architecture, the beauty of its material, its relation to sky and landscape, and its decorating subservience to man—all those qualities which afterwards played so superb a part in Paolo Caliari's art—are displayed in Liberale's most charming work, his National Gallery 'Dido'. On the other hand, such a picture as the 'Epiphany' of the Verona Cathedral, while based on Mantegna's great creation in the Uffizi, has something rustic and Tyrolese about it, as if a shepherd accustomed to yodelling were trying to sing Bach's *Christmas Oratorio*. And Liberale's late works prove how little he had submitted himself to the serious discipline of the figure arts, for most of them are mere rags.

Liberale's
miniatures
Pl. 137

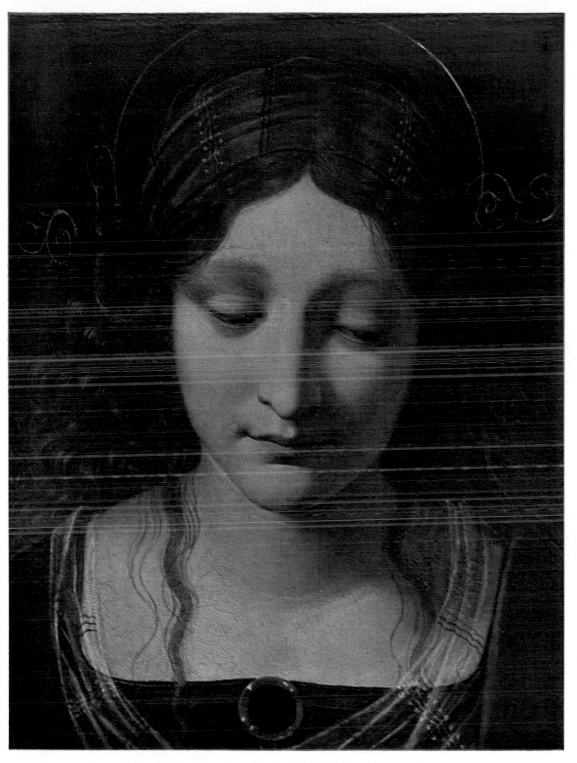

VII. Boltraffio: *Head of the Madonna*. Detail of Plate 151

VIII. Dosso Dossi: *Landscape*. Detail of Plate 172

XIII

We need not linger here over such followers of Liberale as Giolfino, Liberale's
followers with his taste for ugliness occasionally relieved by a certain whimsical winsomeness, nor Torbido, who, before he was swept away by the deluge brought down by Giulio Romano, tasted of the pure springs of Giorgione's art, and, refreshed by them, painted two or three haunting portraits, such as the wistful young man in the Doria Gallery, or the ivy-crowned youth at Padua.

The best of Liberale's pupils was Francesco Caroto, on the whole Caroto the ablest Veronese painter of his generation. A sojourn at Mantua brought him under Mantegna's personal influence, which therefore not only affected him more vitally than it had his other townsmen, but prepared him to assimilate his own style to that of the more Mantegnesque among them. In him, therefore, the two tendencies of which we spoke before ran together and fused perfectly, while neither lost its qualities. But those qualities had never been intellectual, nor was Mantegna in his last phase the man to give Caroto the discipline he required. He lived without it, and with no ideas of his own; yet, vaguely aware of their need, he was humbly eager to take over Raphael's or Titian's, and was even ready to copy other people's designs.

Caroto was thus, in spirit, little more than an eclectic; but, happily for him, the traditional conventions of his predecessors still kept firm hold on him, and even when he strayed, he never strayed from their colour sense and their honest technique. On the contrary, by remaining faithful to these, he was able to improve and even extend them, and hand them on to become that almost unrivalled instrument which Paolo Caliari perfected.

There is something winningly simple in the comeliness of Caroto's women, as in the 'St. Ursula' at San Giorgio, and in the sturdiness of Pl. 134 his men, as in the San Fermo altar-piece. In his landscape there is a haze and a distance, and, at times, a mystery suggestive of Leonardo. At his rare best, his colour partakes of the harmonies subtilized almost into monochrome of the late Titian.

XIV

Thus far we have dealt with artists whose mode of visualization never Pictorial
visualization broke through the forms created at Padua under Donatello's influence and developed under the inspiration of the Antique by Mantegna. I

have spoken in my *Central Italian Painters*, of visualization, how important a part it plays in art, how it is affected by success or failure in comprehending the specific problems of art, and how the works it produces modify and even dictate the way each one of us looks at the visible world. I need not repeat what was said there. But here, where the treatment is necessarily more historical, for the better understanding of what is to follow, I must add, in the abbreviated and almost cryptic form required by the exiguity of this small book, one or two observations that would need as many volumes for their full development with commentary and instances.

During the three centuries from about 1275 to 1575, when Italy created masterpieces deserving universal attention, two changes in visualization took place. At the beginning, we discover a method founded on line—first on dead line, to which debasement had reduced form, and then on ductile, and at times even functional line, which revived the attenuated forms, gave them contours, and lifted them up to the exalted beauty of the early Sienese. Under Niccolò Pisano, Arnolfo, and Giotto this linear mode of visualizing began to give place to the plastic, based upon the feeling for planes and the striving for fully realized substance and solidity. Arrested by the lack of genius among the followers of these three pioneers, plastic visualizing had to await the fifteenth century for its complete triumph. The victory was scarcely achieved when that great but unconscious revolutionary, Giovanni Bellini, hitherto an adept of the plastic vision, began all at once to visualize in still another mode, which, to differentiate it from the linear and the plastic, I may call the commencement of the pictorial mode. This happened because he had a revelation of the possibilities of colour. Before his day, except in a rudimentary way at Verona, colour, no matter how enchanting in its beauty, was a mere ornament added to the real materials, which were line in the fourteenth century, and line filled with light and shade in the fifteenth. With Bellini, colour began to be the material of the painter, the chief if not the sole instrument with which his effects were to be produced. Yet Bellini never dreamt of abandoning the shapes which the plastic vision had evolved; he simply rendered them henceforth with colour instead of with line and chiaroscuro; he merely gave up the plastic-linear for the plastic-pictorial.

Now, Bellini's great followers, Giorgione and Titian, were far too intellectual as artists, as well as too firmly rooted in a mighty and still recent past, to surrender, any more than their master did, the fine feeling for form, for movement, and for space engendered by the

Plastic visualization

Bellini and the pictorial model

Quattrocento. They and their companions and pupils remained still within the plastic-pictorial mode of visualizing, and never reached the purely pictorial—not Tintoretto, not even Bassano. But the Veronese, who started with a certain rudimentary sense of their own for colour as material, and quickly appreciated Bellini's revelation, had no continuous tradition of form, no steadying intellectual purpose, and they found it only too easy to drop the plastic element and to be purely pictorial.

XV

The first purely pictorial artist in Italy was Caroto's pupil, Domenico Brusasorci—a statement, it must be understood, made historically and not at all with intent to praise. By no means all Brusasorci's works, however, show him in this light. Most of them, while pleasant and occasionally delightful, tell a tale of groping and stumbling, with Caroto's baggage on his back, after Michelangelo and Parmigianino, Titian and Bonifazio. But in the altar-piece at Sant' Eufemia, in his frescoes at the Bishop's Palace, or those of even less intrinsic merit in the Ridolfi Palace at Verona, in certain decorations elsewhere in that town and at Trent, and in such portraits as the one in the Uffizi, which still passes for the likeness of Giorgione by himself, or, better still, in that of a lady, in the collection of the late E. P. Warren, of Lewes,[1] we find a way of handling contour, mass, and surface, of grouping and co-ordinating, even a dependence upon effects produced by actual brushwork, which only seem to us less modern than Tiepolo or certain famous painters of today because of their inevitable cargo of Cinquecento shapes and attitudes. Brusasorci's historical importance is therefore of the highest order, for, with this new vision resulting from the almost complete emancipation of colour from the control of plastic form and line, he designed afresh what came to hand, much as Giotto and Mantegna had done before him, leaving a mode of arrangement and lighting, as well as actual compositions, that his successors could take over with little or no change.[2]

One may ask why, if he brought in as much newness, he is not to be considered as great as Giotto or Mantegna. The answer is simple. Newness is a very minor consideration in the world of art. In that

Brusasorci

Pl. 141

Newness in art

[1] Now in the Rhode Island School of Design, Providence, R.I.

[2] It seems less certain now than it did three decades ago that the innovator was Brusasorci. Probably it was Paul Veronese. This artist's variety, fecundity, and pictorial mastery still await the recognition from our generation that previous centuries never failed to give him.

world it is the intrinsic quality only that counts, and that quality, no matter by what materials and with what vision it is obtained, must always be Form, Movement, and Space harmonized together: and of this harmony Brusasorci was only an inferior master.

Brusasorci's
followers
Pls. 140, 142 His followers, Farinati, Zelotti, and Paolo Caliari, not to speak of others like Felice, his son, and Bernardino India, illustrate the value of the new material and formulae in a way that has been repeated perhaps millions of times since; for it is their mode of visualizing, if any, that still reigns in the world of painting. That mode, in the hands of genius, serves some of the highest purposes, but it affords no assistance whatever to the mediocre. These it does not, as did the Giottesque and Quattrocento traditions, draw forth, foster, and lead, enabling them to produce their best; it arms them with instruments beyond their feeble strength to wield; it furnishes them no guidance, and encourages them to seek for originality when they are only capable of anarchy.

Pl. 140 Farinati, despite much excellent work done after the pattern of Brusasorci, ended miserably, while Paolo, using the same patterns, lifted them by the force of genius into that Palace of Art where there are but few mansions, not all equal, but all great. I have spoken in Paolo
Veronese my *Venetian Painters* of Paolo's career, and here I can but refer to him briefly and in connexion with his precursors. In a sense, although he holds the relation to Brusasorci that Giotto held to Cimabue or Mantegna to Squarcione, he is not one of the very greatest artists. The lack of intellectual tradition in the school that produced him prevented his raising himself to the rarest peak of all. But taken as a whole, he was as much the greatest master of the pictorial vision as Michelangelo was of the plastic, and it may be doubted whether, as a mere painter, Paul Veronese has ever been surpassed.

XVI

Native
Milanese art We must turn back a century and more to the beginnings of the Renaissance in Milan and its dependencies. The art of painting must have had every material encouragement in a country so flourishing, abounding in opulent towns, not wanting in luxurious country gentry, and ruled by splendour-loving princes. There seem to have been painters enough and to spare, as we may infer from Giovanni da Milano's activity in Florence and Leonardo da Bisuccio's in San Giovanni a Carbonara at Naples. But the life of art must depend upon causes other than those merely economic and political, or it would not have to be said that Milan and all her lands never produced a painter

even approaching the first rank. She lacked genius, and was therefore always a dependency in matters aesthetic. In the fourteenth century her painters were provincial Giottesques; in the earlier decades of the next century they were humble, somewhat quaint followers of Pisanello; and the chronicle of Milanese painting for the remainder of that century and the first half of the Cinquecento would be brief indeed if we withdrew the names of Foppa, Bramante, and Leonardo. Foppa was a Brescian, trained in Padua; Leonardo was a Florentine, and so, in education, was Bramante. That there was a school of painting in Milan during all these years is as undeniable as that there was one during the same period in Rome; but it was scarcely more indigenous in the one place than in the other.

The most important work of the early Milanese Quattrocento still extant is the compendious cycle of frescoes in the Monza Cathedral, recounting the life of Queen Theodolinda. It is clear that they owe Pl. 138 their inspiration to Pisanello, and it is interesting to observe how their authors have left out the modelling, relaxed the line, and added to the prettiness, particularly of the faces. One is almost tempted to accuse them of deliberate purpose in making away with all that might interfere with prettiness.

What is true of these Monza frescoes holds true for the entire school of Milan. Prettiness, with its overtones of gentleness and sweetness, formed, as it were, the primordial substance of Milanese painting. Like an infinite ocean of soap-bubbles, it covered even the most salient figures with a formless iridescence, while less resisting shapes were dissolved into it as if they were dewdrops upon the shining sea.

If we stop to consider the nature and origin of prettiness, we shall Prettiness soon understand why it is a source at once of inferiority and of in art popularity in art. Prettiness is all that remains of beauty when the permanent causes of the sensation are removed. Beauty is the quality we ascribe to things visible, when we realize that they are life-enhancing. In the figure arts that quality is the offspring of a perfect harmony between tactile values (or form) and movement. It finds embodiment in such shapes, attitudes, and compositions as enable the artist, with the vision he commands, to convey his effect. By them-selves, these shapes, attitudes, and compositions are mere skins and, like skins, when removed from the bodies which grew them, they quickly wither, shrivel, and fall to dust.

The painter who lacks the capacity for tactile values and movement, in other words, the painter who has no creative talent, is reduced to imitating those who have; for in art all shapes, all attitudes, all

arrangements are in origin the outcome of the life-communicating power. Such an artist's imitation will necessarily be without form and void, for could he produce the effect of inner substance and vitality, he need not have imitated; it will have the skin of beauty without the life. Yet just as the human face at the moment when death robs it of the inspiring force and sustaining will, may, for an instant, wear its love-liest expression, so art, when smoothed out and simplified by the subtraction of vital modelling, and relaxed by the withdrawal of movement, becomes at that moment most seductive and alluring. The warmth of vitality, the life of life, that created it has not completely left it, while all that overwhelmed one, all that was as a Burning Bush, has given way to something quite within one's grasp, almost at one's mercy.

This is the moment in the decline of art when it necessarily produces prettiness (hence, by the way, the attractiveness of the first-fruits of a decline); and prettiness, being what it is, is, for the reasons already given, necessarily inferior. It is at the same time popular, because it is intelligible, even to the point of flattery.

It follows from what has been said, that prettiness can only appear when a given art movement has reached its climax, when full-blown beauty has been attained, and so consciously enjoyed as to tempt imitation of the apparent cause, the mere design or pattern. Prettiness is not easily generated by archaic art because, while art is in that condition, it is so obviously striving for the realization of form and movement that no imitation can fail to show signs of the same zeal, and therefore to partake, in no matter how feeble a degree, of its excellence. Archaic art, when aped, will result in crudity, in quaintness, in childish absurdities, but not in prettiness. When this does appear in the midst of archaic art, it may safely be considered as a survival from the last phase of finished art, as the Gothic prettiness which occasionally shows its bewitching face in the midst of all the stern endeavour of the Quattrocento.

It has been necessary to say these few words about prettiness, because the struggles it engaged in with real art take up so much of the history of painting at Milan, although more, of course, in its later than in its earlier phase.

XVII

Quattrocento painting in Milan, as we know it at least, owed its existence to Vincenzo Foppa. Although in composition and landscape

Foppa

he occasionally shows traces of Pisanellesque training, he got his serious education at Padua along with the Bellini, Mantegna, and Tura. His achievement, as represented by works that have come down to us, is less in quantity and probably also in quality than that of his fellows. Yet it may be questioned whether, putting Mantegna on one side, Foppa's native talents were inferior to Tura's or even to the Bellinis'. Had these artists suffered his exile from all sources of inspiration, had they during their more plastic period been completely deprived of stimulating rivalry, they might have stopped where he did, or even sooner—as befell Tura, in spite of his later start and his close vicinity to Padua and Venice. That Foppa's arrested development was not due to natural torpor but to the lack of incentive, may be justly inferred from the perspective and the light and space in his National Gallery 'Epiphany', which tell us that, although he was then over fifty, he was quick to learn of Bramante.

Pls. 143–4

Pl. 143

It is even possible to imagine in what direction he might have developed under favouring circumstances. He reveals, in his treatment of figures and landscape, a powerful grasp of inner substance, but, excepting in architecture when painted under Bramante's influence, a singular indifference to the precise and sharp definition of surface. As perhaps no other master of his time, he tends to soften the impact between surface and atmosphere, and his feeling for colour is in accord, for he prefers silvery, almost shimmering effects, bordering on monochrome, to the variegated tints esteemed by the adepts of utmost definition. These few words will suffice to show that Foppa's instincts were not with Mantegna or Tura, but with Giovanni Bellini. Under as favourable a start the Brescian might have attained to pictorial vision as early as the Venetian, or even earlier, for he never, like Bellini, passed through an initial phase of intense precision of outline.

What he did attain, if much less, is still considerable. With his profound sense of interior substance he could not help having a grandeur of form at times recalling Piero della Francesca; and though he lacks the poetry of space and shuns rather than courts action, his compositions are among the most impressive of his century. He is never without merit. Even his action, as we must grant while looking at his two 'St. Sebastians' at Milan, is that of a master, and in a work like his Berlin 'Deposition' of a great master. In what other treatment of this subject do we find such anticipations of Michelangelo's noblest style? Then his conceptions, like Bellini's, have a smile of tenderness in their severity. Nothing is so near in spirit to the Venetian's Madonnas

Pl. 144 as some of Foppa's—for example, the one formerly belonging to Prince Trivulzio.[1] His colour schemes, with their pervasive silvery greys and subdued greens, are the perfect vehicle for all that he attempts to convey. In Northern Italy he ranks, indeed, after Mantegna and the Bellini alone, and his influence was scarcely less, for no nook or cranny between Brescia, the Gulf of Genoa, and the crest of the Mt. Cenis escaped it.

XVIII

Butinone and Zenale We cannot linger over Butinone and Zenale, the first and elder of whom seldom rises above the quaintness and whimsicality of that attractive little imitator of Donatello and Mantegna, Gregorio Schiavone; while the younger was sufficiently skilful to be able to graft certain minor Leonardesque fruits upon the rugged Foppesque trunk. Together they painted a polyptych which still lights up with splendour the sordid market town of Treviglio, where both were born. It is, in the main, an offspring of Foppa's art, but less serious, more pleasing, and, above all, more gorgeous.

Pls. 147–8

Borgognone The most remarkable of Foppa's followers was Ambrogio Borgognone—one is tempted to say the most remarkable native painter of the whole Milanese land. It is true that his range is limited, seldom carrying him beyond the horizon of his master, and it is also true that he is not conspicuous for peculiar excellence in form or movement or space-composition. Nor is he altogether free from the feebleness of the imitator, and from the prettiness which, in his later years, was deluging his country. But he has left us one of the most restrained, most profound, and most refined expressions in art of genuine piety. Were Christian piety the real source of the pleasure that religious people take in painting, they would greatly prefer Borgognone to their actual favourites, Fra Angelico, or Francia, or Perugino. But they are attracted consciously by the sweetness of type in all these masters, and unconsciously by the charm of line and colour in Angelico, the cool, green meadows of Francia, and the space harmonies of Perugino. The Milanese is not so appealing on any of these grounds; nevertheless, besides being a rare and noble Illustrator, he was all but a great painter.

Pl. 145

As a painter, he came perhaps as near as was possible for a man firmly fixed in habits of plastic visualizing to being a Renaissance Whistler. He had Whistler's passion for harmonies of tone, and

[1] Now in the Castello Museum, Milan.

synthetized, abbreviated, symbolized drawing. Such drawing could scarcely assert itself against the plastic sturdiness of his figures in altar-pieces, nor yet (although somewhat more) when he was putting in a set landscape; but in the glimpses he gives of city streets, of stretches of canal, of rural bits, and at times in quite small figures, his taste was more free to follow its bent. He then reminds one, as no other Italian, of the exquisite American. At Nantes there is an ideal harmony in grey, blue, and black that the modern artist could not easily have surpassed.

Pl. 146

XIX

With Borgognone the Foppesque tradition in the Milanese disappeared. But, long before his death, it had put forth in Brescia, its founder's native town, a branch destined to extend it to its utmost limits, and to carry it over into the new horizons of pictorial vision, for which, from the first, it seemed so well adapted. Here, for the the present, we must leave it, until we complete our tale of Milanese painting.

We turn back to the beginning of the last quarter of the fifteenth century, when Foppa's style had not yet completely conquered the field. At that moment it received reinforcement from Bramante, who came to stay for many years in Milan. It may be questioned whether his influence upon Lombard architecture was wholly beneficent, seeing that his own forms were already so far advanced as to invite imitation and prettiness rather than solid comprehension, and thus acted there like a dissolvent, as Leonardo's art did to a much greater degree in his own domain of painting. Yet it is certain that in that domain too Bramante, though playing much less of a part, had an influence very significant and almost wholly for good. It could not be otherwise, for Foppa's problems were still his problems, while he brought to bear upon them one of the most soaring intellects of the age, developed under its most advanced and severest teaching.

Bramante

As a figure artist we must rather infer him from certain Central Italian elements in the pictures of his followers than actually know him in his own works. Although he practised sculpture, painting, and even engraving, it seems clear that it was generally in subordination to architecture, if not actually dictated by it. Yet the few paintings that remain reveal a decorator in the most serious sense of the word, with heroic types, statuesque in pose, grand in form, and magnificent in movement, closely allied in spirit and pattern to those of Piero della

Francesca and his pupils, Melozzo, Signorelli, and 'Bartolommeo della Gatta'. Bramante must, however, have painted relatively little, or his influence on this art would be much more perceptible than it is. Although it doubtless extended to Zenale and others, its main channel was Bramantino. Through him it spread in due measure over the later stretches of Milanese painting, fecundating perhaps the best elements in the art of Luini and Gaudenzio.

Bramantino

But as we might expect from one following close upon the footsteps of a master whose chief interest was another craft, Bramantino, in spite of such excellent attempts at serious treatment of form as are seen in General del Mayno's 'Christ'[1], soon sank to a formlessness meticulously devoid of substance, and a flimsiness the contemptible effects of which it takes all his fascination to dispel. Fascinating, however, he remains. In the first place, he inherited from his artistic forebears something of the poetic madness of the Umbro-Tuscans which all his native Milanese instincts for prettiness could not squander and bring to naught. At times he is positively captivating, as in the Brera fresco of the 'Madonna and Angels', or the Locarno 'Flight into Egypt'. His types retain something of Melozzo's grandeur, while anticipating much of Parmigianino's or Rosso's sensitiveness. Then, as Bramante's pupil, he had an exquisite feeling for architectural profiles, so that in truth many of his pictures would lose nothing except the massing of the general arrangement if the figures were absent. His practice of lighting as much as possible from below, and his fondness for poetical contrasts of light and shade, complete the impression of a style that is seductive for all its frequent intrinsic inferiority. If we seek for a groundwork of

Pl. 149

serious figure art in such works as the Layard 'Adoration of the Magi' (now in the London National Gallery), or the already mentioned 'Flight', we meet with disappointment; but they have something irresistibly winning—like the airs in Berlioz's *Enfance du Christ*.

XX

The rest of Renaissance painting in the Milanese is grouped around

The School of Leonardo

the artist who so determined its character and shaped its course that it has ever since been known as his school—the school of Leonardo da Vinci—while its finest products have commonly passed for his own.

When towards 1485 that most gifted of Florentines settled in Milan, he was little over thirty; and, although he had behind him his 'Epiphany', the least quaint and most intellectual design produced in

[1] Now in the Rohoncz Castle Collection, Thyssen Bequest, Lugano.

the Christian world up to that date, although he had already passed out of the region Mantegna held as his demesne and beyond the tasks its dwellers had set themselves, he had not yet reached his full growth. He still clung to many of the mere *impedimenta* handed on to him by Verrocchio; he still had to find his way to perfect freedom. It will scarcely be maintained that the road thither lay through the streets of Milan, and it may be questioned whether Leonardo would have found it at all if he had not returned to Florence. One even wonders whether, if he had never left his own city, he would not have attained to a much greater emancipation of his real self, and attained it much sooner; and one may well deplore that he was so long exiled from the focus of the arts, to its loss, to his own loss, and to the loss of beauty for ever. Imagine what might have been if he had had for pupils, or at least for followers, Michelangelo and Andrea del Sarto, instead of Ambrogio da Predis and Boltraffio! But he passed his best years in Lombardy, perhaps not unaffected by the pervasive passion for prettiness. Even a Leonardo was scarcely the better for having to paint the court beauties of that subtle sensualist, Ludovico il Moro. As the reward for every-thing is more of the same thing, these clients probably increased their demands with every revelation the mighty genius condescended to make of a loveliness hitherto perceived passionately but vaguely. Leonardo was thus, despite himself, an accomplice in chief in the conspiracy for prettiness; for if his sovereign art could illumine with beauty even the prettiest woman, this was quite beyond the reach of ordinary men, his scholars. Considerations of this kind may perhaps account for Leonardo's almost too great attention to the head, and for his carrying facial expression perilously close to the brink of the endurable: they may also account for the fact that never, during his long residence in Milan, did he find a full opportunity for exercising his highest gift, his mastery over movement.

If Leonardo was not the better for Milan, it may be maintained that neither was Milan the better for Leonardo. In the face of the pro-ductions of Predis, Boltraffio, Cesare da Sesto, Gianpietrino, Solario, Oggiono, Luini, Sodoma, and others, it may sound paradoxical to doubt that Leonardo's long abode was clear gain for the school. But most of these productions are of small intrinsic value. The only serious interest attached to them is that they record ideas of the master's; their chief attraction is that they record these ideas in terms so easy to grasp and remember that, like mnemonic jingles, they flatter the most commonplace minds. Take away Leonardo's share in these composi-tions, and you have taken away nearly all that gave them worth. We

The influence of Leonardo

Pls. 150–60

are grateful to these Lombards for preserving designs of the Florentine only as we are to disciples who have preserved sayings of Sages too absorbed or too indifferent to record them with their own hands. It is possible, however, that these Milanese painters, if left to their natural development, would have been capable of an utterance of their own not altogether without import. Perhaps if the great Etrurian lord had not reduced them to slave amanuenses, these secondary artists, stimulated by germane Venetian influences, would have developed out of Foppa's tradition a school of painting like the Brescian, but of wider range and longer breath; and it is not inconceivable that it would have culminated in an artist more like Veronese than like Luini.

Notoriously enslaving are minds more developed and ideas more advanced than one's own. The only conditions upon which they may do us good, forming better habits and teaching better methods, are patient submission and well-nigh endless imitation. But while we remain in this probationary stage, to the extent that we succeed in becoming copies of someone else, we are more interesting morally than aesthetically. Nor is it otherwise in the arts. The temporary effect of contact between the man who has solved most of the problems of his profession and the one who has solved only a few, is to make the latter throw up his problems altogether and abandon himself to imitating what he can—the obvious. In the domain of the figure arts, the obvious appears as shape, as silhouette, as smile. These are copied to the best of the imitator's ability, until the day when he understands just what, in terms of art, they mean: and that day frequently fails to dawn.

XXI

Leonardo's early followers

Leonardo's first effect on Milan was slight. Except in the most superficial way, it was felt solely by his few assistants and pupils. It may have been that he painted only for the Court and its connexions, and remained almost unknown to others; or that the local craftsmen were not ready to value his merits. For his first stay of fifteen years or more, if he had never come back, would have left relatively faint traces. It was only upon his return after a long absence that he exerted his prodigious, perchance disastrous influence. There had been time for the enthusiasm of his rare adherents, backed up by reports of his instantaneous triumph in Florence, to draw the attention of their companions to his greatness, and to bring all the young to his feet.

Leonardo's earlier followers at Milan were not only fewer in

number than his later ones, but less enslaved. They had known other masters, and had already formed habits that were hard to get over. Furthermore, he himself was still seeking, and although he was so close to perfection, he had not yet attained it. There was thus no finished product to entice them. If they imitated him at all, they had also to imitate something of his endeavour, and their work was necessarily the more vital for it. He was, for instance, constantly striving for that subtler and subtler intensification of modelling by means of light and shade which he finally attained in his 'Mona Lisa'; and some serious reflection of this striving is found occasionally in Predis and Boltraffio, but almost never in the younger generation, despite their showy high finish. It was no doubt due to this more intimate acquaintance with Leonardo's methods that Predis was able to execute a copy like his National Gallery 'Virgin of the Rocks', so much closer to the original than any copies of the 'Last Supper' made by the more glib imitators of the younger generation.

But even these early followers, who have left us so many straight-forward, dignified portraits of men, also fell into mere prettiness when they attempted to follow the master in the portrayal of charming women and peach-faced boys. Predis, the painter of the Poldi profile of Francesco Brivio, all mind and character, could sink to the gipsy prettiness of the 'Girl with Cherries' in New York; and Boltraffio, from the sturdiness of the male bust in the late Dr. Frizzoni's collection at Milan,[1] to the sugariness of the women's heads in the choir of S. Maurizio, or of effeminate lads like his youthful Saviours and St. Sebastians. Even Madonnas, probably executed on the designs of the master, and replete with his fascination, like those of the Poldi and National Gallery, Boltraffio contrives to spoil with sugar and perfume. It was unavoidable: for Leonardo's heads of women and children had a tendency to sweetness which was kept down by the exercise of his sovereign power over form, but which was bound to assert itself directly that power was lacking.

It was much worse with those pupils who came under Leonardo when, returning to Milan, too busy to teach them in earnest, employing them as executants rather than scholars, he had completely perfected his art, and created types as incapable of further intensification as are his 'Mona Lisa' and the heads in his 'Madonna with St. Anne'. Every attempt to reproduce them was bound, except in the hands of another Leonardo, to end in mere prettiness. And this perhaps wholly accidental result was unhappily only too welcome:

Predis
Pl. 150
Boltraffio

Pls. 151, VII

[1] Now in the collection of Conte Contini Bonacossi, Florence.

once revealed it was bound to increase. By its own momentum, as it were, it would tend to greater and greater sweetness. It would absorb all interest, and end in sickliness, affectation, or sheer vulgarity, as so frequently it did in Gianpietrino, Cesare da Sesto, and Sodoma.

We Europeans, even when not aware of it, hold to our own individuality, and can never be content with merely copying our masters, however great they may be. Accordingly, when once the form has dropped out of a beautiful and significant face, how will the secondary artist assert his own individuality if not by making the face prettier and more expressive than the one he is imitating? Not only is there no other course, but this one is popular and remunerative. Yet that way lies Avernus, from which, proverbially, the return is not easy.

Prettiness in art But why, one may ask, are prettiness and expression not sources of artistic enjoyment? The answer is that mere prettiness appeals, not to those ideated sensations which are art's real province, but directly to the head, to the heart, and to less noble parts of us; and appeals as actuality, not as art. The admirers of a pretty woman in a picture regard her with Stendhal's eyes as the promise of the same face in real life—it cannot be otherwise, since living prettiness is so overwhelmingly attractive. Prettiness is thus little more than a pictograph, and is scarcely an art quality at all, seeing that the figure arts have for their materials the only elements that in vision can cause direct life enhancement—form, movement, space, and colour—and of these prettiness is practically independent.

Expression is the twin sister of prettiness. Of course I do not refer to the unconscious mirroring in the face of the entire body's action. That is permissible, and may have independent quality as Illustration, although the greater the art the more careful is it not to let this quality get out of hand. But I mean the expression which in actual life we connect with the emotions, and which is reproduced for the value it has there. In art it can have little or no intrinsic merit, for all such merit accrues from tactile values and from action and their harmonies, while the muscles concerned with the subtle facial transformations required for emotional expression have little if any systemic effect upon us, and the ideation of their play can have but the faintest direct life-communicating power.

Besides these specifically artistic reasons, there is at least one other, of a more general but important order, against emotional expression in art. It is this. Directly expression surpasses its visible cause—the action manifested by the figures—we are inevitably led to seek for the cause of it in sources beyond and outside the work of art. The aesthetic

moment—that too brief but most exquisite ecstasy when we and the work of art are one—is prevented from arriving; for the object of vision, instead of absorbing our entire attention as if it were a complete universe, and permitting us to enjoy the feeling of oneness with it, drives us back on curiosity and afield for information, setting up within us a host of mental activities hostile to the pure enjoyment of art.

And if all this be true of figures and whole compositions, it is much more true of single heads. In the best art the head alone is but a limited vehicle for expression, and great art has always been perfectly aware of these limitations, making a point, it would seem, of giving the face, when presented alone, its most permanent aspect. But such treatment requires genius on the part of the producer, and natural as well as cultivated appreciation on the part of his public. The ordinary craftsman must exercise such functions as he has, and, standing at the level of the masses, he produces what they crave for, pictures that communicate information and promises, instead of life and beatitude.

XXII

Enough perhaps has been said to justify my want of enthusiasm for such bewitching Leonardesque heads as the 'Belle Colombine' of Leningrad, and to prepare the reader for my estimate of Luini, Sodoma, Gaudenzio Ferrari, and Andrea Solario. Pl. 158

Luini is always gentle, sweet, and attractive. It would be easy to form out of his works a gallery of fair women, charming women, healthy yet not buxom, and all lovely, all flattering our deepest male instincts by their seeming appeal for support. In his earlier years, under the inspiration of the fancy-laden Bramantino, he tells a biblical or mythological tale with freshness and pleasing reticence. As a mere painter, too, he has, particularly in his earlier frescoes, warm harmonies of colour and a careful finish that is sometimes not too high. Luini

But he is the least intellectual of famous painters, and, for that reason, no doubt, the most boring. How tired one gets of the same ivory cheek, the same sweet smile, the same graceful shape, the same uneventfulness. Nothing ever happens! There is no movement; no hand grasps, no foot stands, no figure offers resistance. No more energy passes from one atom to another than from grain to grain in a rope of sand. Pl. 154

Luini could never have been even dimly aware that design, if it is to rise above mere orderly representation, must be based on the

possibilities of form, movement, and space. Such serious problems seem, as I have said, to have had slight interest for any of Leonardo's pupils, either because the pictures the master executed at Milan offered insufficient examples, or because the scholars lacked the intelligence to comprehend them. Certainly Marco d'Oggiono's attempts encourage the conclusion that the others did well to abstain. But the subtlety of Leonardo's modelling, at least, Luini could not resist; and as he had little substance to refine upon, he ended with such chromolithographic finish as, to name one instance out of many, in the National Gallery 'Christ among the Doctors'. His indeed was the skill to paint the lily and adorn the rose, but in serious art he was helpless. Consider the vast anarchy of his world-renowned Lugano 'Crucifixion'; every attempt at real expression ends in caricature. His frescoes at Saronno are like Perugino's late works, without their all-compensating space effects.

Sodoma, the most gifted of Leonardo's followers, is not a great artist, but at his best he half persuades us that, with severe intellectual training, he might have been one. It is possible that he lacked only education and character to become another Raphael. He obviously had as keen a sense of beauty, and he was as ready to appreciate and to attempt to appropriate the highest achievement of others—provided it was not too intellectual. But he had neither the initial training nor the steady application to master the fundamental problems, and it is significant that while he was for years in Rome and imitated Raphael, there is no trace in his numerous paintings of any acquaintance with Michelangelo.

The bulk of his work is lamentable. No form, no serious movement, and, finally, not even lovely faces or pleasant colour; and of his connexion with Leonardo no sign, unless the slapdash, unfunctional light and shade be a distorted consequence of the great master's purposeful chiaroscuro.

Gaudenzio seems to have been less than his fellows under the direct influence of Leonardo or his works. He was by temperament an energetic mountaineer, with a certain coarse strength and forcefulness. His earliest paintings, the Scenes from the Passion at Varallo, are provincial but pretty miniatures on a large scale. Prettiness gained on him at Milan, but never quite conquered a certain crude sense for reality, which, when it reasserted itself, permitted him to produce works with a curious breath of Rubens about them, like his frescoes at Vercelli.

Solario was by training almost as much a Venetian as a Leonardesque Milanese. His magnificent National Gallery 'Portrait of a

Pl. 153

Sodoma

Pl.s 155–6

Gaudenzio
Ferrari

Pl. 157

Solario
Pl. 159

Senator' recalls Antonello, Alvise Vivarini, and Gentile Bellini; and even his Louvre 'Cardinal d'Amboise' is more Venetian than Milanese. But the bulk of his work is only too obviously Lombard. Yet, for all his high porcelain finish, for all his prettiness, for all his too long sustained smile, he is neither so lifeless nor so stereotyped as Luini. It is harder to forget a youthful delight in his Louvre 'Vierge au Coussin Vert' than to renounce almost any other early enthusiasm for paintings of this school. How they enhanced one's dream of fair women, all these painters so distasteful now; how they guided desire and flattered hope! Youth still looks at them with the same eyes, and from their Elysian seats they smile down upon me with the words: 'It is for the Young that we worked—what do you here?'[1]

Pl. 160

XXIII

Before turning east to Brescia, where, as I have already said, Foppa's tradition found its final development, we must glance for an instant westwards. It has been remarked before that this master's influence made itself felt to the shores of the Mediterranean, and to the crests of the Mt. Cenis. But as it passed over Piedmont, it encountered the last waves of Franco-Flemish tradition, and drove them back, not, however, without losing part of its own Italian character and itself acquiring something of the Northern. To the historian, this encounter and mingling of art forms, and all that it implies in the state of mind of the artist, should constitute an important and even delightful field of study. But we must content ourselves with a word regarding the completest product of this movement, Defendente Ferrari.

The School of Piedmont

Were we to treat him as a serious artist, the fourth rank might be too high for him, for he has none of the qualities essential to the figure arts. But he disarms criticism by naïvely abandoning all claims to them, and he even inveigles us, for the twinkling of an eye, into disregarding their existence. He gives us pleasant flat patterns with pleasant flat colour, put on like enamel or lacquer, sometimes with jewel-like brilliance. Into these bright arabesques he weaves the outlines of pious, quasi-Flemish Madonnas, and occasionally the clean-cut profile of a donor—one of those profiles that even the humblest Lombards struck off so well. I recollect a grand triptych, gorgeous in gilt, with a Gothic canopy daintily carved, and in the midst the Blessed Virgin, the

Defendente Ferrari

Pl. 163

[1] What has just been said of Luini, Gianpietrino, and Sodoma applies equally to the two Castilian Ferrandos, one surnamed Yañez and the other de Llanos, who painted the copious reredos of Valencia Cathedral. They are at least as Milanese as Cesare da Sesto.

silhouette of a tender Flemish Madonna, with the Child caressingly held in her arms, as she floats in space with the crescent moon at her feet; and I confess that the memory of this picture fills me with a greater desire to revisit it than do many far more ambitious and even more admirable works. Defendente, living, like Crivelli, out of the current of ideas, developed, like that enchanting Venetian, although on the most modest lines, the purely decorative side of his art. In truth, painting is a term that covers many independent arts; and this little Piedmontese master practised one of them. Its relation to the great art is not unlike that of monumental brass to sculpture: and we prefer a good brass to a poor piece of sculpture.

XXIV

The School
of Brescia

Pl. 161

Foppa's real successors, those who carried to their logical conclusion his tendency to greyish silvery harmonies of colour and a plastic-pictorial vision, were his own countrymen, the Brescians. We shall not delay over Civerchio and Ferramola, for the one is too shadowy and the other too insignificant a figure, but hasten on to their pupils, Romanino and Moretto. In spite of their faults—and they are many—it is a pleasure to turn from the later Milanese, with their mere surface colour and their merely plastic light and shade, to these Brescians, less talented, perhaps, but left free to unfold their own character under the genial influences of Venice. While speaking of Foppa, we noted how much he had in common with Bellini; we observed the same feeling for inner substance, and the same inclination to let this substance melt gradually, as it were, into the circumambient atmosphere, losing nothing of its own consistency, yet not ending abruptly as if imprisoned within a razor-edged outline. His followers were naturally ready to understand all the advances made on that road by Giambellino, and perfected by his pupils, Giorgione and Titian. Consequently, in a sense, Moretto, Romanino, and their companions, whom political and social conditions submitted to the domination of Venice, were all but Venetians in their art. What distinguished them from the islanders was, in the first place, the Foppesque heritage of grey, silvery, rather sombre tone, and then that inferiority in draughtsmanship and that want of intellectual purpose always to be expected from dependants and provincials, which resulted in great inequality of output. On the other hand, they were not behind the best Venetians in a command over the imaginative moods, particularly of the solemn yet reconciling and even inspiring kind, produced by the play of light

and colour. It is this, in fact, which almost gives some few of their works a place in the world's great art.

Romanino was the older, the more facile, the cleverer, but also, for all his brilliancy, the more unrestrained and provincial, in spite of having been so much exposed to Giorgione's influence that more than one picture of his, moulded by that influence, is still attributed to Giorgione himself, or to Titian. His altar-pieces, as a rule, are too rich and fiery in tone, and his best qualities appear only in fresco. There, however, he carries one away on the wings of his wafting ease, his fresh, clean colour, his unpretentious yet frequently happy design. Delightful indeed are the sunny colonnades of the castle at Trent, where Romanino's frescoes, with much of the flimsiness, have still more of the delicious colour of gorgeous butterflies floating in the limpid spring atmosphere! Delightful, again, is it in passing along fragrant Bergamask lanes to stop and enjoy the easy grandeur and charming dignity of his paintings in the open-air shrine at Villongo!

Moretto, the fellow-pupil of Romanino, is the nearest approach to a great artist among his exact contemporaries in Northern Italy outside Venice, and even if we include Venice he is more than able to hold his own with men like Paris Bordone and Bonifazio. He has left, it is true, no such record of the all but realized Renaissance dream of life's splendour and joy as they have done with their 'Fisherman and Doge' and 'Rich Man's Feast'. His colour is not so gay, and at his worst he sinks perhaps even lower than they, but he is much more of a draughtsman and of a poet, and consequently more of a designer. Thanks to these gifts, when Moretto is at his best, his figures stand and grasp, their limbs have weight, their torsos substance; and, even when these merits are less conspicuous, we can forgive him many a shortcoming for the sake of the shimmer, the poetic gravity of his colour, shot through as it is with light and shade. He had, besides, unusual gifts of expression, and a real sense of the spiritually significant. It is therefore not surprising to find that, although he has left no such irresistible works as Bordone's and Bonifazio's two masterpieces, he has produced more truly admirable designs, more genuine portraits, and finer single heads. His 'St. Justina', now at Vienna, is one of the heroic creations of Italy, with something almost of Antique grandeur and directness. Only less remarkable in its simplicity of expression and largeness of design is the picture in the pilgrimage church of Paitone, representing the apparition of the Madonna to a peasant boy; and worthy of a place beside it is the fresco at Brescia, wherein we see an ancient hermit

Girolamo
Romanino

Pl. 164

Moretto

Pl. 90

Pl. 166

Pl. 165

Pl. 168

Moroni

Pl. 171

Pls. 169–70

beholding the Queen of Heaven rising out of a burning bush. Wonderful as illustration is his so-called 'Elijah Waked by an Angel' (in San Giovanni Evangelista), which is really a highly poetical landscape, in the foreground of which we see two grand figures that we might easily mistake for the sleeping Centaur Chiron mounted by Victory. In quite another phase he takes a more purely mundane complexion, and in a work like the 'Christ at the Pharisee's', in S. Maria della Pietà at Venice, he anticipates, as no other, the handling of similar themes by Paolo Veronese. As for Moretto's portraits, I will mention but one, the 'Ecclesiastic' at Munich, but that one not easily outmatched: as character penetratingly perceived and frankly presented, as design simplicity itself, and as colour a perfect harmony in dark, soft, twilight greys.

Moretto had for pupil Moroni, the only mere portrait painter that Italy has ever produced. Even in later times, and in periods of miserable decline, that country, Mother of the arts, never had a son so uninventive, nay, so palsied, directly the model failed him. His altarpieces are pitiful shades or scorched copies of his master's, and the one exception proves the rule, for the 'Last Supper' at Romano is only redeemed from the stupidest mediocrity by the portrait-like treatment of some of the heads. But even with the model before him, Moroni seldom attained to his master's finest qualities as a painter; and while it is true that some of his work is distinguished with difficulty from Moretto's, it is only from the master's less happy achievements. Moroni is at once hotter and colder in colour than Moretto, totally wanting that artist's poetry of light, and seldom if ever approaching his cool, grave tones. As a draughtsman, on the other hand, he is scarcely inferior; and in his pre-eminent masterpiece, the National Gallery 'Tailor', there are form and action better than Moretto's best.

We must judge Moroni, then, as a portrait painter pure and simple; although even here his place is not with the highest. His teacher's masterpiece, the 'Ecclesiastic' we have just described, inevitably suggests Velazquez. It has design and style, and is lifted up into universal relations, bearing the honour with simplicity. Moroni gives us the sitters no doubt as they looked, with poses that either were characteristic or the ones they wished to assume. But, with the possible exception of the 'Tailor', the result is rather an anecdote than an exemplar of humanity. These people of his are too uninterestingly themselves. They find parallels not in Titian and Velazquez and Rembrandt, but in the Dutchmen of the second class. Moroni, if he were as brilliant, would remind us of Frans Hals.

XXV

Scarcely less Venetian than the Brescians were the later Ferrarese; and the ablest of them before Correggio, the only one who need occupy us here, Dosso Dossi, owed everything that gives him consideration to Giorgione and Titian. As a figure artist in any serious sense he merits no attention. His drawing is painfully slipshod, his modelling puffy and hollow; but he must have been richly endowed by nature with a feeling for poetic effects of light and colour, and he caught something of Giorgione's haunting magic. As a romantic Illustrator he has few rivals. He painted with the same ease, the same richness of tone, the same glamour, and the same drollery as his friend Ariosto wrote. There is as little inner substance in the paintings of the one as there is its literary equivalent, character, in the poems of the other, but in both the texture is too gorgeous and too fascinating to permit a sober thought. So we look spellbound at Dosso's Circes absorbed in their incantations, and are lost in the maze of his alluring lights. His landscapes evoke the morning hours of youth, and moods almost mystically rapt. The figures convey passion and mystery. His pictures may not be looked at too long or too often, but when you do come into their presence, for an enchanted moment, you will breathe the air of fairyland.

The School of Ferrara

Dossi

Pl. 172, VIII

XXVI

It is easy to trace Correggio's art back to some of its sources. To begin with, there were his earliest masters, Costa and Francia, and afterwards, at Mantua, the wealth of Mantegna's works, besides personal contact with Dosso and perhaps Caroto. Venice also cast her spell upon him, not improbably through Lotto and Palma; and finally came acquaintance, no matter how indirect, with the designs of Raphael and Michelangelo. But it is obvious that these various rivulets tapped from rolling rivers did not, by merely combining, constitute the delicious stream which we know as Correggio. The same influences doubtless spread in the same region over others without such results. He alone had genius; and he offers a rare instance of its relative independence. A Michelangelo was perhaps inevitable in Florence, a Raphael in Umbria, a Titian in Venice, but not a Correggio in the petty principalities of the Emilia. His appearance in those uninspiring surroundings was a miracle.

His time had no greater right to him than his birthplace; for by

Correggio

temperament he was a child of the French eighteenth century. As is attested by the universal enthusiasm he then inspired, it is in that seductive period that his genius would have found its friendliest environment, both as an Illustrator and as a Decorator—and few have lived in whom these two elements of art coincided more exactly.

The more one reflects upon the art of the epoch known as the Eighteenth Century, the more must one concede its distinguishing trait to have been its sensitiveness to the charm of mere Femininity. The Greeks of course felt this charm, and expressed it in many a terra-cotta figurine which still survives to delight us. Then many centuries intervened during which the charm of femininity remained unrecorded, and until the eighteenth century there was no change, except for one beam that yet sufficed to light up the whole sky. That beam was Correggio. None of his contemporaries, older or younger, expressed it, not even his closest follower, Parmigianino, in whom charm was quickly lost in elegance. Giorgione felt the beauty of womanhood, Titian its grandeur, Raphael its noble sweetness, Michelangelo its sibylline and Pythian possibilities, Paul Veronese its health and magnificence; but none of them, and no artist elsewhere in Europe for generations to come, devoted his career to communicating its charm.

Correggio's
character
Pls. 173-6
Assuming that a sensitiveness to the charm of femininity was Correggio's distinguishing trait, let us see whether it offers the key to his successes and failures as an artist. Before approaching this inquiry, we must get acquainted with his qualities and faults, in order to be able to distinguish what he could do best, what he could do less well, and what not at all. If we compare his merits and shortcomings with those of his great contemporaries, and particularly with those of Raphael, his cousin in art descent, we shall find that Correggio displays less feeling for the firmness of inner substance than any of them, even Raphael. Both these painters made a bad start in a school where form had not been a severe and intellectual pursuit; but the latter, at the right moment, underwent the training that Florence then could give, while the former had nothing sterner in the way of education than the example of Mantegna's maturer works. On the other hand, Correggio was a much finer and subtler master of movement: his contours are soft and flowing as only in the most exquisite achievements of eighteenth-century painting; his action, at the best, is unsurpassable, as in the 'Danaë', with her arm resting on the pillow and Cupid's legs clinging to the couch; in the 'Leda', with the swan's neck gliding over her bosom; in the Budapest Madonna, with the Child's arm lying over
Pl. 173 her breast; or in the 'Antiope', with her arm resting on the ground.

Yet for all his superiority, his movement seldom counts as in Raphael, and his form, inferior as it is, is even less effective than, on its merits, it should be. In both cases the fault is not specific but intellectual. Correggio lacked self-restraint and economy. Possessing a supreme command over movement, he squandered it like a prodigal, rioted with it, and sometimes almost reduced it to tricks of prestidigitation, as in his famous 'Assumption of the Virgin'. He thereby practically defeated the purpose of the figure arts, which is to enhance the vital functions by communicating ideated sensations of substance and action. To produce that effect the figure must be presented with such clearness that we shall apprehend it more easily and swiftly than in real life, with the resulting sense of heightened capacity. Now no work of art meriting attention could be less well fitted to realize this purpose than the fresco in the Parma Cathedral. Instead of quickened perception, this confused mass of limbs, draperies, and clouds, wherein we peer painfully to descry the form and movement, gives us quite as much trouble and is consequently quite as life-diminishing as a similar spectacle in reality. And as actuality it is scarcely superior to those modern round dances, where the changing groups of interlaced whirling figures leave nothing for the tired eyes of the onlooker to rest upon. How much it is a failure in economy and not in specific gift, is illustrated by the 'Ganymede' at Vienna. The Pl. 175 eye contemplates this figure with caressing delight, as it floats over the hill-tops; and yet it is nothing but the exact transfer of one of the figures from a pendentive under the 'Assumption'. Although one of the least confused parts of that whole work, and relatively well placed, this figure of a boy needed isolation—and isolation only—to become a masterpiece of imaginative design. If it be realized that many of the figures thus isolated would become equally triumphant, Correggio's reckless and fabulous extravagance may be appreciated.

This fatal facility in the presentation of movement accounts for his obvious faults, his attitudinizing and nervous restlessness, as well as for the showman's gestures that disgrace his later altar-pieces. Everybody must be doing something, even when least to the point, whether as Illustration or Decoration, although of course such a genius would finally twist pattern around to serve his master passion. A good example is the impish boy in the Parma 'Madonna with St. Jerome', Pl. 176 who is making a face as he smells the Magdalen's vase of ointment! We may go farther, and ascribe to the same cause Correggio's distaste for everything static, which almost amounts to saying for everything monumental. Obliged by the traditions of art in his day to attempt

the monumental in the architectural settings of his altar-pieces, he
created, or at least foreshadowed the Baroque. Left quite to himself,
he might very well have plunged at once into Rococo, and perhaps
ended by emancipating himself, like the Japanese, from everything
architectonic.

Such an artist obviously could not be a space-composer in any signal
sense; and indeed Correggio's name in this connexion is not to be
mentioned in the same breath with Raphael's. Correggio adds to all
the extravagance and restlessness so incompatible with space-com-
position one of the worst tendencies of his time, that of packing the
largest possible figures into a given space—witness his 'St. John the
Evangelist' at Parma, an inspired creation, with no room for the noble
head!

On the other hand, he surpassed Raphael in landscape, as he was
bound to do, with his command over most of the imaginative possi-
bilities of light; for in the domain of light and shade he was perhaps
the greatest Italian master. Some, with Leonardo as their chief, had
used it to define form; others, like Giorgione, had caught its glamour
and reproduced its magic; but Correggio loved it for its own sake.
And it rewarded his love, for it never failed to do his bidding; and,
besides what it enabled him to do for the figure, it put him above all
his contemporaries in the treatment of the out-of-doors. The Crespi
'Nativity' and the Benson 'Parting'[1] show that he was not inferior to
any in conveying the mystery, the hush, the crepuscular coolness of
earliest dawning and latest twilight; nor was he excelled by any other
in the understanding of conflicting lights—as we can see only too well
in his Dresden 'Night'; and he surpasses them all in effects of broad
daylight, such as we find in most of his mythological pieces, and in the
Parma 'Madonna with St. Jerome', rigthy surnamed the 'Day'. This
is the only picture known to me which renders to perfection the
sweeping distances, the simple sea of light evenly distributed yet alive
with subtle glimmerings through the hazes, that constitute one of the
most majestic of nature's revelations, broad noontide in Italy.

Correggio's
mastery
of light

In the figure, also, Correggio's command of light and shade, the
exquisite coolness yet sunny transparency of his shadows, discovered
new sources of beauty. He was not only among the very first—a mere
question of precedence with which art has no concern—but he remains
among the very best who have attempted to paint the surface of the
human skin. Masaccio's terra-cotta-faced people are greater than

[1] The first now in the Brera, Milan, and the second in the National Gallery,
London.

Correggio's, for it is more vital to convey a tonic sense of inner substance than to give the most admirable rendering of the surface. But the skin too has its importance; and its pearliness, its sunny iridescence, as in the 'Antiope', are a source of vivid yet refined pleasure. Without attention to all its aspects, no one could have attained to such a supreme achievement as the 'Danaë', where we watch a shiver of sensation passing over the nude like a breeze over still waters. Correggio's mastery of light explains his colour. Light is the enemy of variegated and too positive colour, and, where it gets control, it endeavours to dissolve tints into monochrome effects of tone. Hence the real masters of light have never been pretty and attractive, although for the same reason they have been great Colourists. Yet, while one would not hesitate in this respect to rank Correggio above Raphael, one must put him below Titian. His surface is too glossy, too lustrous, and too oily to give the illusion of colour as a material.

Aware of what were Correggio's gifts and what his shortcomings, I kept studying his works to find the reason of his rare successes and his frequent failures. Supposing, at one time, that the latter were caused principally by his prodigality, I yet could not account for the small pleasure I took in his altarpieces and other sacred subjects, where the relatively simple arrangements of monumental composition left little room for extravagance. It occurred to me then that these subjects imposed too great a restraint upon his passion for movement: which indeed is true, although it does not explain all their failings; and I thought that perchance in mythological and kindred themes, wherein the Renaissance painter could emancipate himself from the galling fetters of tradition hostile to his art and rejoice in the freedom of a Greek, Correggio would prove triumphant. This also turned out to be not quite, although almost, satisfactory as an explanation; and I was driven finally to conclude that among these pieces it was only those few wherein the female nude was predominant, and where the nude was treated so as to bring to the surface the whole appeal of its femininity, that his exaggeration, his nervousness, his restlessness, disappeared entirely and left only his finer qualities singing, in most melodious unison, harmonies seldom sweeter to human sense. I then understood why his sacred subjects could not please, for he had no serious interest in the male figures, and as to the female figures, the charm of femininity, mixing with the expression imposed by the religious motive, resulted in that insincerity which closely anticipates, if it be not already an embodiment of what in painting we call Jesuitism—and quite rightly, for the Jesuits always traded upon human

Correggio's
failures

weakness, and ended by marrying sensuality to Faith. I understood
also why one constantly returned to the 'Danaë', the 'Leda', the
Pls. 173–4 'Antiope', and the 'Io' as Correggio's only perfect works, and I
realized that they were perfect because in them his genius created
fully, without let or hindrance, while all his faculties were lifted to
their highest function. And they are hymns to the charm of femininity
the like of which have never been known before or since in Christian
Europe. For the eighteenth century, with all its feeling for the same
quality, either failed to bring forth the genius to express it in such
resplendent beauty, or else cooped it up in types too pretty and too
trivial. Correggio was fortunate, seeing that in his day form, which
is the alphabet of art, still spelt out mighty things.

And yet, if we may not place Correggio alongside of Raphael and
Michelangelo, Giorgione and Titian, it is not merely that on this or
that count he is inferior to them for specific artistic reasons. The cause
of his inferiority lies elsewhere, in the nature of all the highest values,
whereby everything, whether in art or in life, must be tested. He is too
sensuous, and therefore limited; and the highest human values are
derived from the perfect harmony of sense and intellect, such a har-
mony as since the most noble days of Greece has never again appeared
in perfection, not even in Giorgione or Raphael.

XXVII

My tale is told. It has been too brief to need recapitulation, and I shall
Parmigianino add but a word about Parmigianino, the last of the real Renaissance
artists in North Italy. He had too overmastering a bent for elegance
Pl. 178 to rest contented with Correggio's sensuous femininity. But this
elegance he approached with such sincerity, with such ardour, that
he attained to a genuine, if tiny, quality of his own, a refined grace, a
fragile distinction, that please in fugitive moments.

There remain no other painters of this period in Northern Italy who
deserve even passing mention here, unless indeed it be the Campi,
Pl. 177 dainty, elegant eclectics, who have left—to speak only of the best—one
of the most elaborate schemes of decoration of the entire Renaissance,
in a church near Soncino, and exquisite mythological frescoes in the
now deserted summer palace at Sabbioneta.

THE DECLINE OF ART

IN these four essays it has been my aim to sketch a theory of the arts, particularly of the figure arts, and especially of those arts as manifested in painting. I chose Italian examples, not alone because I happen to have an intimate acquaintance with the art of Italy, but also because Italy is the only country where the figure arts have passed through all the phases from the imbecile to the sublime, from the sub-barbarian to the utmost heights of intellectual beauty, and back to a condition the essential barbarism of which is but thinly disguised by the mere raiment, tarnished and tattered, of a greater age. I have already treated of what makes the visual, and, more definitely, the figure arts: to test the theory, we must see whether it explains what it is that unmakes them.

Art defined

It will not be amiss to restate this theory once more; and in brief it is this. All the arts are compounded of ideated sensations, no matter through what medium conveyed, provided they are communicated in such wise as to produce a direct effect of life-enhancement. The question then is what, in a given art, produces life-enhancement; and the answer for each art will be as different as its medium, and the kind of ideated sensations that constitute its material. In figure painting, the type of all painting, I have endeavoured to set forth that the principal if not sole sources of life-enhancement are TACTILE VALUES, MOVEMENT, and SPACE-COMPOSITION, by which I mean ideated sensations of contact, of texture, of weight, of support, of energy, and of union with one's surroundings. Let any of these sources fail, and by that much the art is diminished. Let several fail, and the art may at the best survive as an arabesque. If all be dried up, art will perish. There is, however, one source which, though not so vital to the figure arts, yet deserves more attention than I have given it. I mean COLOUR. The essay on the Venetian Painters, where colour is discussed, was written many years ago, before I had reached even my present groping conceptions of the meaning and value of things. Some day I may be able to repair this deficiency; but this is not the place for it, nor does the occasion impose it; for as colour is less essential in all that distinguishes a master painting from a Persian rug, it is also less important as a factor in the unmaking of art.

In order to avoid using stereotyped phrases, I have frequently substituted the vague objective term 'Form' for the subjective words 'Tactile Values'. Either refers to all the more static sources of life-

enhancement, such as volume, bulk, inner substance, and texture. The various communications of energy—as effective, of course, in presentations of repose as of action—are referred to under 'Movement'.

Desire for
newness

It is clear that if the highest good in the art of painting is the perfect rendering of form, movement, and space, painting could not decline while it held to this good and never yielded ground. But we Europeans, much more than other races, are so constituted that we cannot stand still. The mountain-top once reached, we halt but to take breath, and scarcely looking at the kingdoms of the earth spread at our feet, we rush on headlong, seldom knowing whither, until we find ourselves perchance in the marsh and quagmire at the bottom. We care more for the exercise of our functions than for the result, more therefore for action than for contemplation. And the exercise of our functions, among those of our race who are the most gifted, rarely if ever dallies with the already achieved, but is mad for newness. Then too we care vastly more for the assertion of our individuality than for perfection. In our secret hearts we instinctively prefer our own and the new to the good and the beautiful. We are thus perpetually changing: and our art cycles, compared to those of Egypt or China, are of short duration, not three centuries at the longest; and our genius is as frequently destructive as constructive.

Nature of
genius

Utilitarian prejudice misleads us concerning the true nature of genius, which word we almost invariably restrict to those human forces which are highly beneficial. Defining genius thus, we naturally fail to discover it in periods of decline, and we wonder vacuously how ages can pass without producing it. Now, while there may well be considerable differences in the human crop from generation to generation, and age to age, there seems to be no reason for assuming that these differences can be great enough to exclude genius—unless indeed there occurs some actual race decay such as manifested itself among the Mediterranean stocks in our fourth and fifth centuries. Even in those humiliating periods, when the shrivelled crone of an Ancient World, growing more and more benumbed, retained but the bare strength for keeping body and soul together, genius was not totally extinct, although narrowed down to the more menial tasks of soldiering, governing, persuading, and exhorting. But Italy, after Raphael and Michelangelo, Correggio, Titian, and Veronese, was by no means in such straits. The race remained not only vigorous but expansive, and was then only beginning to exert, through countless self-appointed emissaries, its fullest influence upon European culture. It was displaying abundant genius in other fields, even in the arts, if we consider

music, and it would be singular if it produced none with the highest aptitudes for figure painting.

If, however, we define genius as the capacity for productive reaction against one's training, we shall not be obliged to deny it to whole professions in ages that are otherwise healthy and brilliant; we shall learn to regard it as given almost as much to destruction as to construction; we shall explain its self-assertiveness, and understand the instinctive sympathy and imitation it inspires, even when it seems to be most baneful in its effects.

Imagine Michelangelo, Raphael, and Correggio followed by artists who could have as effectively reacted against them as they did against their masters, Ghirlandaio, Timoteo Viti, and Costa. When you bear in mind that each of them, before he died, introduced a peculiar mannerism—that Michelangelo lived long enough to be distinguished with difficulty from Marcello Venusti, and that perhaps a premature death alone saved Raphael from sinking to a less brutal Giulio Romano—it is not hard to conceive that a genius with the Florentine's fury, but succeeding him, might have whirled his hammer through the accepted moulds of form, and finished closer to Courbet and Manet than to their distant precursor Caravaggio; that another with the Umbrian's sweetness and space might have become a more admirable Domenichino and that a third with Correggio's gift for the rendering of femininity might have combined the best elements in Fragonard, Nattier, and Boucher. Each would remain a person of note, and historically interesting, but none, in spite of undeniable genius, would occupy a throne in the most sacred precincts of the Palace of Art.

Course of genius

Thus the relatively diminished power of reaction displayed by the most vigorous of the Mannerists and Eclectics, Realists and Tenebrists, who succeeded the classic masters, was due most probably not merely to a lack of energy, but to their energy being misdirected, scattered, and otherwise ill-spent. It is not unlikely that the sheer talent manifested by the Caracci and Guido Reni, by Domenichino and Caravaggio, would, while the figure arts were on the ascending curve, have given them the places of Signorelli and Perugino, Pintoricchio and Uccello.

Pls. 180–3

But decline in their day was inevitable. Art form is like a rolling platform, which immensely facilitates advance in its own direction, while practically prohibiting progress in any other course. During the archaic stage of art, as I have defined it earlier in this book, no artist of talent can stray far, for archaic art is manifestly inspired by the purpose of realizing form and movement. The artist may fail to realize them

completely; he will certainly fail to realize them in proper combination, for then he would be already classical. He may exaggerate any one tendency to the extreme of caricature, as indeed the less gifted of archaic artists are apt to do. But through his presentation of form, or of movement, or of both together, he cannot fail of being in some measure life-enhancing; for these essential elements of life-enhancement are the necessary preoccupations of the archaic artist.

As a consequence of the successful striving for form and movement, shapes are produced, types created, attitudes fixed, and all raised to their highest power, in designs which, in the exact degree of their excellence, draw attention away from the means that went to make them and concentrate it admiringly upon the end achieved. The effect is then readily mistaken for the cause, and the types, shapes, attitudes, and arrangements, which have resulted from the conquest of form and movement, come to be regarded as the only possible moulds of beauty, and are canonized.

Talent readily perceives the new goal, and its progress now is hastened not only by the instinctive craving for self-assertion no matter against what, and for change no matter from what, but also by the flattering breezes of popularity. For the populace is sensually amotional, and the archaic, with its dryness, has nothing to say to it; while in an art that has reached its culmination and become classic, as I have endeavoured to explain earlier in this book when defining prettiness, certain elements invariably come to the surface which, besides appealing to the heart of the crowd and glorifying its impulses, procure it one of its darling joys, the utmost emotion at the least outlay of rational feeling.

But classic art, producing these things adventitiously and never aiming for them, speaks too softly to the emotions, is too reticent in expression and too severe in beauty to satisfy the masses. They therefore greet with applause every attempt which self-assertiveness and the mere instinct for change will inspire the younger artists to make. And this because every variation upon classic art leads necessarily through schematization and attenuation to the obvious. Once the end is mistaken for the means, it will occur to the first clever youth that, by emancipating the oval of the face from the modelling which originally produced it, he would be skimming off all that made it attractive, and would present its attractiveness unalloyed. He thus gets prettiness of oval, and to make it more interesting, the artist of the new school will not long hesitate to emphasize and force the expression. Nor will he stop there, but will proceed in like fashion with the action,

and continue with the simple process of neglecting the source of its value, Movement, and accentuating the resulting silhouettes, till they too become accurate, fully representative pictographs. Having got so far, he will then be borne one stage farther along the rolling platform of art-reaction, and will attempt to combine these pictographs, not of course in designs based on the requirements of form and movement, but in arrangements that will be most obviously pretty and eloquent. But that time, without realizing whither his applauded progress— which is really no more than blind energy—was taking him, he will have got rid of form and movement; he will have thrown art out of the door, and, unlike nature, art will not come back through the window.

In art, as in all matters of the spirit, ten years are the utmost rarely reached limits of a generation. The new generation follows hard on the heels of the old. Its instincts for change and self-assertion, far from being the same, are naturally opposed, and the newcomers, looking coolly at the achievements of their immediate precursors, end with a feeling of vague but extreme dissatisfaction. Just what is wrong they cannot tell, for their teachers, unlike those in archaic schools, have not directed their attention to form and movement; and their own increased facility and pleasure in mere representation and execution, instead of helping them, lead them astray. They feel the groping need of a return to the classics; but on the one hand they seldom have the energy to wrench themselves wholly free from the domination of the authorities still in power, and on the other they have lost the key, forgotten the grammar, and do not know what it is in the classics to which they should return. One thinks it is the colour, or the chiaroscuro; another the shapes; another the attitudes; and yet another the invention or symmetrical arrangement. Finally one, abler than the rest, must and does arise, who persuades himself and others that, by combining all these elements, great art will return.

The Mannerists, Tibaldi, Zuccaro, Fontana, thus quickly give place to the Eclectics, the Caracci, Guido, and Domenichino. Although counting many a painter of incontestable talent, and some few who, in more favouring circumstances, might have attained to greatness, yet taken as a school, the latter are as worthless as the former, understanding as little as they that art will only return with form and movement and that, without them, it is mere pattern. No amount of rearrangement will infuse life. Vitality will reappear only when artists recognize that the types, shapes, attitudes, and arrangements produced in the course of evolution are no more to be used again than spent

cartridges, and that the only hope of resurrection lies in the disappearance of that facility which is in essence an enslaving habit of visualizing conventionally and of executing by rote. Then artists shall again attain tactile values and movement by observing the corporeal significance of objects and not their ready-made aspects, which were all that the Realists like Caravaggio cared about. This has not yet taken place in Italy, and consequently, although in the last three and a half centuries she has brought forth thousands of clever and even delightful painters, she has failed to produce a single great artist.

THE PLATES

I. VENETIAN PAINTERS

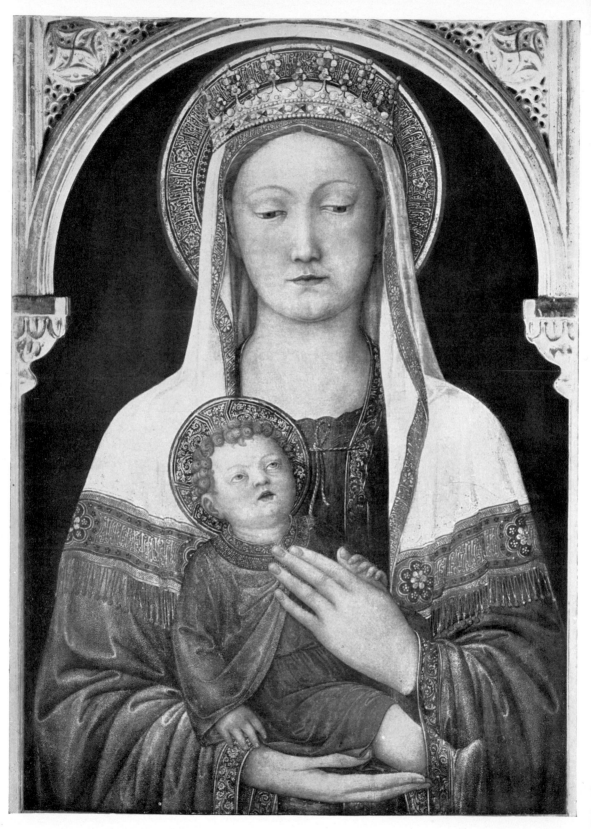

1. JACOPO BELLINI: *Madonna and Child*. Uffizi, Florence

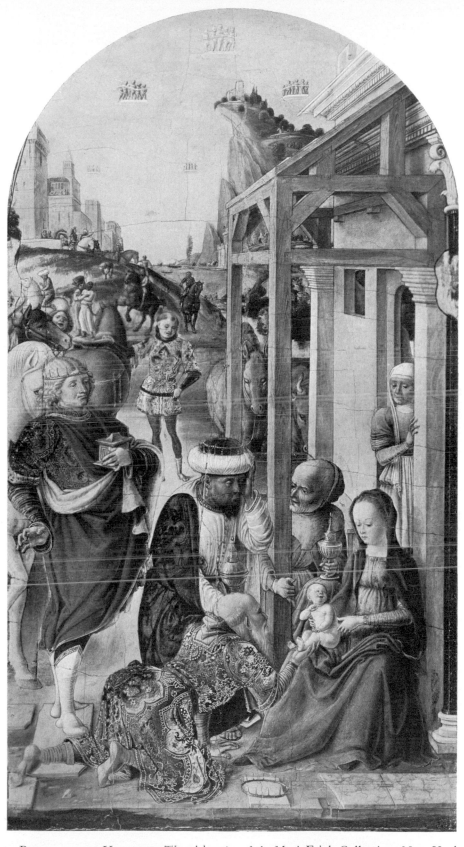

2. BARTOLOMMEO VIVARINI: *The Adoration of the Magi*. Frick Collection, New York

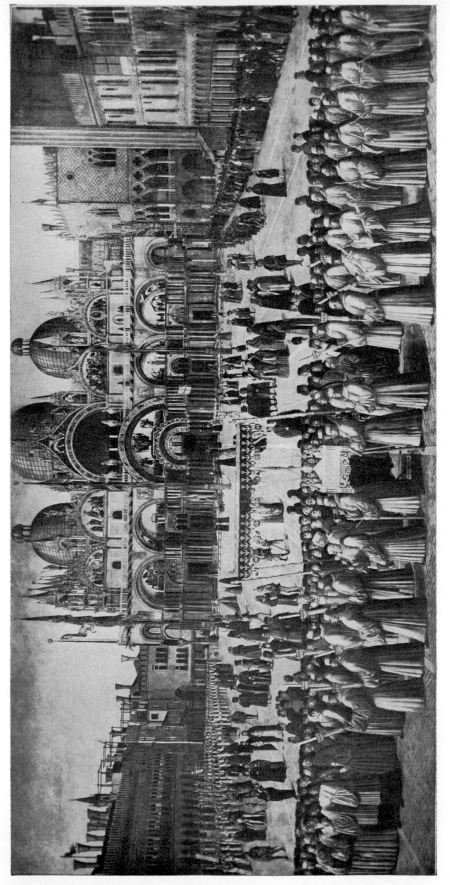

3. GENTILE BELLINI: *Procession in Piazza S. Marco*. Academy, Venice

5. GENTILE BELLINI: *Detail from 'Saint Mark preaching'*. Brera, Milan

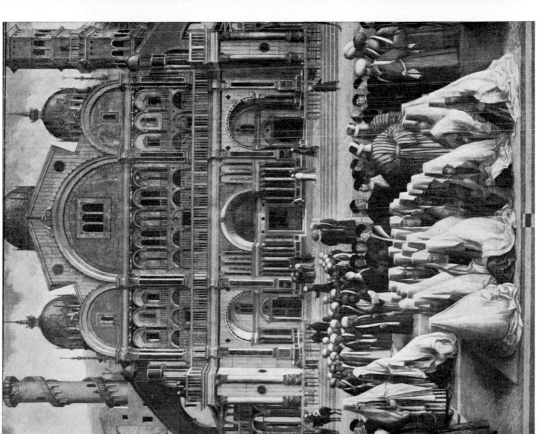

4. GENTILE BELLINI: *Detail from 'Saint Mark preaching'*. Brera, Milan

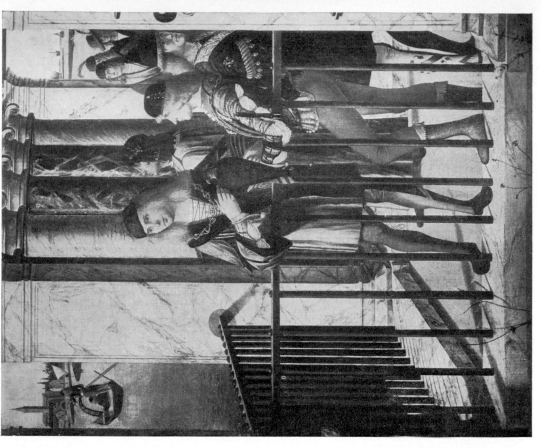

7. Vittore Carpaccio: *Detail from the 'Story of Saint Ursula'.*
Academy, Venice

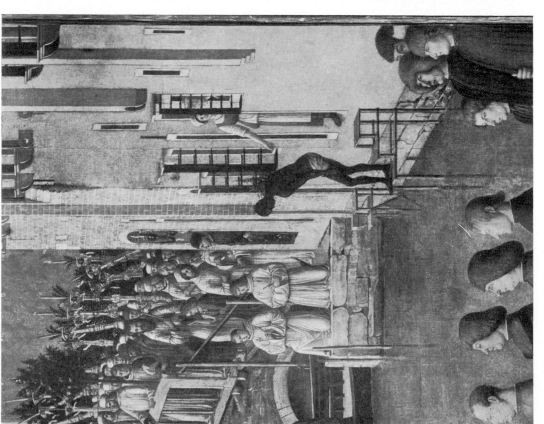

6. Gentile Bellini: *Detail from the 'Miracle of the Cross'.*
Academy, Venice

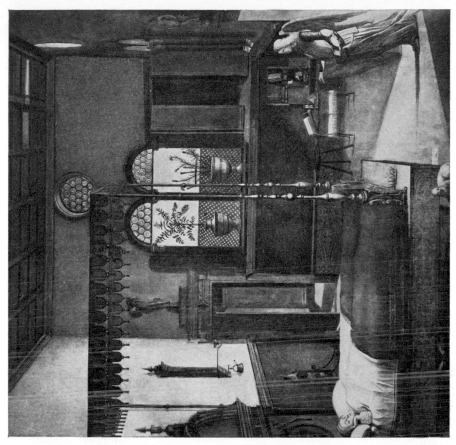

9. VITTORE CARPACCIO: *Saint Ursula's Dream.*
Academy, Venice

8. VITTORE CARPACCIO: *Detail from the 'Story of Saint Ursula'.*
Academy, Venice

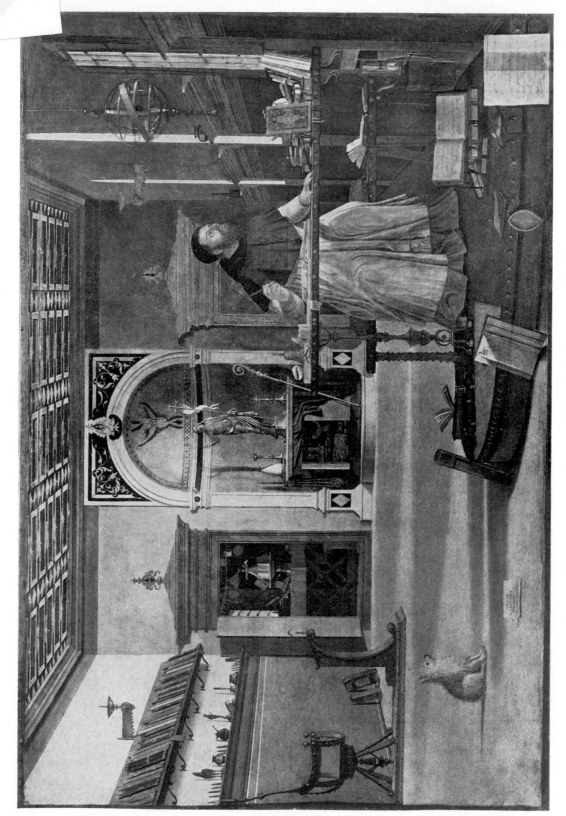

10. Vittore Carpaccio: *Saint Jerome in his Study*. S. Giorgio degli Schiavoni, Venice

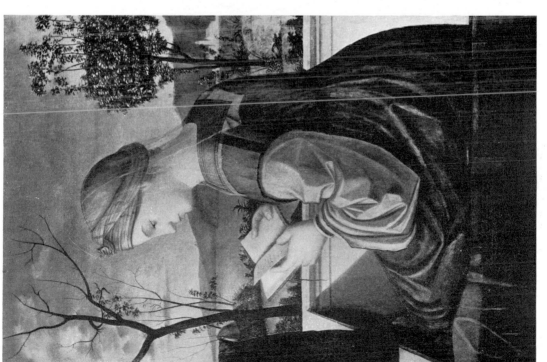

12. CARLO CRIVELLI: *Madonna and Child.*
National Gallery of Art, Washington (Kress Collection)

11. VITTORE CARPACCIO: *A Saint reading.*
National Gallery of Art, Washington (Kress Collection)

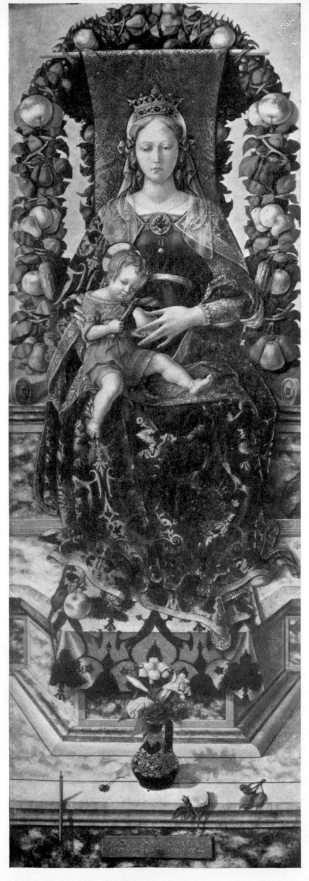

· 13 · Carlo Crivelli: *Madonna and Child enthroned*. Brera, Milan

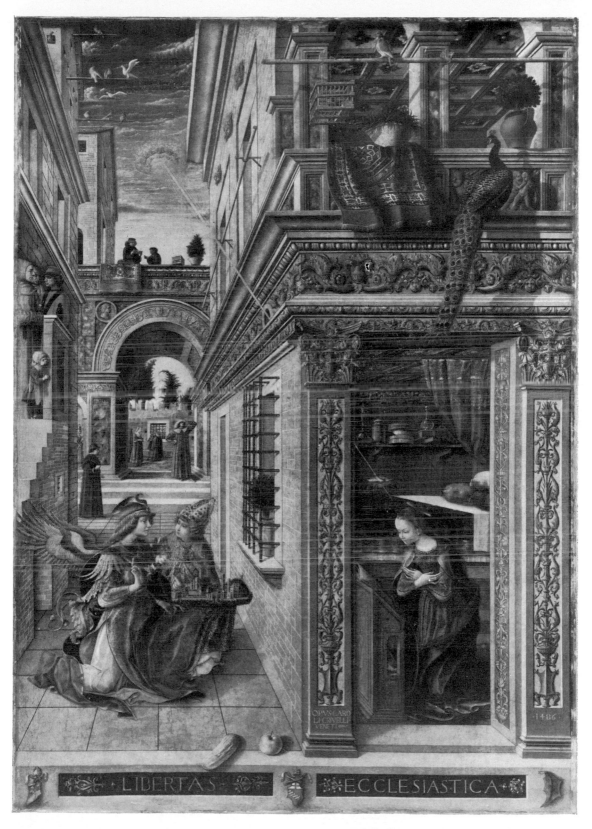

14. CARLO CRIVELLI: *The Annunciation*. National Gallery, London

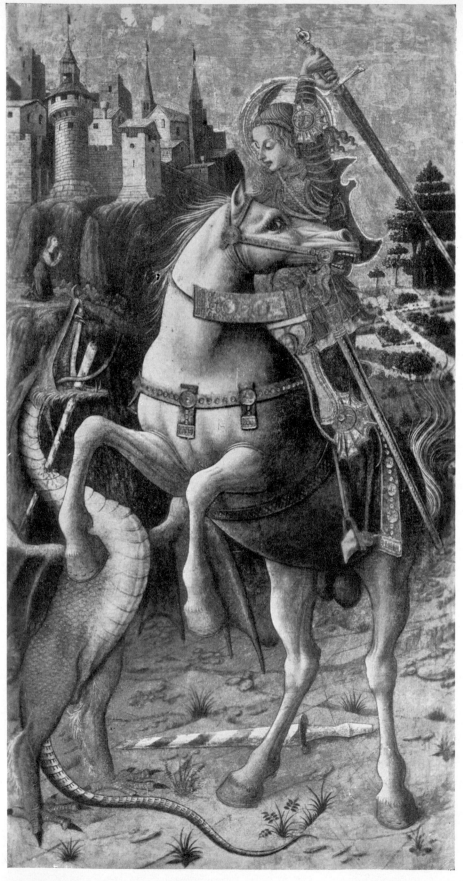

15. Carlo Crivelli: *Saint George and the Dragon*. Isabella Stewart Gardner Museum, Boston

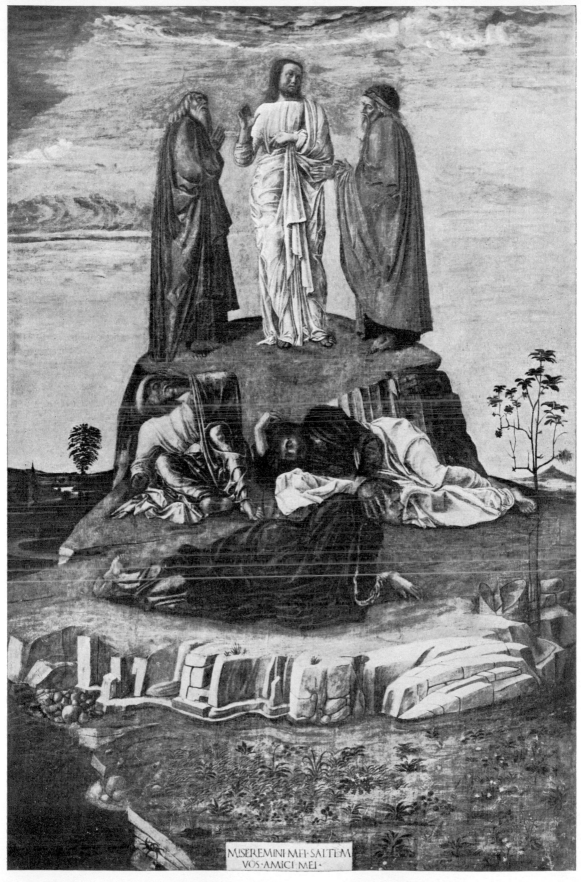

MISEREMINI MEI SALTEM
VOS AMICI MEI

16. GIOVANNI BELLINI: *The Transfiguration*. Museo Correr, Venice

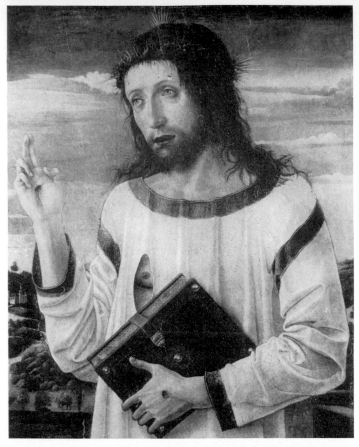

17. GIOVANNI BELLINI: *The suffering Christ*. Louvre, Paris

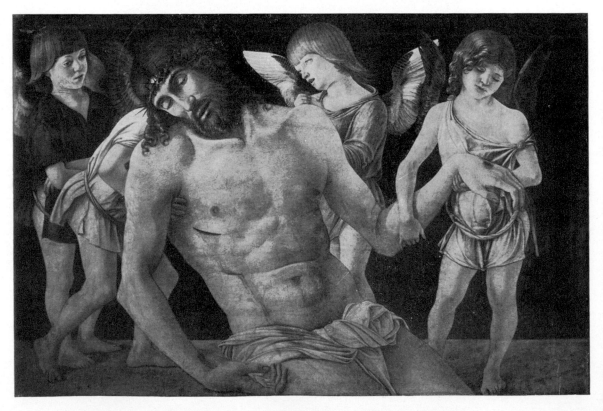

18. GIOVANNI BELLINI: *Pietà*. Palazzo Comunale, Rimini

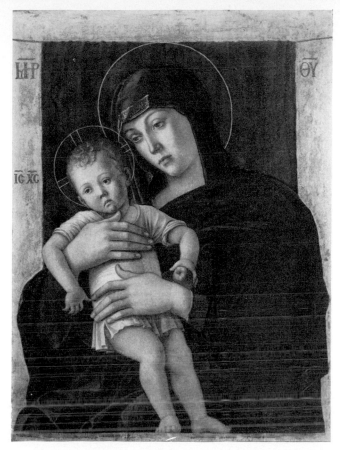

19. GIOVANNI BELLINI: *Madonna and Child*. Brera, Milan

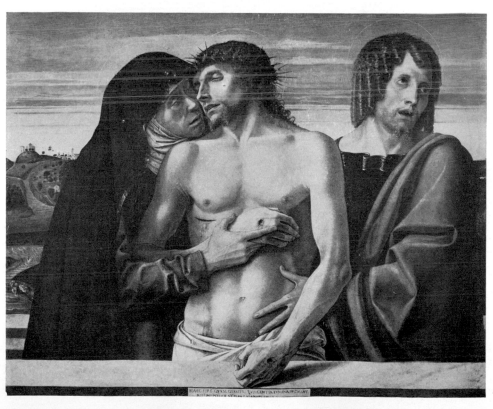

20. GIOVANNI BELLINI: *Pietà*. Brera, Milan

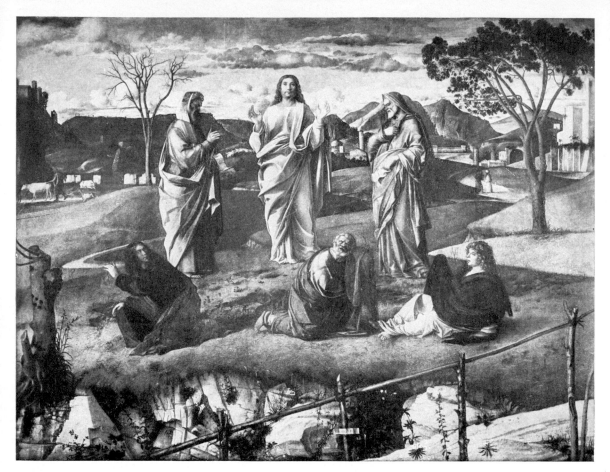

21. GIOVANNI BELLINI: *The Transfiguration*. Pinacoteca, Naples

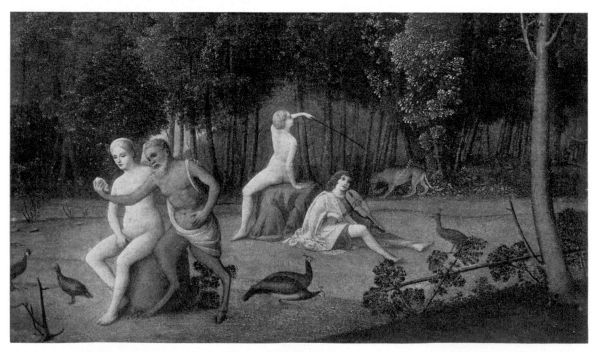

22. GIOVANNI BELLINI: *Orpheus*. National Gallery of Art, Washington (Widener Collection)

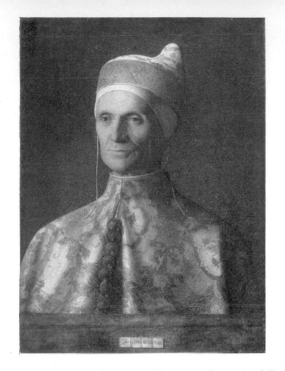
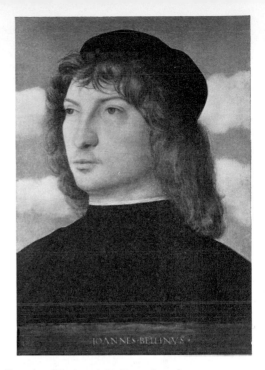

23. GIOVANNI BELLINI: *Portrait of Doge Loredan*. National Gallery, London

24. GIOVANNI BELLINI: *Portrait of a Venetian Gentleman*. National Gallery of Art, Washington
(Kress Collection)

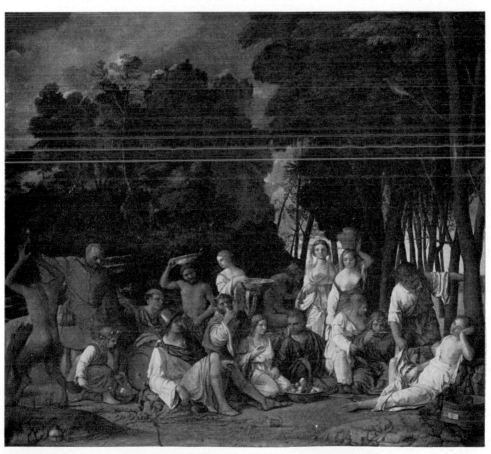

25. GIOVANNI BELLINI: *The Feast of the Gods*. National Gallery of Art, Washington
(Widener Collection)

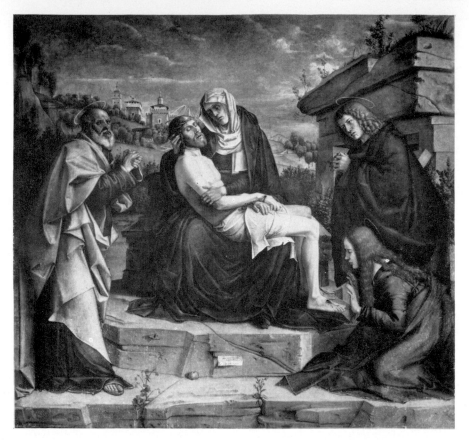

26. BARTOLOMMEO MONTAGNA: *Pietà*. Monte Berico, Vicenza

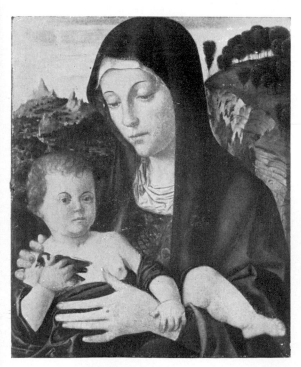

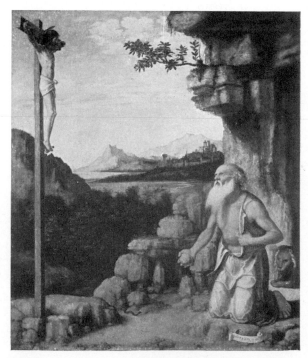

27. BARTOLOMMEO MONTAGNA: *Madonna and Child*. Ashmolean Museum, Oxford

28. CIMA DA CONEGLIANO: *Saint Jerome in the Wilderness*. National Gallery of Art, Washington
(Kress Collection)

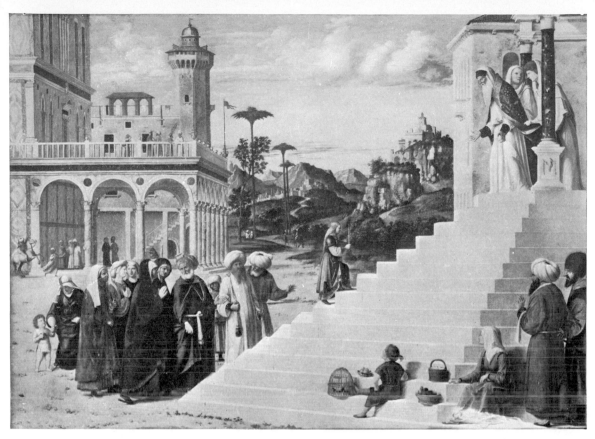

29. CIMA DA CONEGLIANO: *The Presentation of the Virgin*. Gallery, Dresden

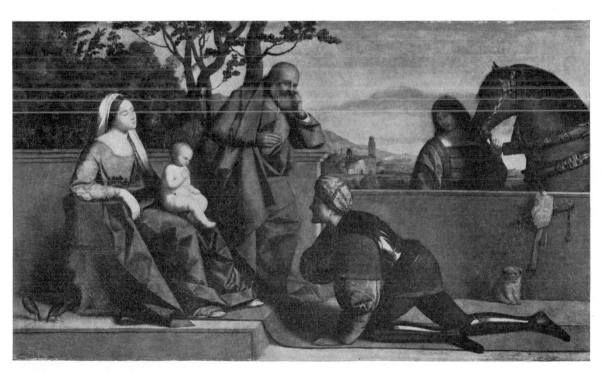

30. VINCENZO CATENA: *Madonna and Child with kneeling knight*. National Gallery, London

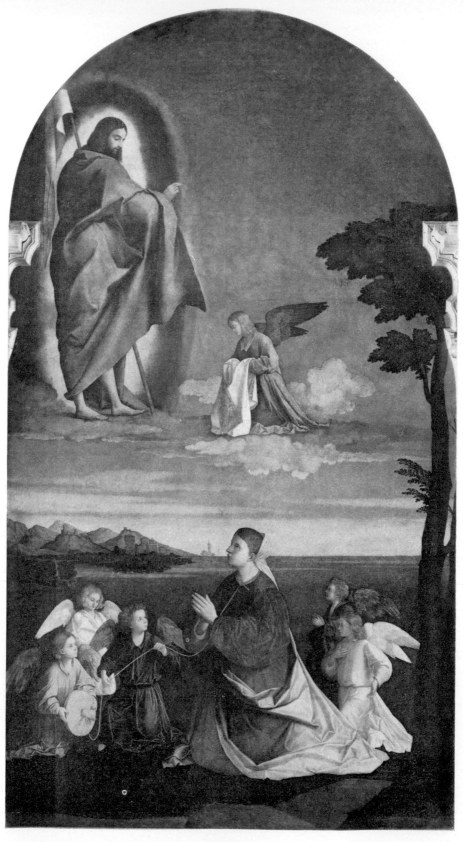

31. VINCENZO CATENA: *Christ appearing to Saint Christina.*
Santa Maria Mater Domini, Venice

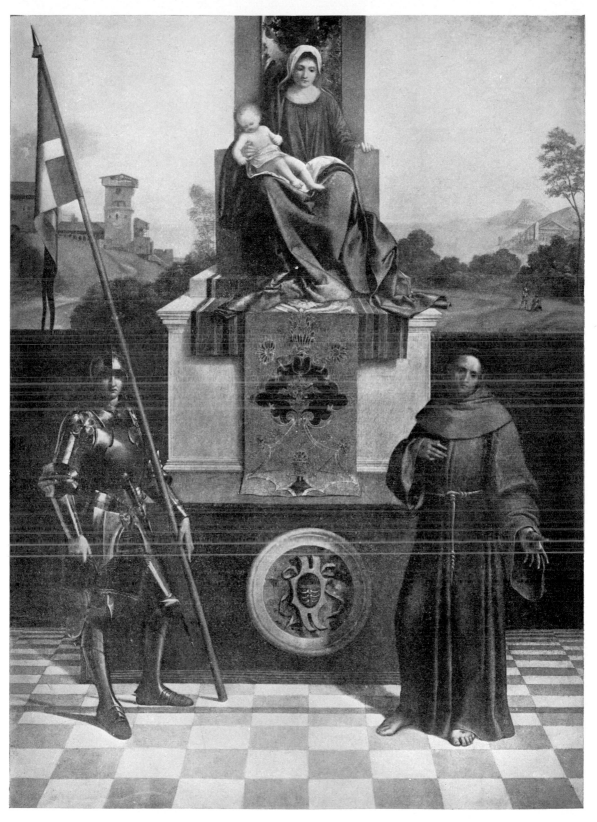

32. GIORGIONE: *Madonna and Child with Saints*. San Liberale, Castelfranco

34. GIORGIONE: *Detail from the Castelfranco Madonna* (Plate 32)

33. GIORGIONE: *Detail from the Castelfranco Madonna* (Plate 32)

36. GIORGIONE: *The Trial of Moses*. Uffizi, Florence

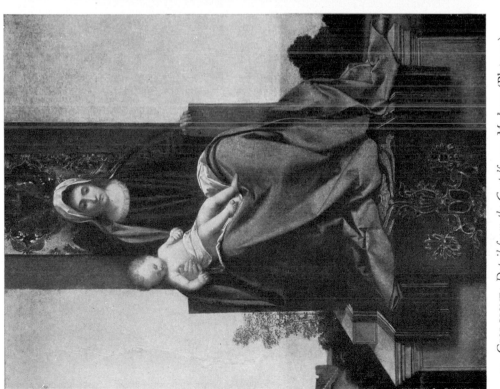

35. GIORGIONE: *Detail from the Castelfranco Madonna* (Plate 32)

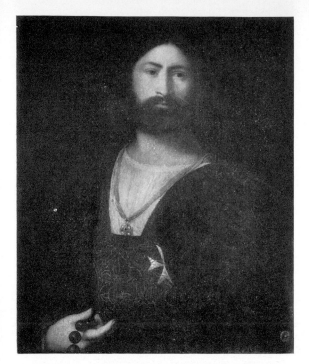

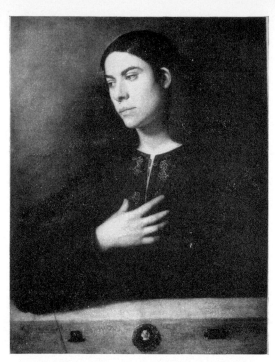

37. GIORGIONE: *Portrait of a Man*. Uffizi, Florence 38. GIORGIONE: *Portrait of a Man*. Gallery, Budapest

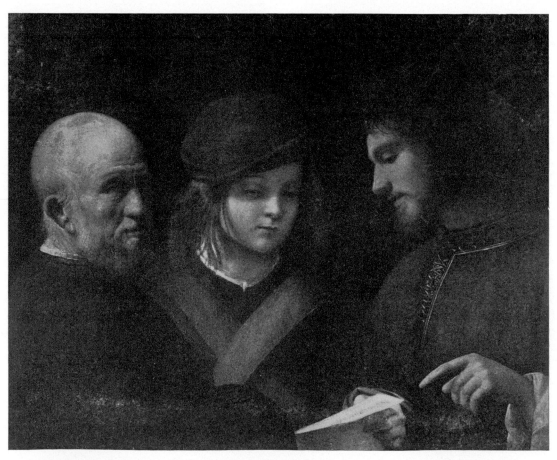

39. Master of the Three Ages (early Giorgione?): *The Three Ages*. Pitti Palace, Florence

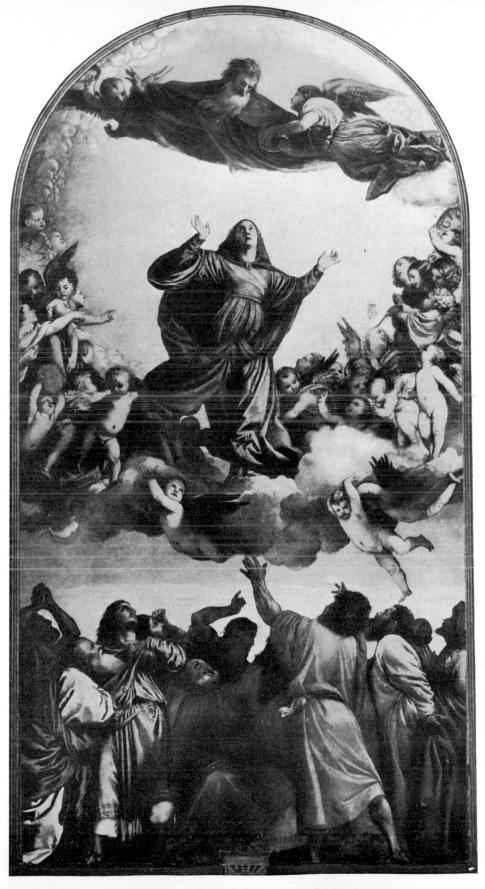

40. TITIAN: *The Assumption*. Santa Maria dei Frari, Venice

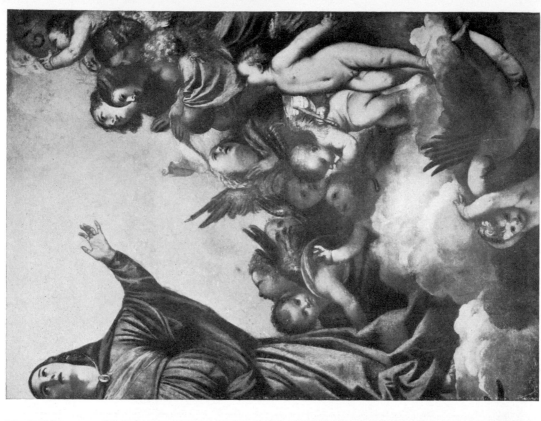

42. TITIAN: *Detail from the 'Assumption'* (Plate 40)

41. TITIAN: *Detail from the 'Assumption'* (Plate 40)

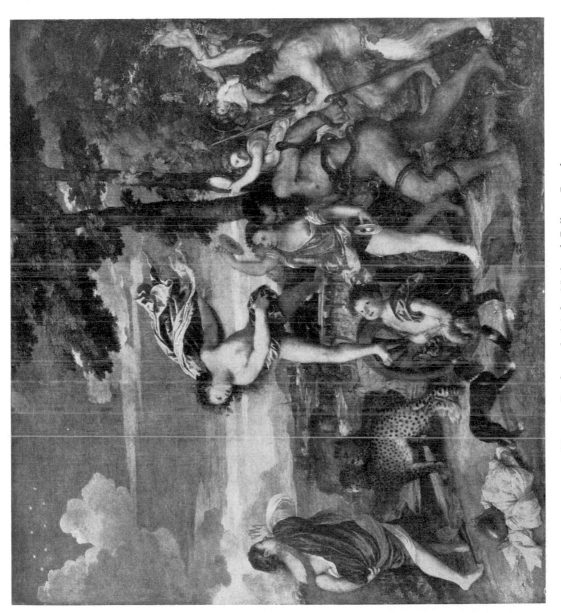

43. TITIAN: *Bacchus and Ariadne*. National Gallery, London

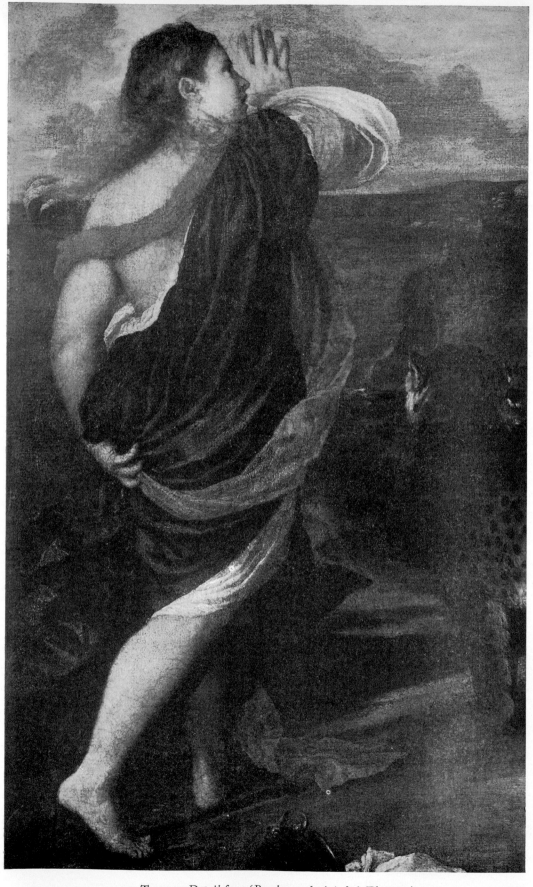

44. TITIAN: *Detail from 'Bacchus and Ariadne'* (Plate 43)

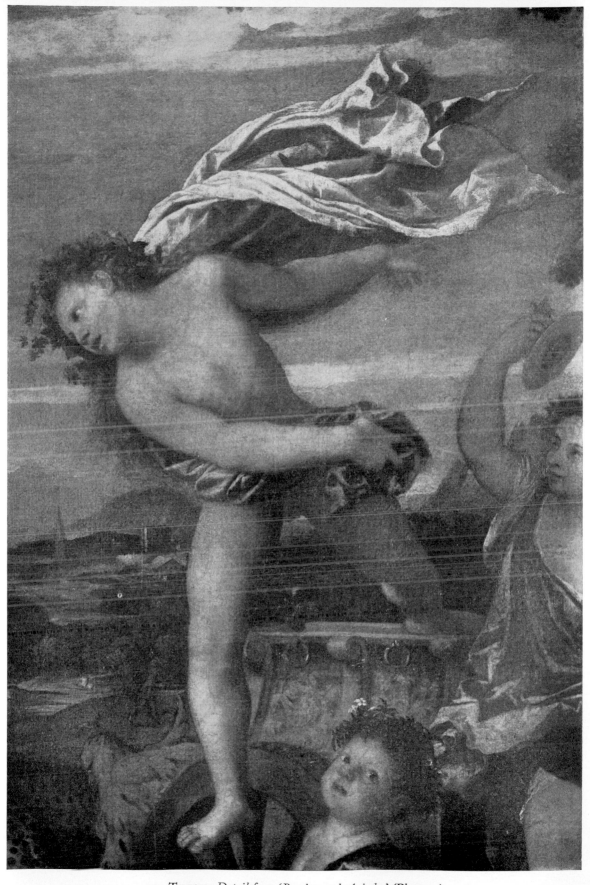

45. TITIAN: *Detail from 'Bacchus and Ariadne'* (Plate 43)

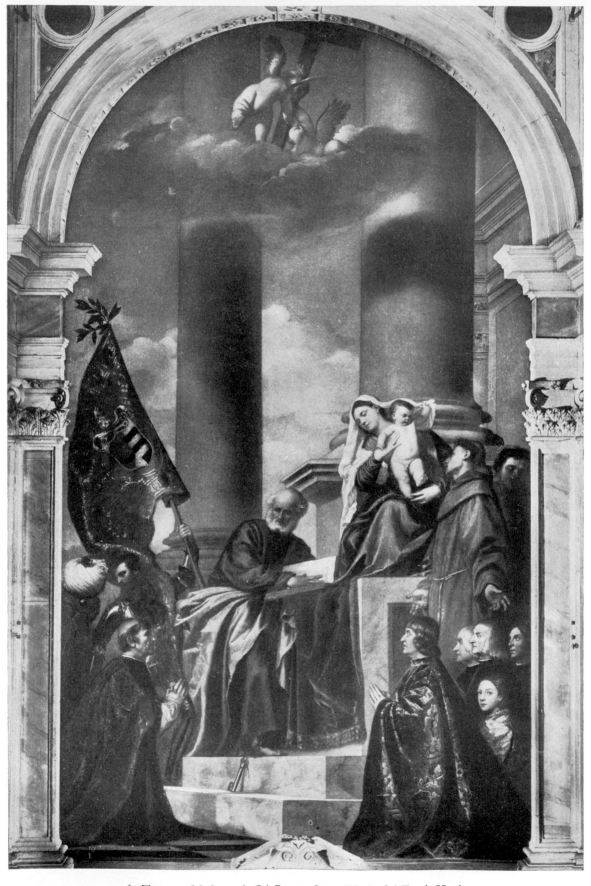

46. TITIAN: *Madonna di Ca' Pesaro*. Santa Maria dei Frari, Venice

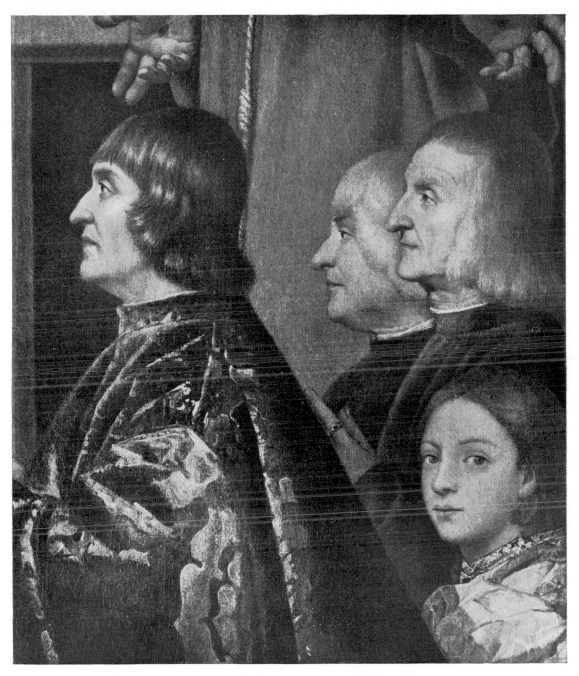

47. TITIAN: *Detail from the 'Pesaro Madonna'* (Plate 46)

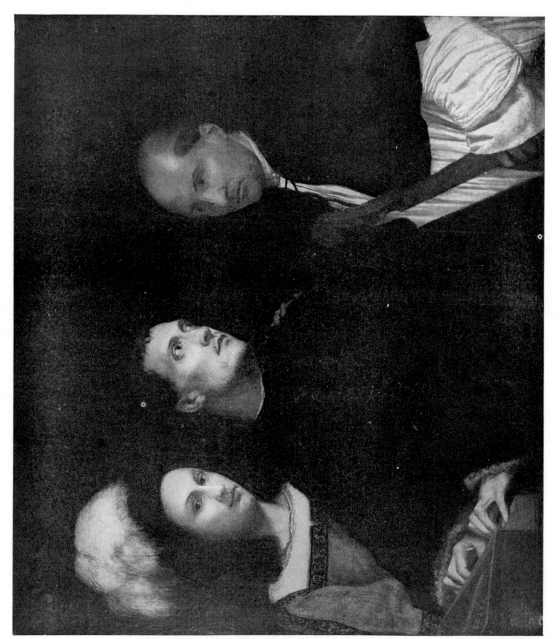

48. TITIAN: *The Concert*. Pitti Palace, Florence

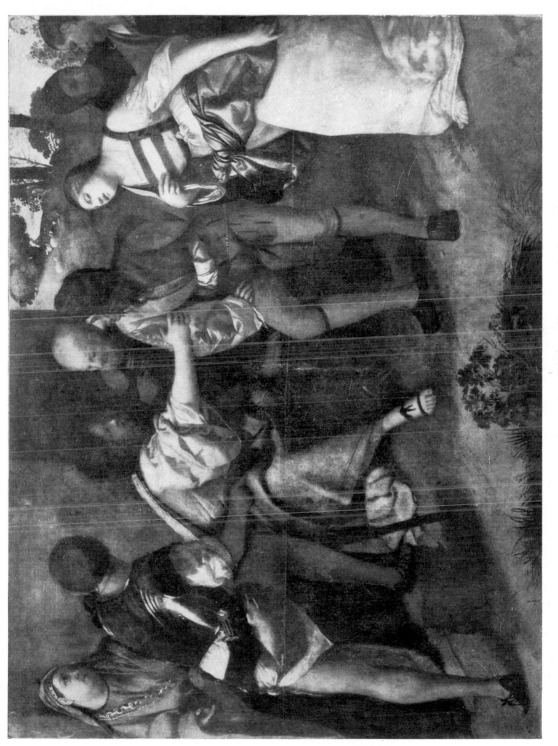

49. GIORGIONE: *The Adultress brought before Christ, Art Gallery, Glasgow*

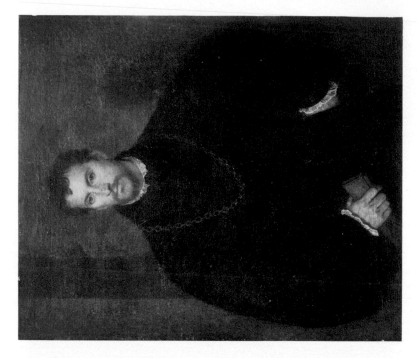

51. TITIAN: *Portrait of a Gentleman*. Pitti Palace, Florence

50. TITIAN: 'L'homme au gant'. Louvre, Paris

53. GIORGIONE: *Bust of a Man.* Arthur Sachs Collection, Paris

52. TITIAN: *Portrait of a Man.* State Museum, Copenhagen

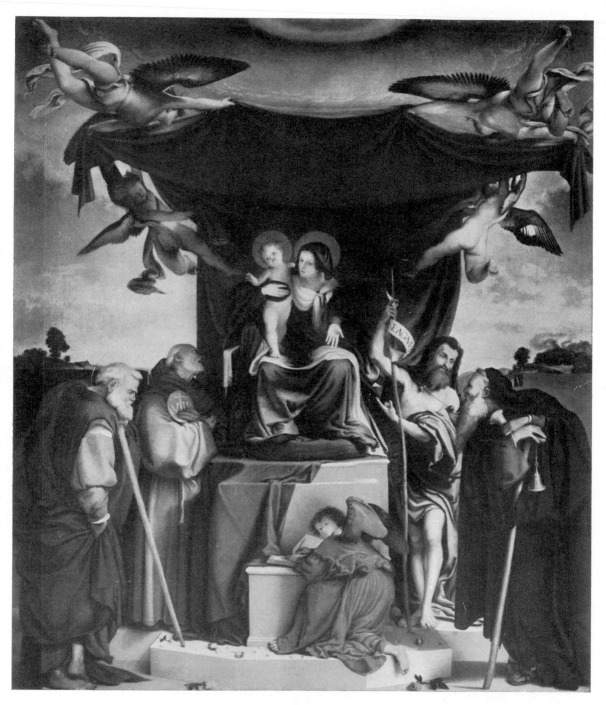

54. LORENZO LOTTO: *Madonna and Child with Saints*. San Bernardino, Bergamo

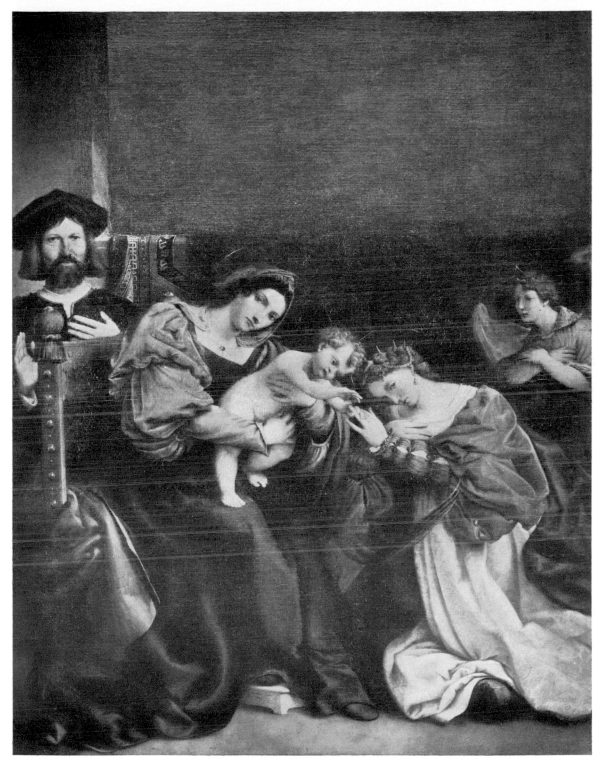

55. LORENZO LOTTO: *The Marriage of Saint Catherine*. Accademia Carrara, Bergamo

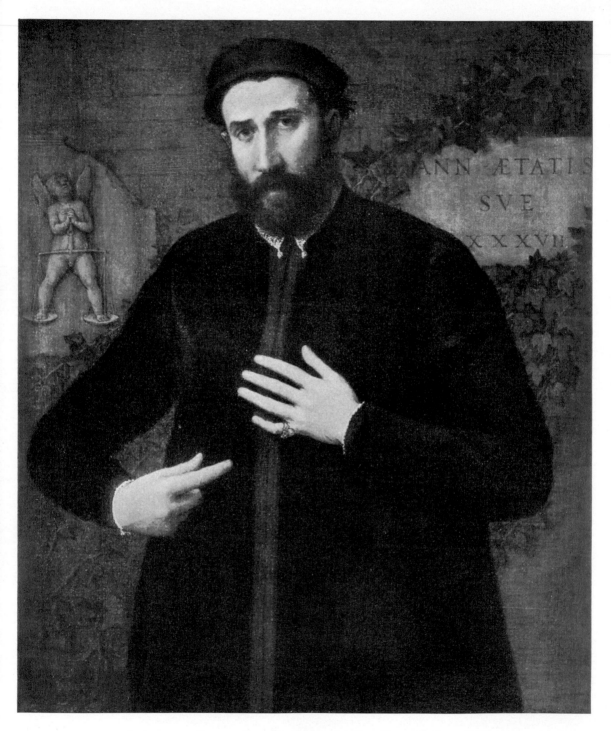

56. LORENZO LOTTO: *Portrait of a bearded Man*. Doria Gallery, Rome

57. LORENZO LOTTO: *Allegory*. National Gallery of Art, Washington (Kress Collection)

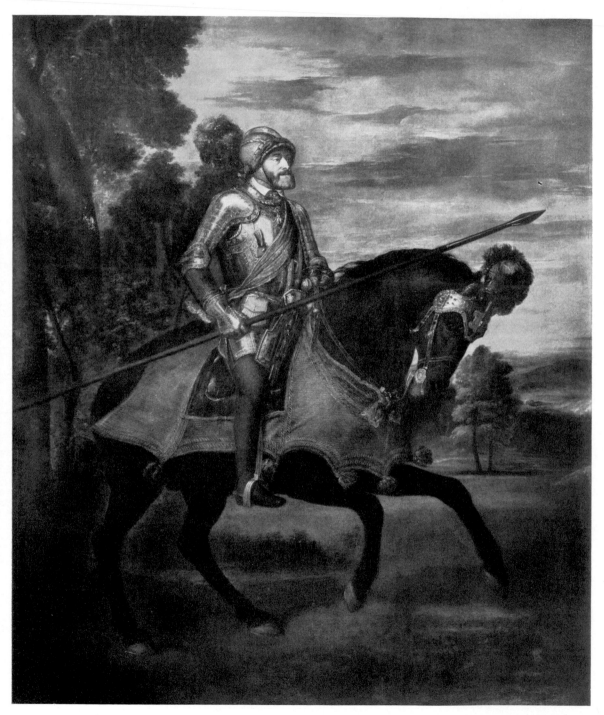

58. TITIAN: *Charles V on horseback*. Prado, Madrid

59. TITIAN: *Allegory of Wisdom*. Library of St. Mark's, Venice

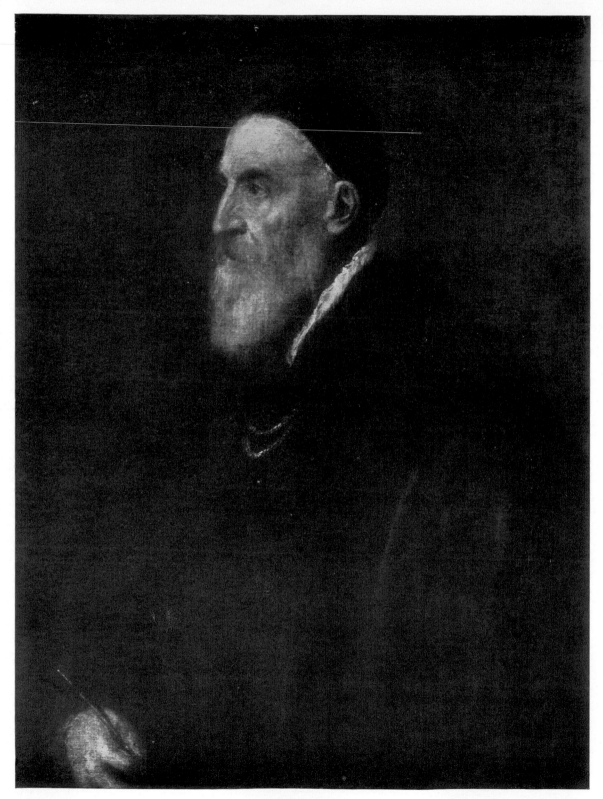

60. TITIAN: *Self-portrait*. Prado, Madrid

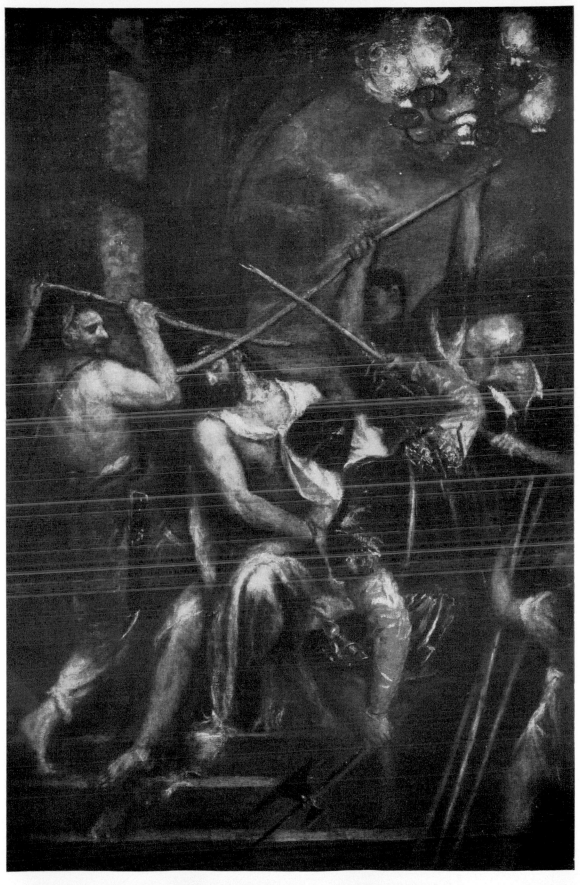

61. TITIAN: *Christ crowned with Thorns*. Alte Pinakothek, Munich

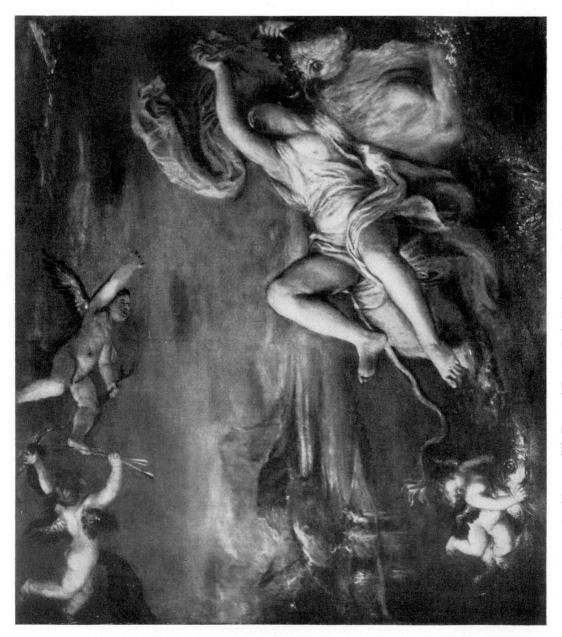

62. Titian: *The Rape of Europa*. Isabella Stewart Gardner Museum, Boston

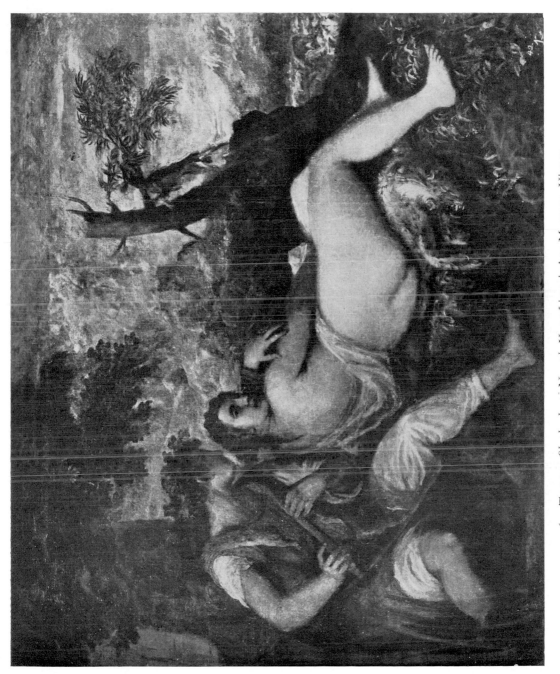

63. TITIAN: *Shepherd and Nymph*. Kunsthistorisches Museum, Vienna

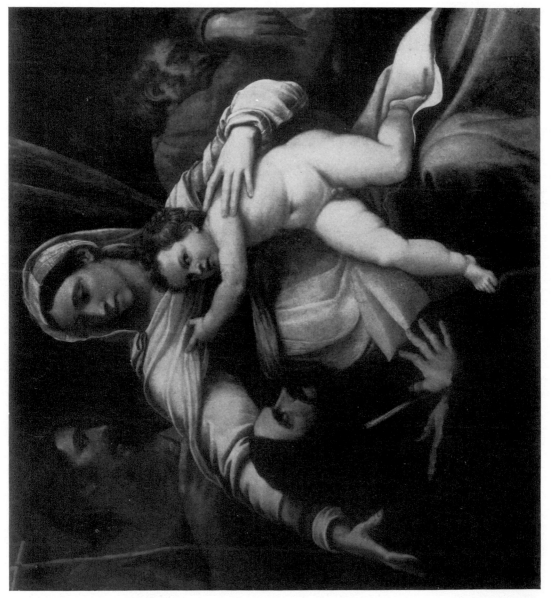

64. SEBASTIANO DEL PIOMBO: *The Holy Family with a Donor*. National Gallery, London

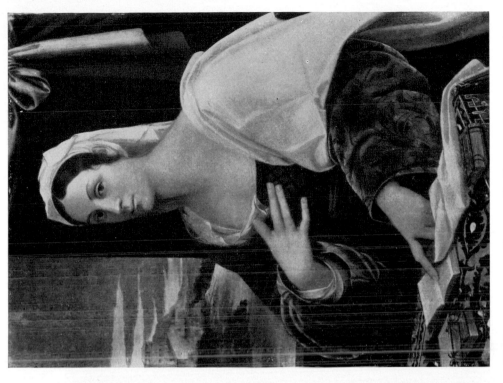

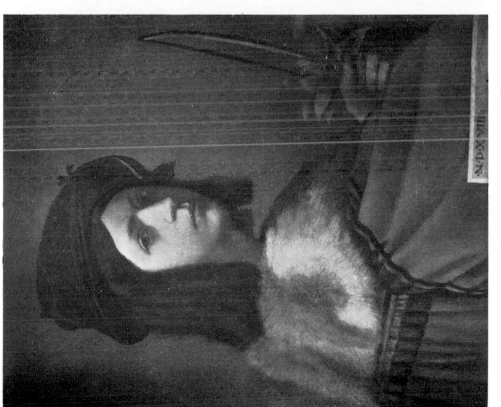

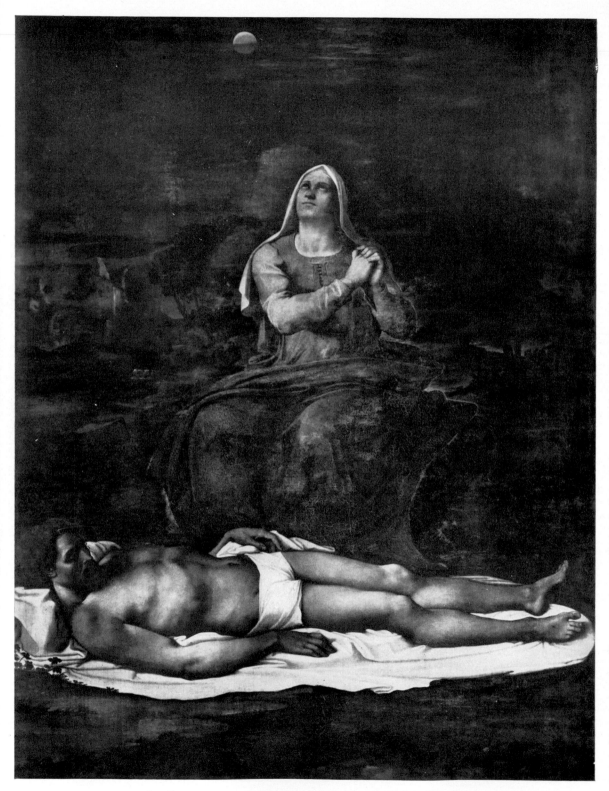

67. SEBASTIANO DEL PIOMBO: *Pietà*. Museo Civico, Viterbo

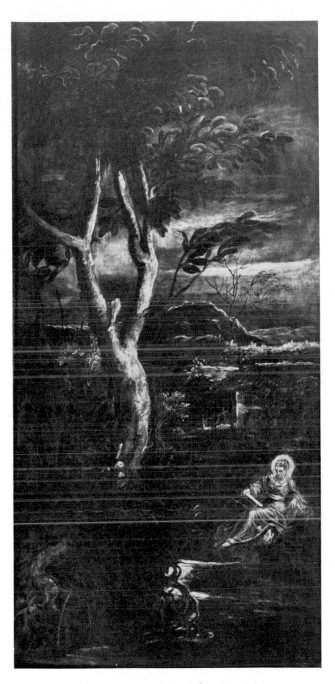

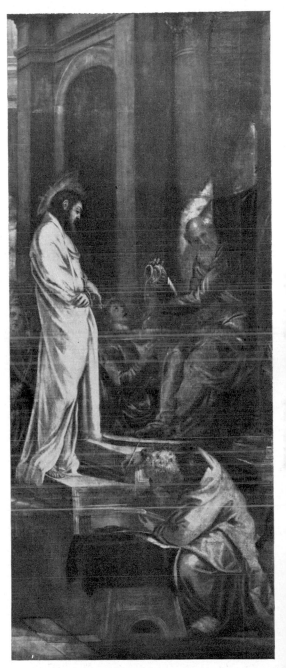

68. TINTORETTO: *Saint Mary Magdalene.*
Scuola di San Rocco, Venice

69. TINTORETTO: *Detail from 'Christ before Pilate'.*
Scuola di San Rocco, Venice

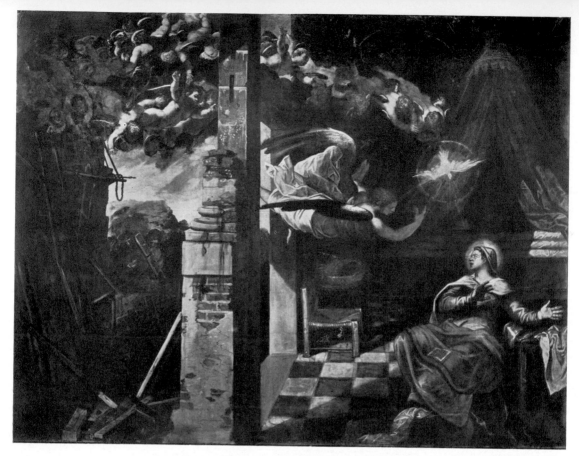

70. TINTORETTO: *The Annunciation*. Scuola di San Rocco, Venice

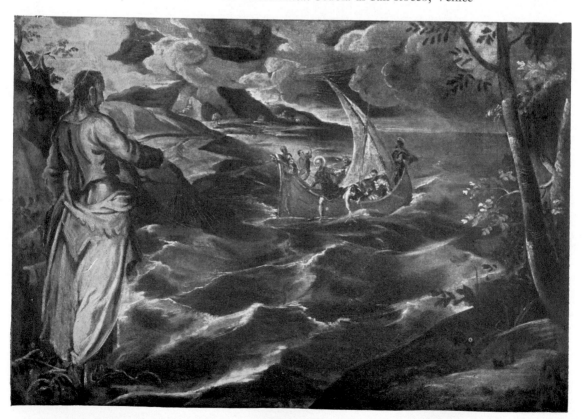

71. TINTORETTO: *Christ at the Sea of Galilee*. National Gallery of Art, Washington (Kress Collection)

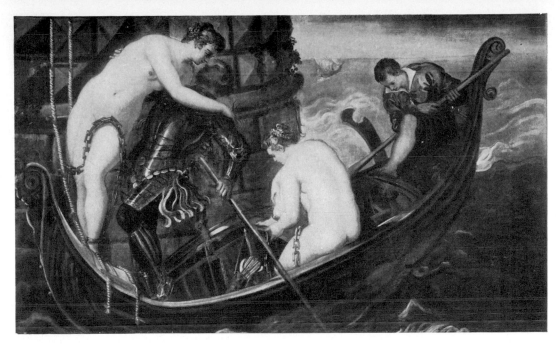

72. TINTORETTO: *The Liberation of Arsinoe.* Gallery, Dresden

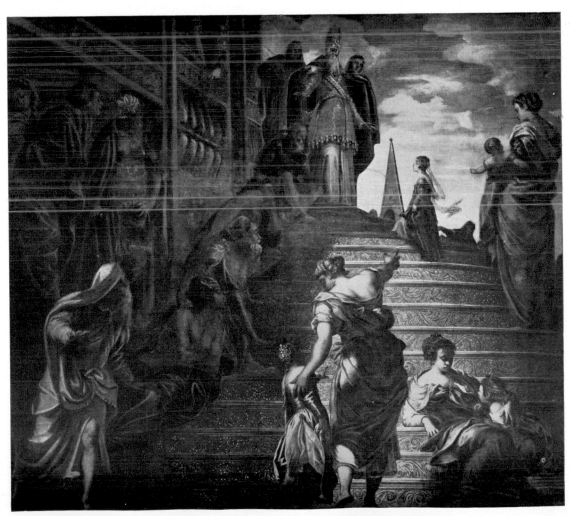

73. TINTORETTO: *The Presentation of the Virgin.* Santa Maria dell'Orto, Venice

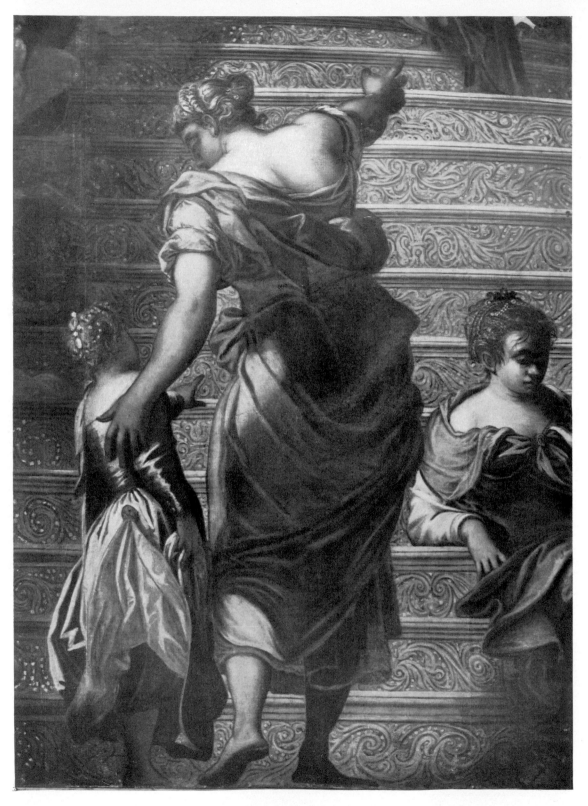

74. Tintoretto: *Detail from the 'Presentation of the Virgin'* (Plate 73)

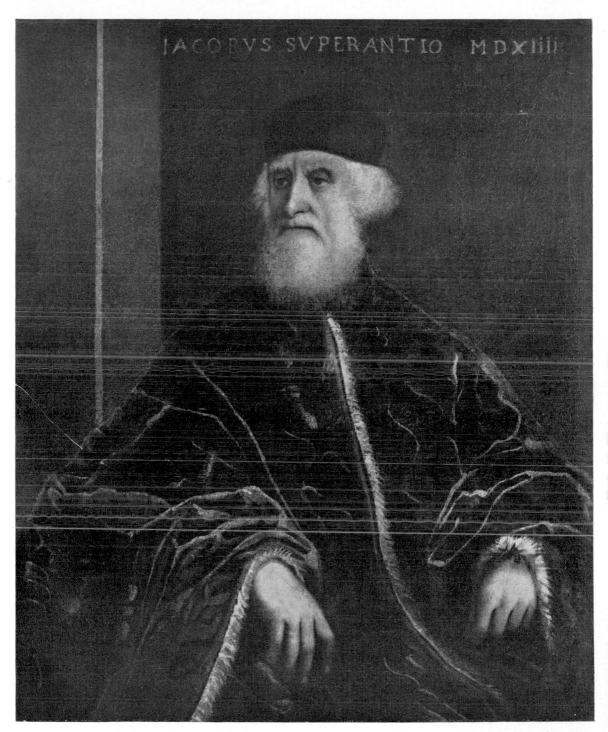

75. TINTORETTO: *Portrait of Jacopo Soranzo*. Academy, Venice

78. Tintoretto: *The Discovery of the Body of Saint Mark*. Brera, Milan

79. Tintoretto: *Storm rising while the Body of Saint Mark is being transported*. Academy, Venice

80. PORDENONE: *Madonna and Child with two Saints and Donor.* Duomo, Cremona

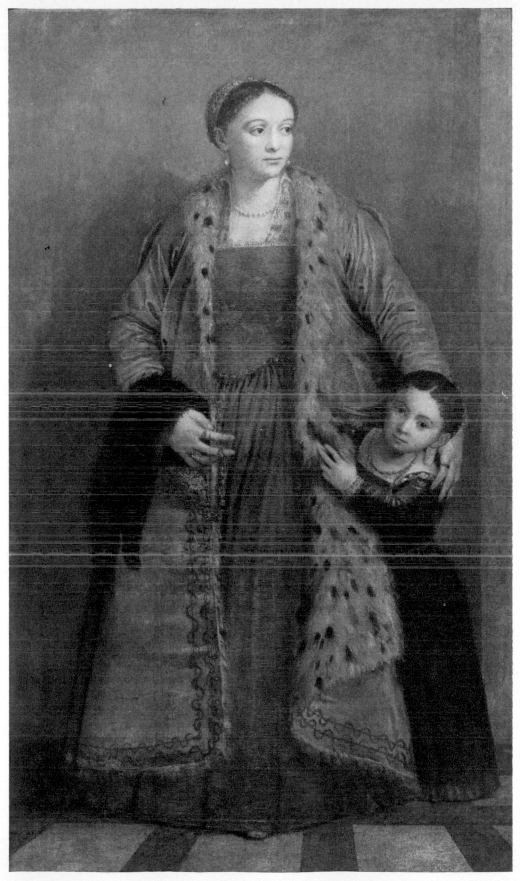

81. PAOLO VERONESE: *Portrait of a Lady with her small Daughter*. Walters Art Gallery, Baltimore

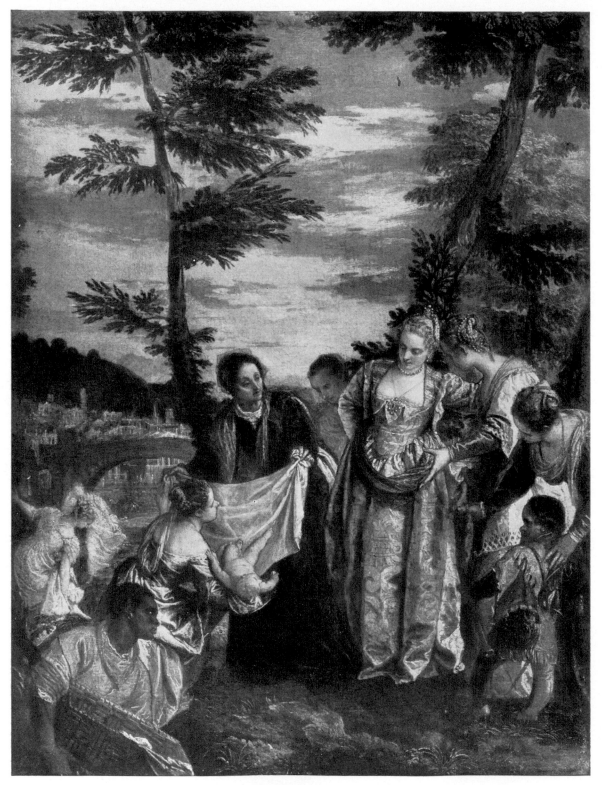

82. Paolo Veronese: *The Finding of Moses*. Prado, Madrid

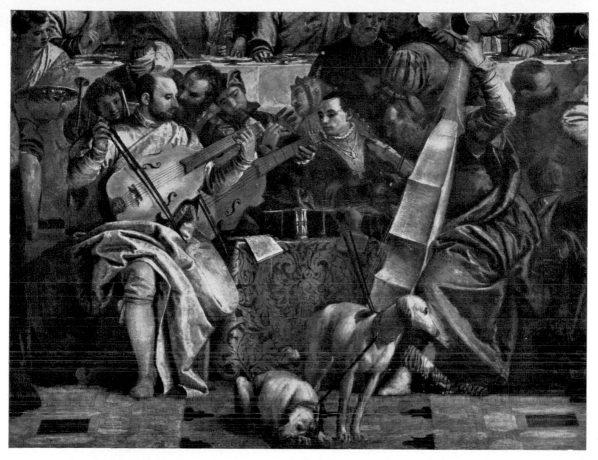

83. PAOLO VERONESE: *Detail from the 'Feast at Cana'*. Louvre, Paris

84. PAOLO VERONESE: *Detail from 'Christ at Emmaus'*. Louvre, Paris

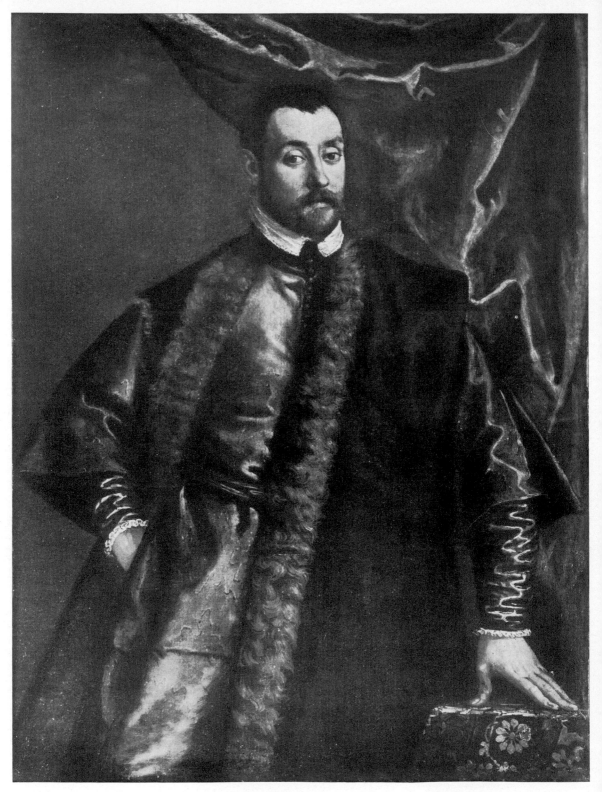

85. PAOLO VERONESE: *Portrait of a Man*. Colonna Gallery, Rome

86. PAOLO VERONESE: *The Holy Family with the Infant Saint John*. Rijksmuseum, Amsterdam

87. PALMA VECCHIO: *The Meeting of Jacob and Rachel*. Gallery, Dresden

88. PALMA VECCHIO: *Sacra Conversazione*. Gallery, Dresden

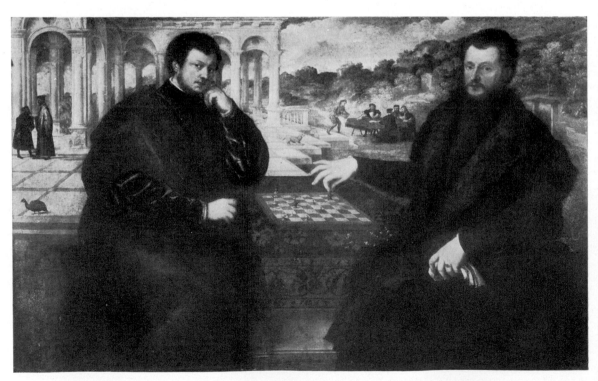

89. PARIS BORDONE: *The Chess Players*. Staatliche Museen, Berlin-Dahlem

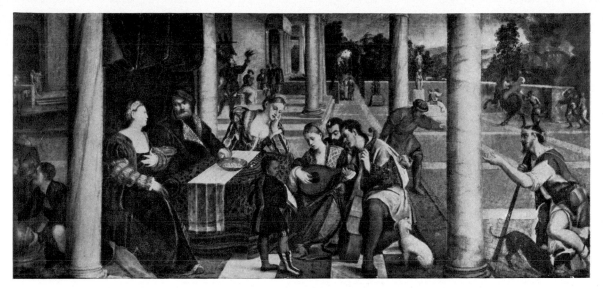

90. BONIFAZIO VERONESE: *The Rich Man's Feast*. Academy, Venice

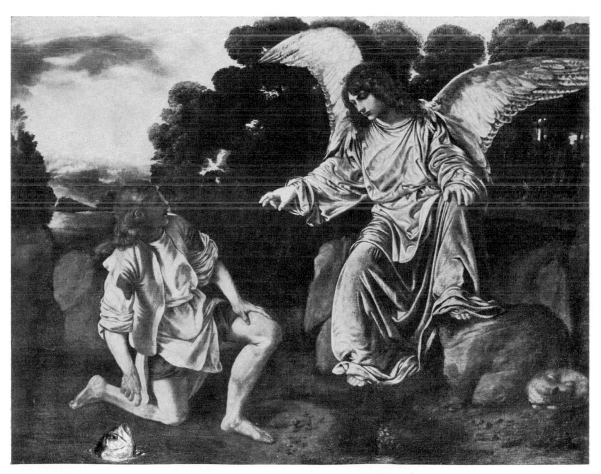

91. SAVOLDO: *Tobias and the Angel*. Borghese Gallery, Rome

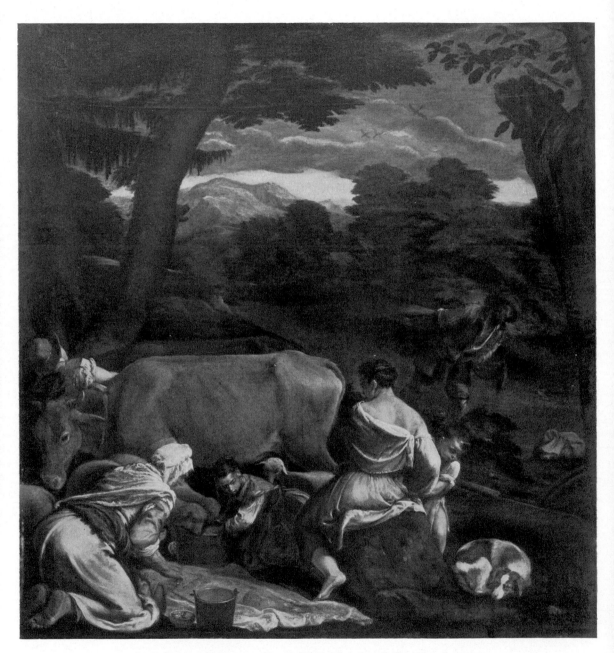

92. JACOPO BASSANO: *Rustic Scene*. Thyssen Collection, Lugano

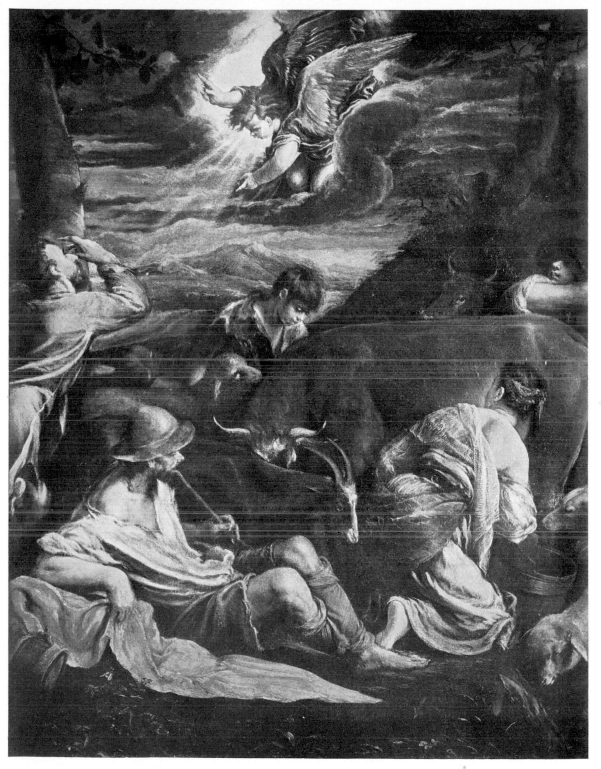

93. Jacopo Bassano: *The Annunciation to the Shepherds*. National Gallery of Art, Washington
(Kress Collection)

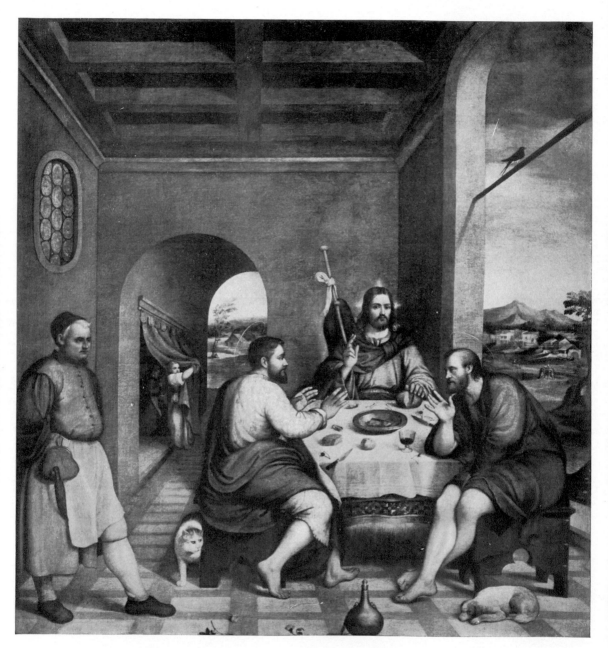

94. Jacopo Bassano: *Christ at Emmaus*. Parish Church, Cittadella

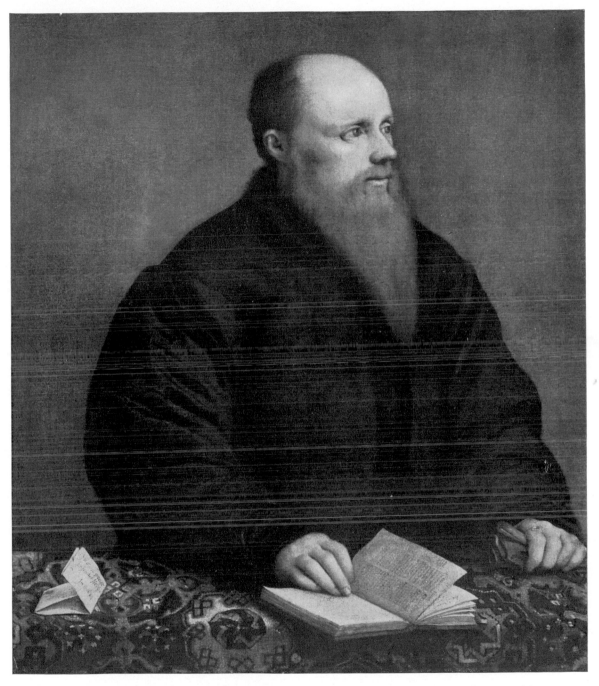

95. JACOPO BASSANO: *Portrait of a Man of Letters*. Brooks Memorial Art Gallery, Memphis, Tennessee
(Kress Collection)

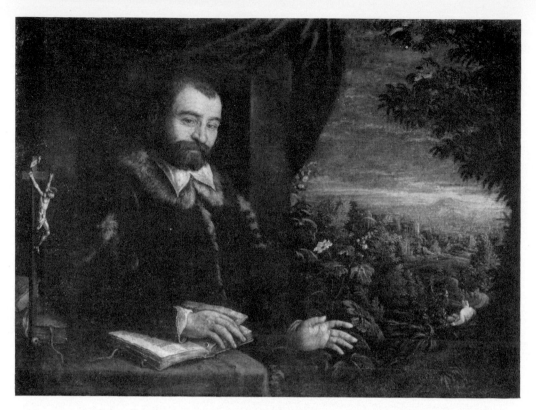

96. LEANDRO BASSANO: *Portrait of a Man*. John G. Johnson Collection, Philadelphia

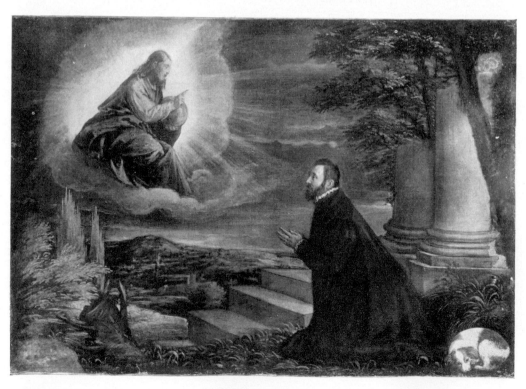

97. LEANDRO BASSANO: *Christ appearing to a Gentleman in Prayer*. Fogg Art Museum,
Cambridge, Mass.

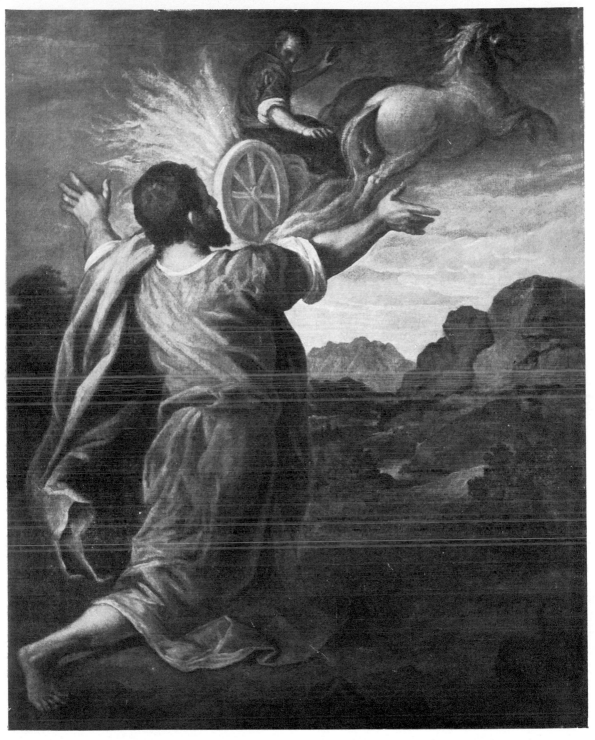

98. PALMA GIOVANE: *The Prophet Elijah carried up to Heaven*. Ateneum, Helsinki

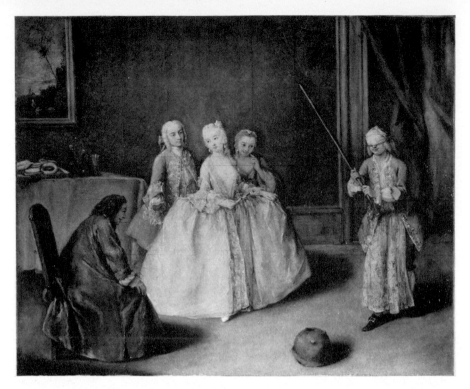

99. PIETRO LONGHI: *Blind Man's Buff*. National Gallery of Art, Washington
(Kress Collection)

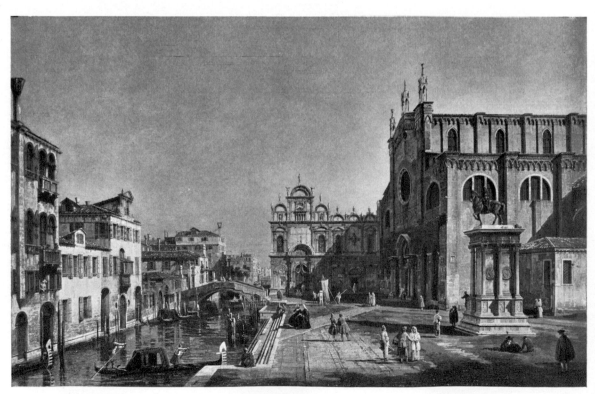

100. CANALETTO: *View in Venice*. National Gallery of Art, Washington (Widener Collection)

101. BERNARDO BELLOTTO: *View of the Ponte Vecchio, Florence*. Museum of Fine Arts, Boston

102. FRANCESCO GUARDI: *View on the Cannaregio, Venice*. National Gallery of Art, Washington
(Kress Collection)

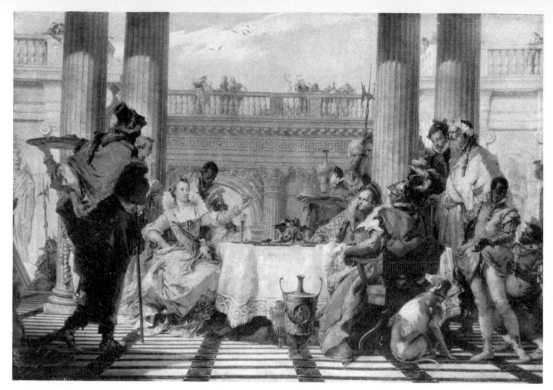

103. Giovan Battista Tiepolo: *The Banquet of Cleopatra*. National Gallery of Victoria, Melbourne
(Felton Bequest)

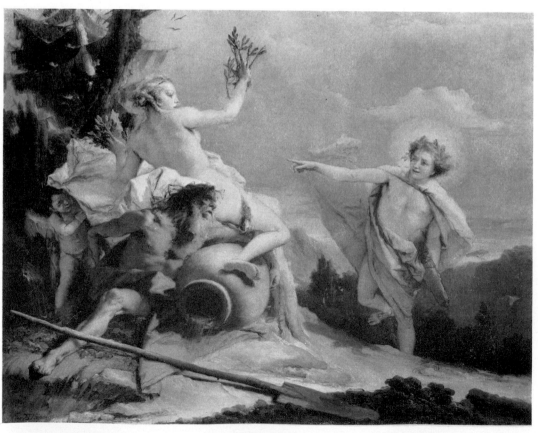

104. Giovan Battista Tiepolo: *Apollo pursuing Daphne*. National Gallery of Art, Washington
(Kress Collection)

II. NORTH ITALIAN PAINTERS

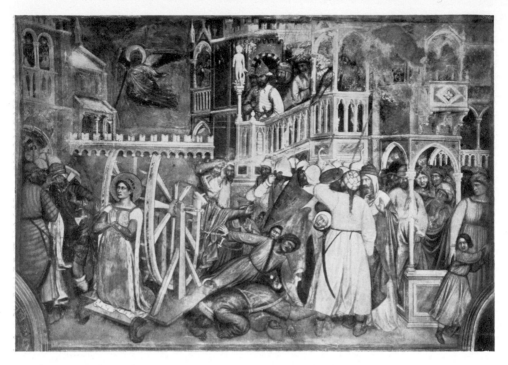

105. ALTICHIERO: *The Martyrdom of Saint Catherine*. Oratory of S. Giorgio, Padua

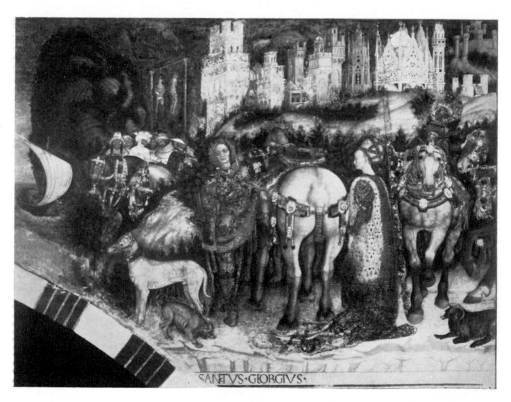

SANTVS·GIORGIVS·

106. PISANELLO: *Saint George and the Princess of Trebizond*. Sant'Anastasia, Verona

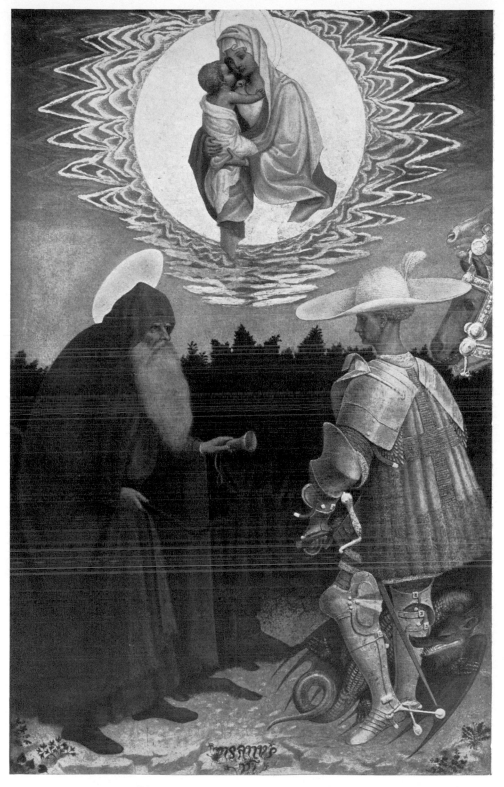

107. PISANELLO: *Madonna and Child with two Saints*. National Gallery, London

108. PISANELLO: *The Vision of Saint Eustace*. National Gallery, London

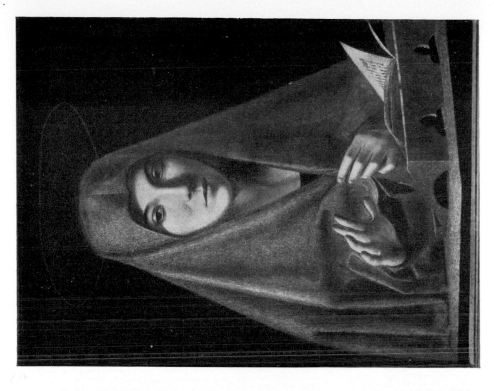

110. ANTONELLO DA MESSINA: *The Virgin Annunciate*.
National Museum, Palermo

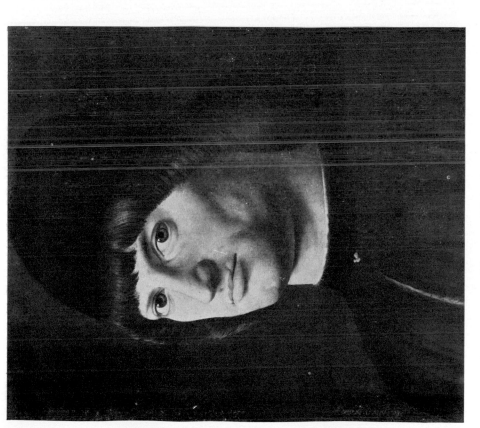

109. ANTONELLO DA MESSINA: '*Il Condottiere*'. Louvre, Paris

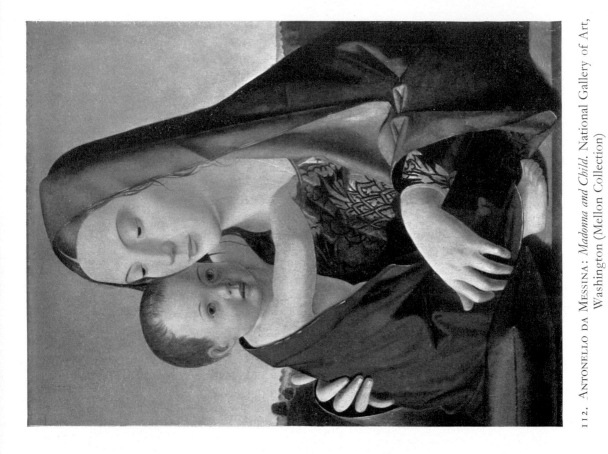

112. ANTONELLO DA MESSINA: *Madonna and Child*. National Gallery of Art, Washington (Mellon Collection)

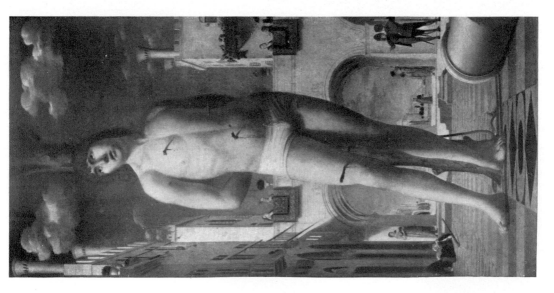

111. ANTONELLO DA MESSINA: *Saint Sebastian*. Gallery, Dresden

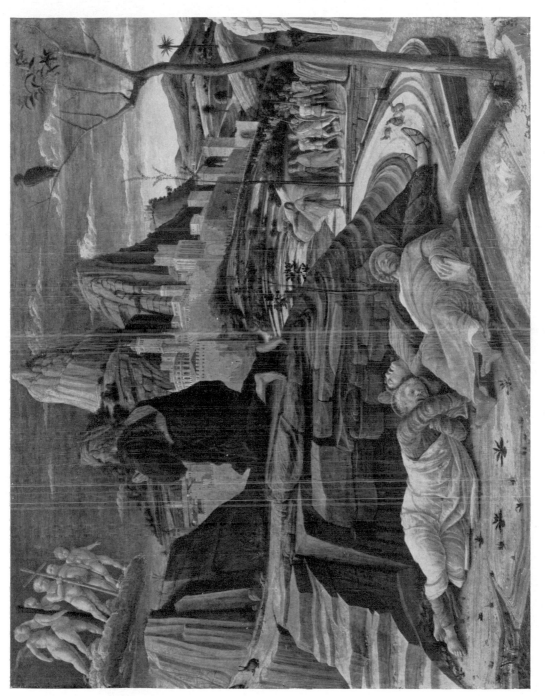

113. ANDREA MANTEGNA: *The Agony in the Garden*. National Gallery, London

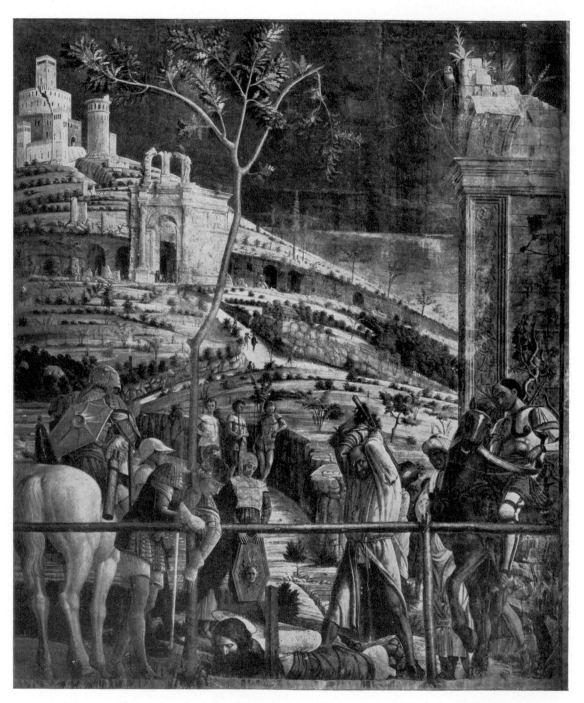

114. ANDREA MANTEGNA: *The Martyrdom of Saint James.* Formerly Eremitani Church, Padua

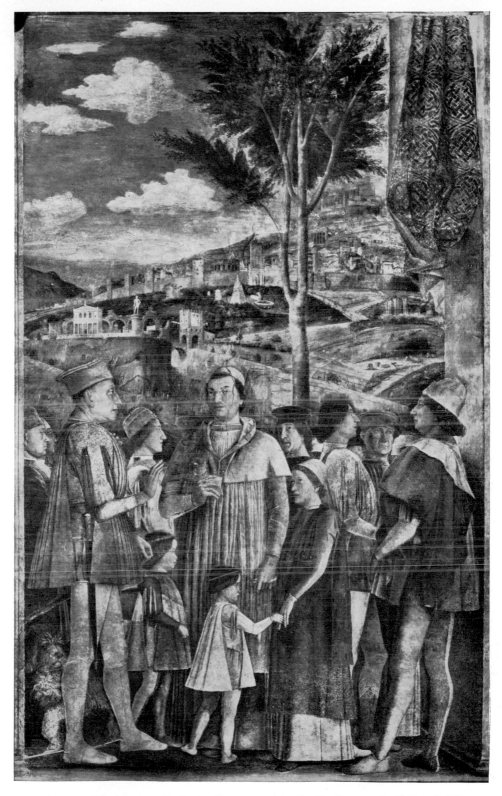

115. ANDREA MANTEGNA: *Lodovico Gonzaga and his family*. Camera degli Sposi, Mantua

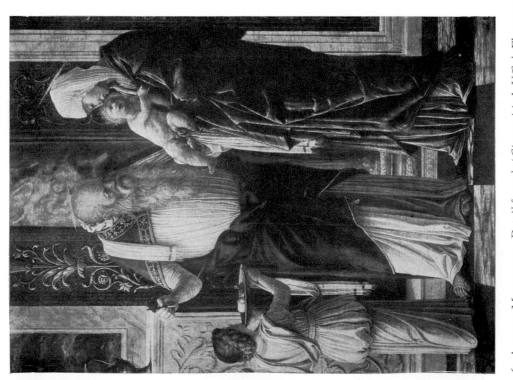

117. ANDREA MANTEGNA: *Judith*. National Gallery of Ireland, Dublin

116. ANDREA MANTEGNA: *Detail from the 'Circumcision'*. Uffizi, Florence

119. COSIMO TURA: *Saint George and the Dragon.*
Cathedral Museum, Ferrara

118. ANDREA MANTEGNA: *Saint Jerome in the Wilderness.*
Museu de Arte, São Paulo, Brazil

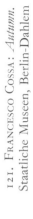

121. FRANCESCO COSSA: *Autumn.*
Staatliche Museen, Berlin-Dahlem

120. COSIMO TURA: *Madonna and Child.*
Academy, Venice

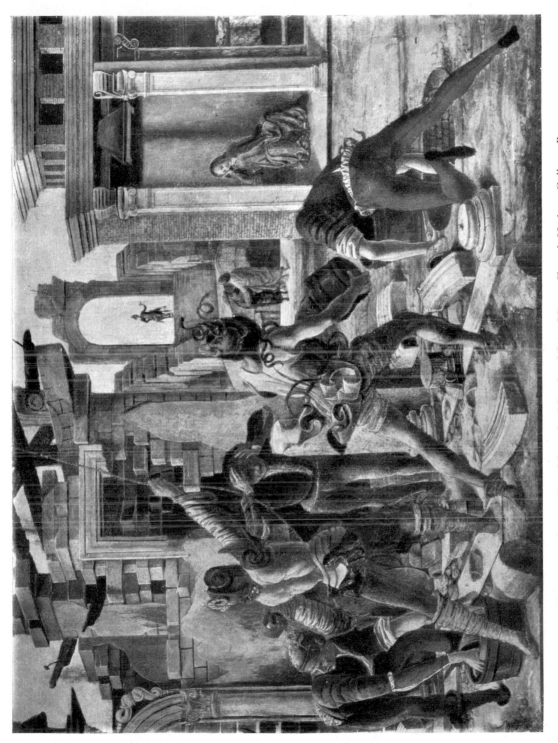

122. Francesco Cossa: *Detail from the 'Miracles of Saint Vincent Ferrer'*. Vatican Gallery, Rome

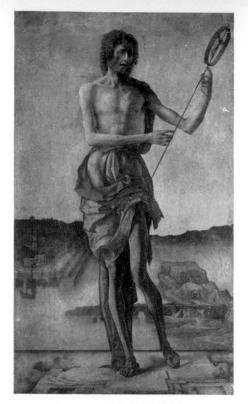

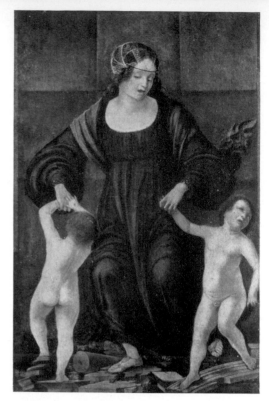

123. ERCOLE ROBERTI: *Saint John the Baptist in the Wilderness*. Staatliche Museen, Berlin-Dahlem

124. ERCOLE ROBERTI: *Hasdrubal's Wife* (formerly known as *Medea*). National Gallery of Art, Washington (A. Mellon Bruce Fund)

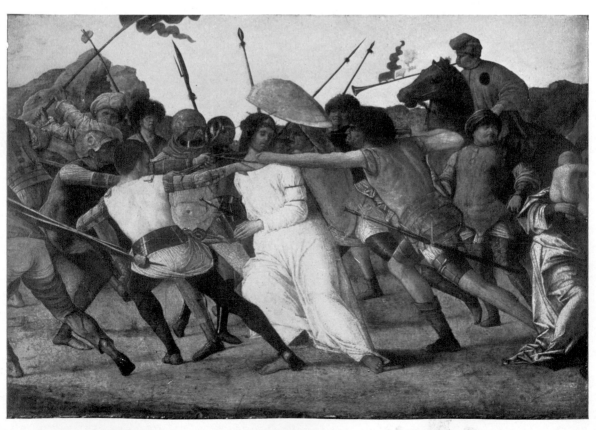

125. ERCOLE ROBERTI: *Detail from 'Christ carrying the Cross'*. Gallery, Dresden

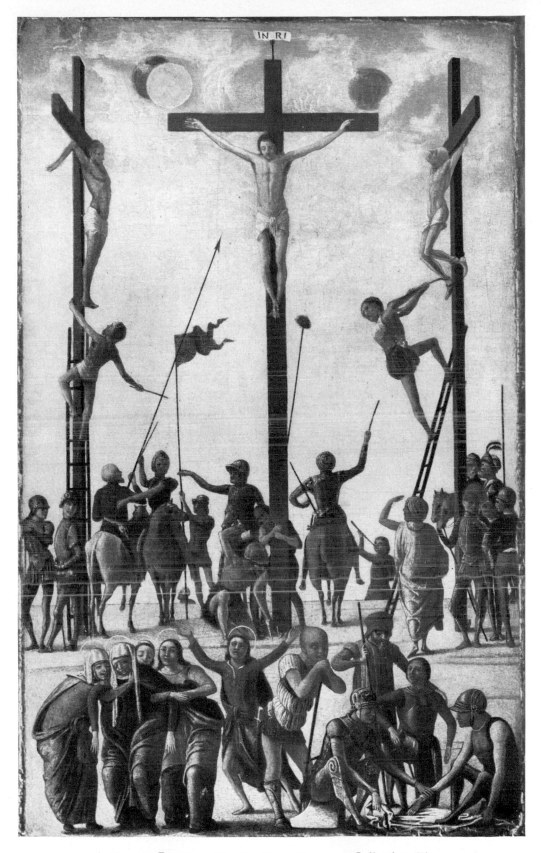

126. ERCOLE ROBERTI: *The Crucifixion*. Berenson Collection, Florence

127. LORENZO COSTA: *The Reign of the Muses*. LOUVRE, Paris

129. FRANCESCO FRANCIA: *Madonna of the Roses*.
Alte Pinakothek, Munich

128. FRANCESCO MARMITTA: *Detail from 'Madonna and Child with Saints'*.
Louvre, Paris

(formerly ascribed to Francesco Bianchi Ferrari)

131. DOMENICO MORONE: *Detail from 'Madonna and Child'.*
San Bernardino, Verona

130. TIMOTEO VITI: *Saint Mary Magdalene.*
Gallery, Bologna

132. DOMENICO MORONE: *Detail from 'The Bonacolsi being chased out of Mantua'*, Ducal Palace, Mantua

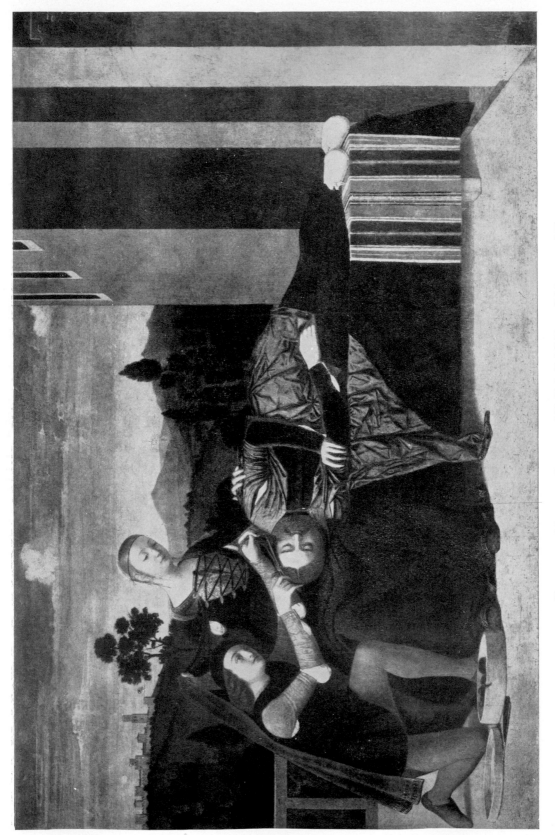

133. Francesco Morone: *Samson and Delilah*. Poldi-Pezzoli Museum, Milan

135. Girolamo dai Libri: *Madonna and Child with two Saints*. Castelvecchio Museum, Verona

134. Giovanni Francesco Caroto: *Saint Ursula*. San Giorgio in Braida, Verona

137. Liberale da Verona: *Illuminated Initial.*
Cathedral Library, Siena

136. Girolamo da Cremona: *Illuminated Initial.*
Cathedral Library, Siena

138. Fratelli Zavattari: *Scene from the Life of Queen Teodelinda.* Cathedral, Monza

139. PAOLO CAVAZZOLA: *Emilio degli Emili*.
Gallery, Dresden

140. PAOLO FARINATI: *Portrait of an Old Man*.
Art Museum, Worcester, Massachusetts

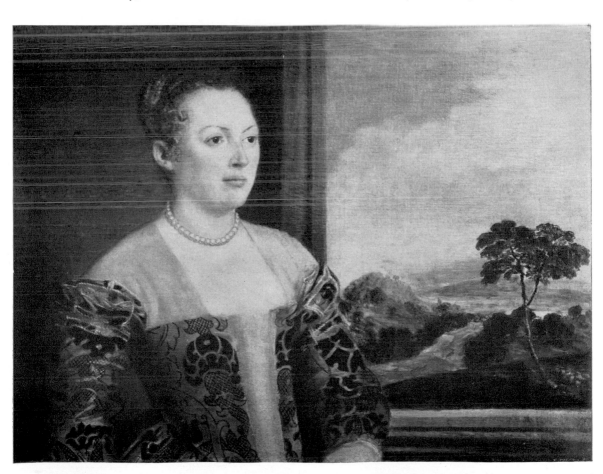

141. DOMENICO BRUSASORCI: *Portrait of a Lady*. Museum of Art, Rhode Island School of Design,
Providence, Rhode Island

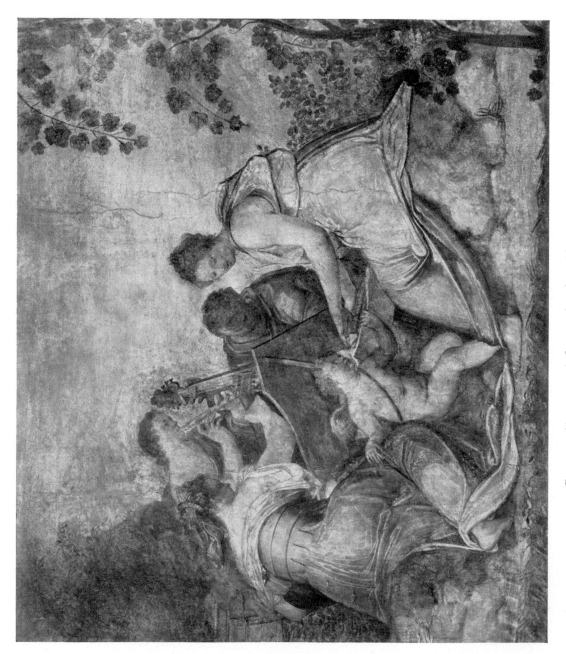

142. BATTISTA ZELOTTI: *A Concert*. Castelvecchio Museum, Verona

143. VINCENZO FOPPA: *Detail from the 'Adoration of the Magi'*. National Gallery, London

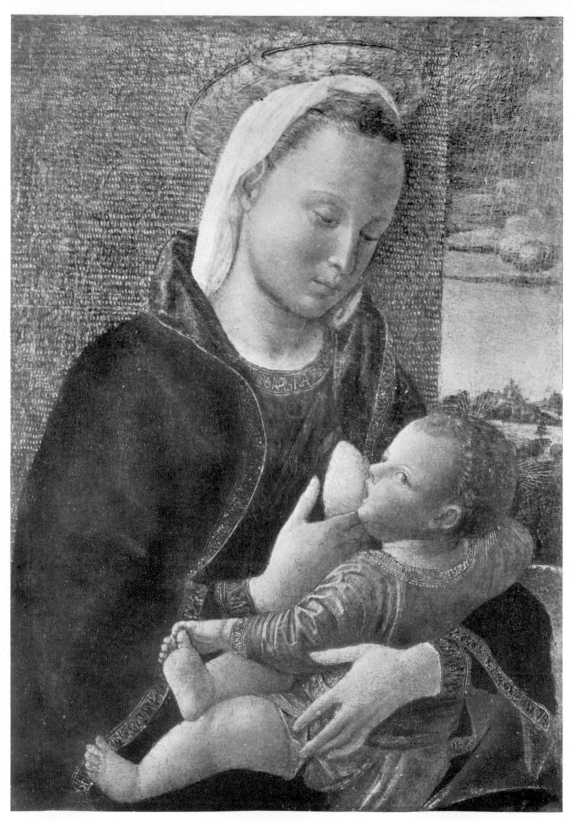

144. Vincenzo Foppa: *Madonna and Child*. Berenson Collection, Florence

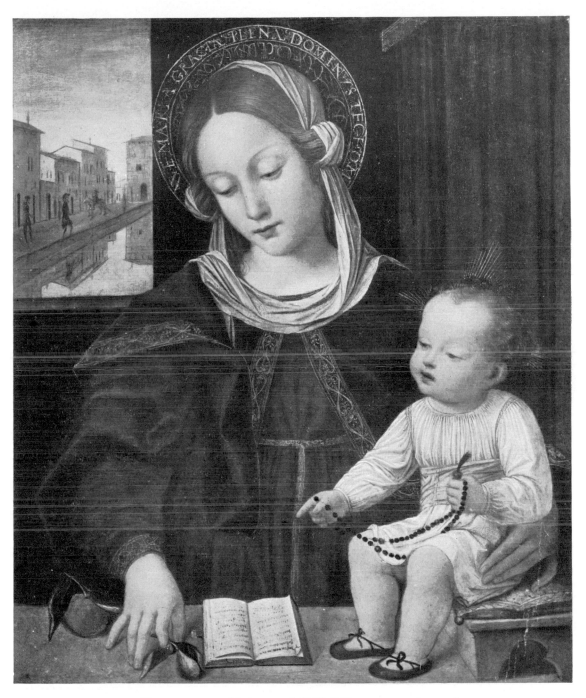

145. BORGOGNONE: *Madonna and Child*. Rijksmuseum, Amsterdam

146. Borgognone: *Scene from the Life of Saint Benedict.* Museum, Nantes

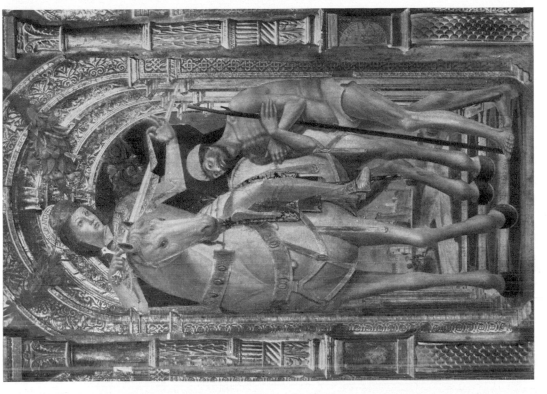

143. BERNARDINO BUTINONE: *Detail from Polyptych.*
San Martino, Treviglio

147. BERNARDINO ZENALE: *Detail from Polyptych.*
San Martino, Treviglio

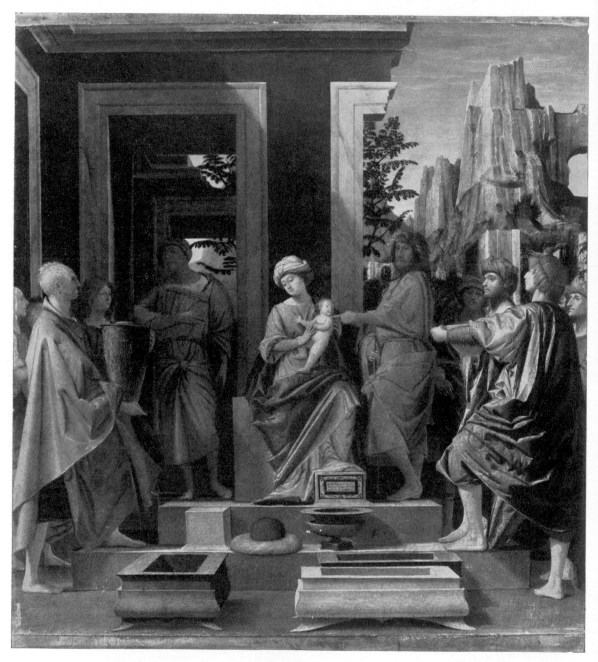

149. BRAMANTINO: *The Adoration of the Magi*. National Gallery, London

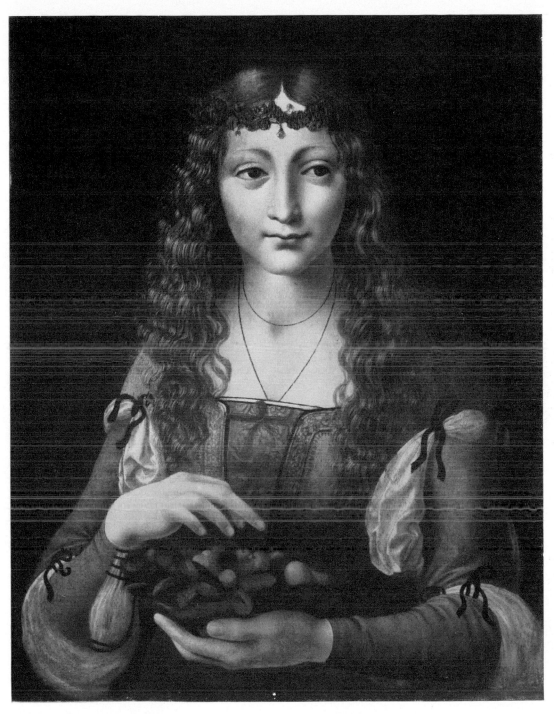

150. AMBROGIO DA PREDIS: *Girl with Cherries*. Metropolitan Museum of Art, New York

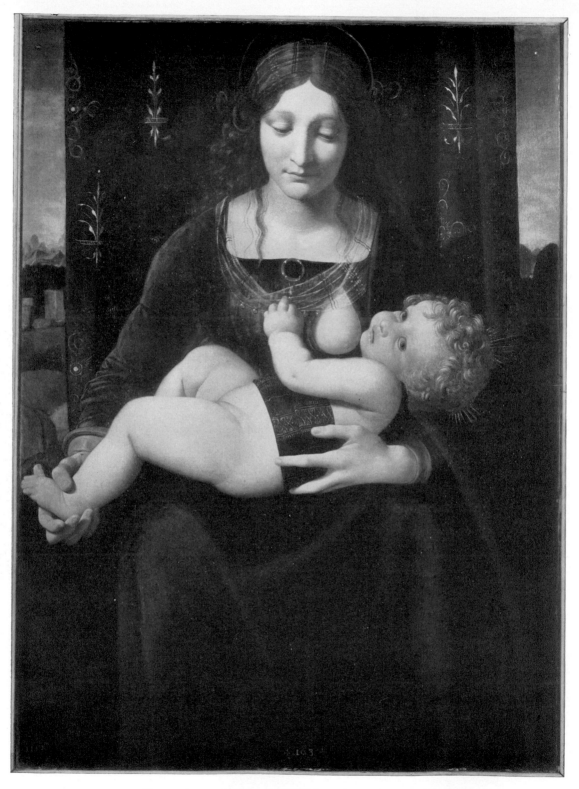

151. BOLTRAFFIO: *Madonna and Child*. National Gallery, London

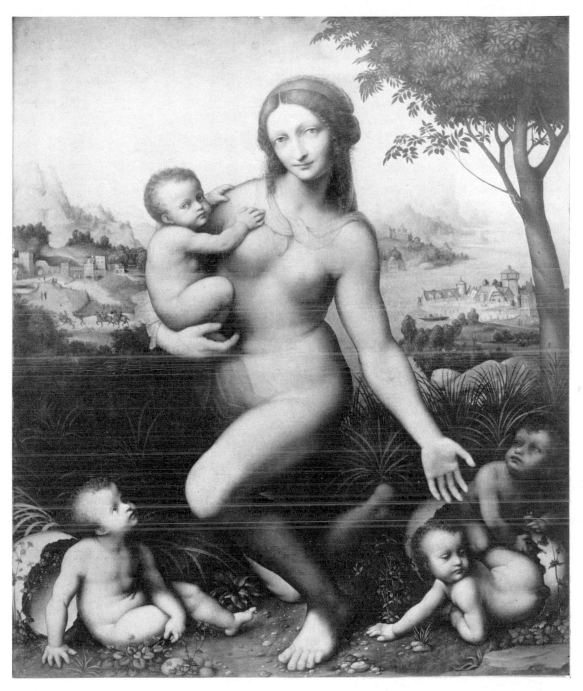

152. GIANPIETRINO: *Leda*. Formerly Fürst zu Wied, Neuwied

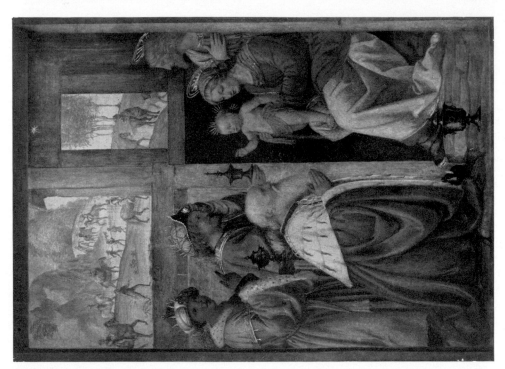

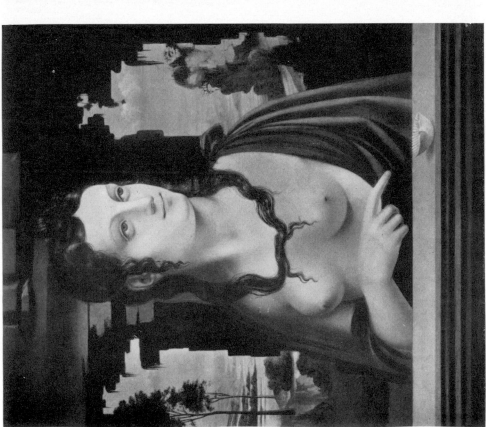

154. BERNARDINO LUINI: *The Adoration of the Magi*. Louvre, Paris

153. MARCO D'OGGIONO: *Venus*. Formerly Lederer Collection, Vienna

155. SODOMA: *Alexander and Roxana.* Farnesina, Rome

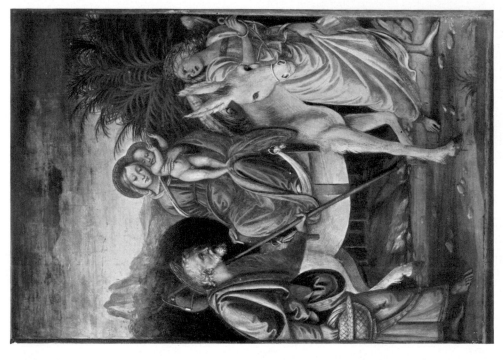

157. GAUDENZIO FERRARI: *The Flight into Egypt.*
Madonna delle Grazie, Varallo

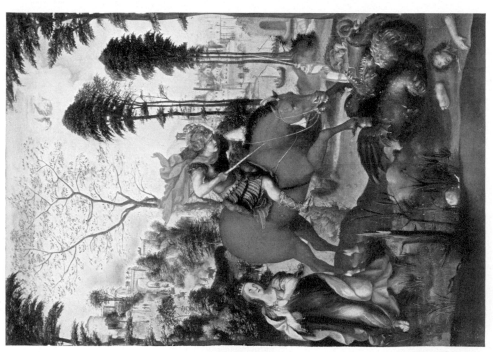

156. SODOMA: *Saint George and the Dragon.*
National Gallery of Art, Washington (Kress Collection)

159. ANDREA SOLARIO: *Portrait of a Venetian Senator.*
National Gallery, London

158. MILANESE, follower of Leonardo *'La belle Colombine'.*
Hermitage, Leningrad

161. Vincenzo Civerchio: *The Nativity and Saint Catherine.*
Brera, Milan

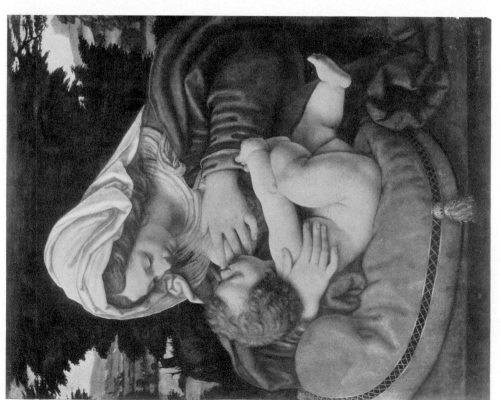

160. Andrea Solario: '*La Vierge au Coussin Vert*'.
Louvre, Paris

162. Girolamo Romanino: *Detail from Decorative Fresco*, Castello del Buon Consiglio, Trento

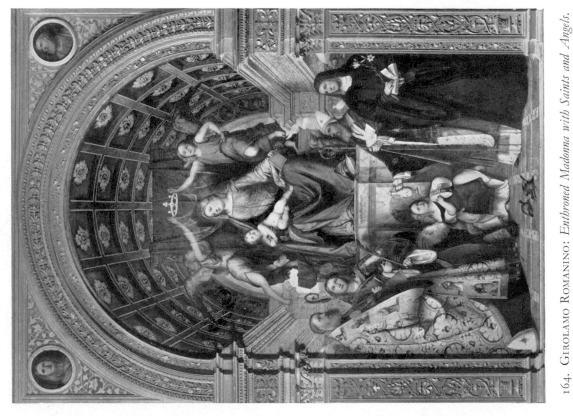

164. GIROLAMO ROMANINO: *Enthroned Madonna with Saints and Angels.*
Municipal Museum, Padua

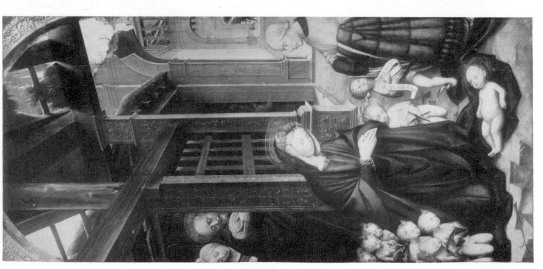

163. DEFENDENTE FERRARI: *The Nativity.*
Staatliche Museen, East Berlin

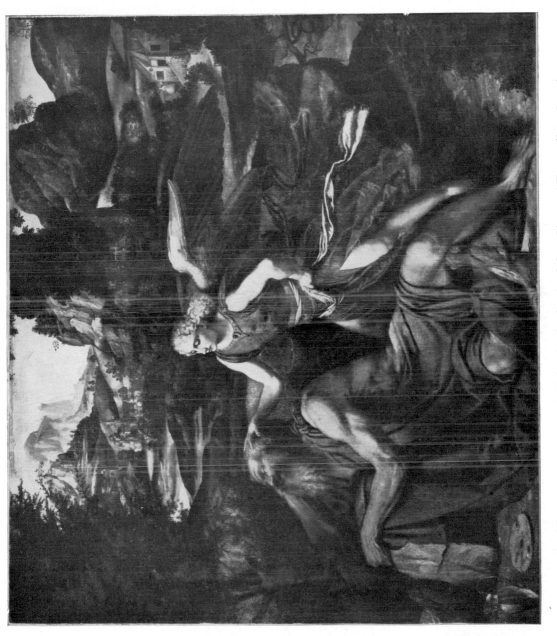

165. Moretto da Brescia: *Elijah woken by the Angel*. San Giovanni Evangelista, Brescia

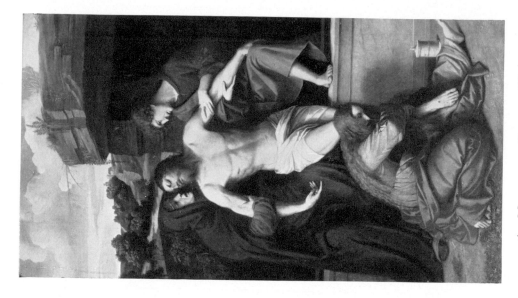

167. MORETTO DA BRESCIA: *Pietà*.
National Gallery of Art, Washington (Kress Collection)

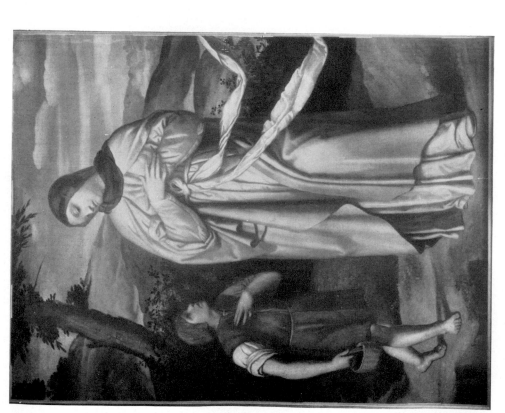

166. MORETTO DA BRESCIA: *The Virgin appearing to a peasant boy*.
Pilgrimage Church, Paitone

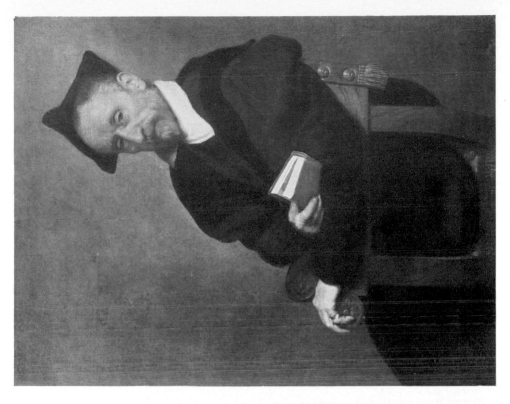

159. GIOVANNI BATTISTA MORONI: *'Titian's Schoolmaster'*.
National Gallery of Art, Washington (Widener Collection)

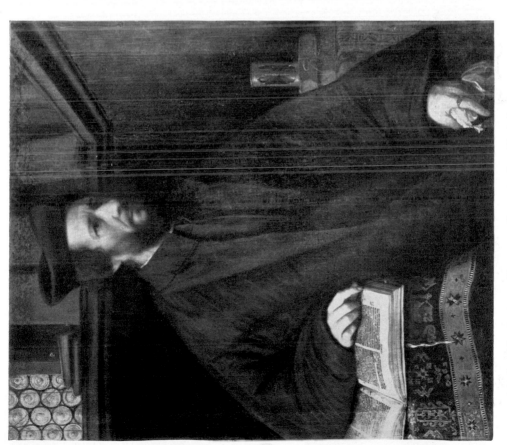

168. MORETTO DA BRESCIA: *Portrait of an Ecclesiastic.*
Alte Pinakotek, Munich

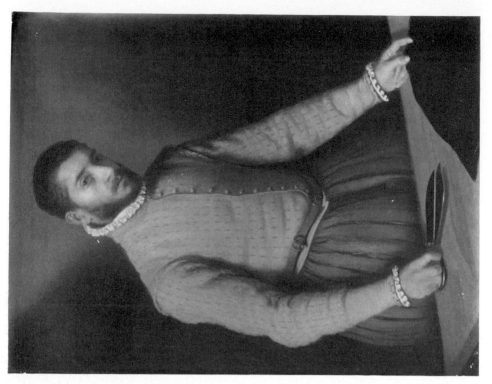

171. GIOVANNI BATTISTA MORONI: *A Tailor.*
National Gallery, London

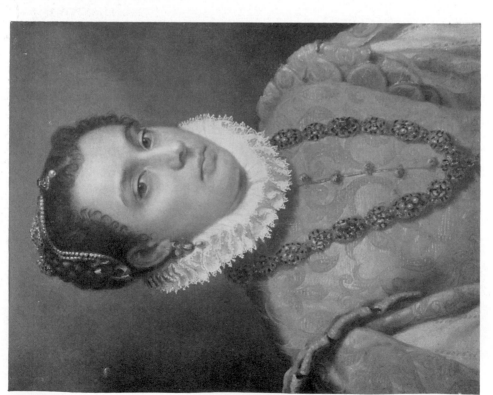

170. GIOVANNI BATTISTA MORONI: *Portrait of a Lady.*
O. B. Cintas Collection, Havana, Cuba

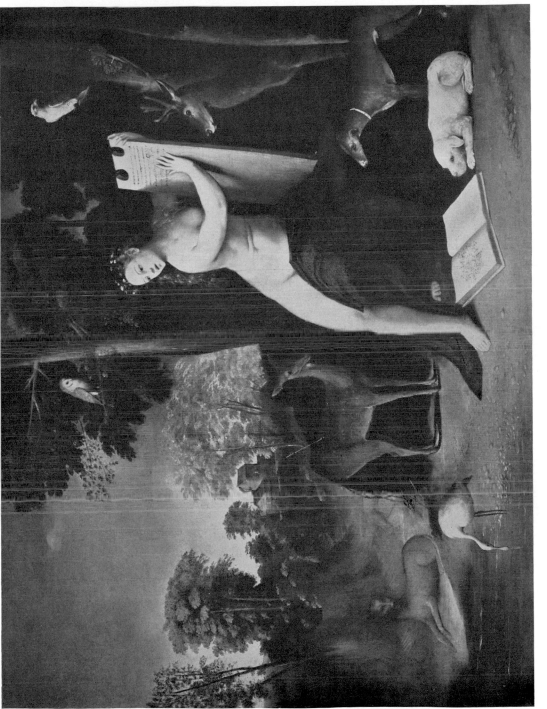

172. Dosso Dossi: *Circe and her Lovers in a Landscape*. National Galery of Art, Washington (Kress Collection)

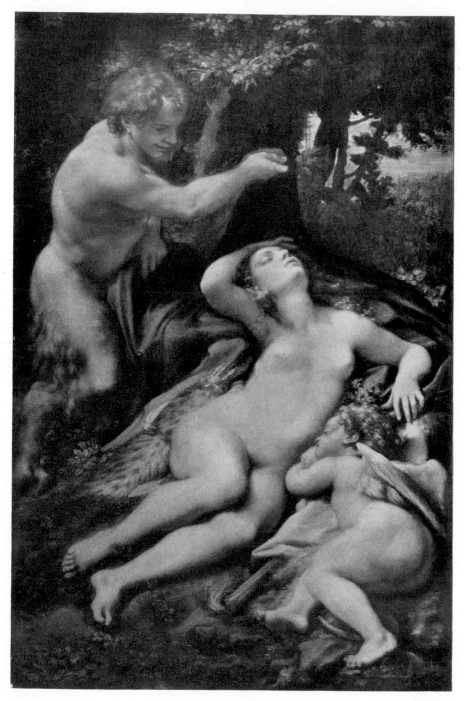

173. CORREGGIO: *Antiope*. Louvre, Paris

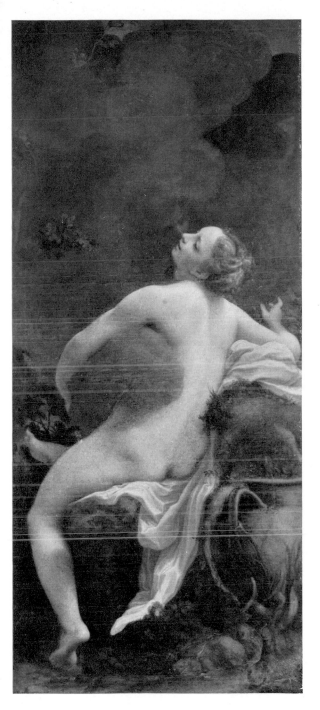

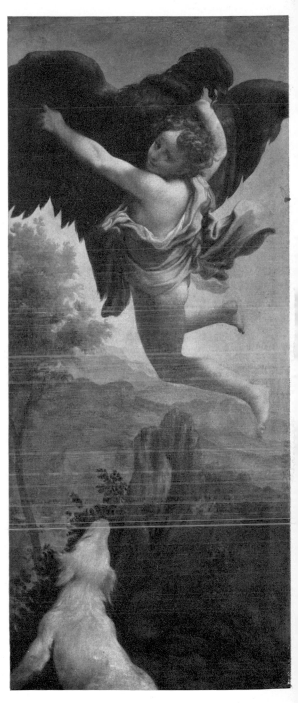

174. CORREGGIO: *Jupiter and Io*.
Kunsthistorisches Museum, Vienna

175. CORREGGIO: *Ganymede*.
Kunsthistorisches Museum, Vienna

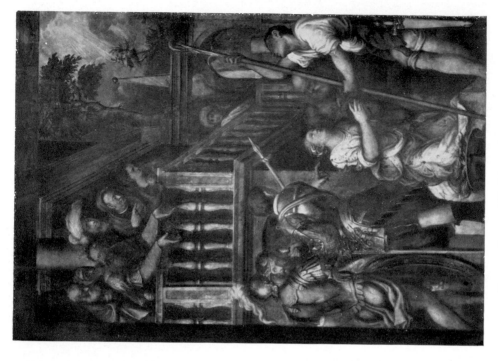

177. GIULIO CAMPI: *The Martyrdom of Saint Agatha.*
Sant'Agata, Cremona

176. CORREGGIO: *Madonna and Child with Saint Jerome.*
Gallery, Parma

179. Farmigianino: *The Madonna of the Rose*. Gallery, Dresden

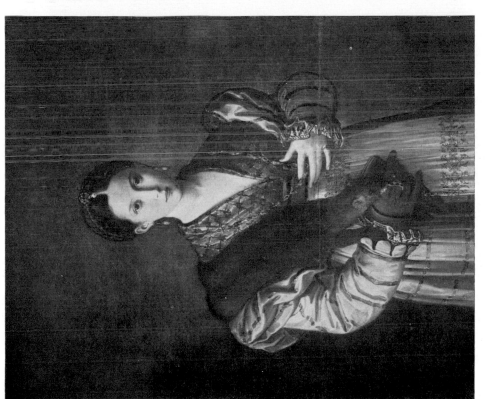

178. Parmigianino: '*La Bella*'. *Detail*. National Museum, Naples

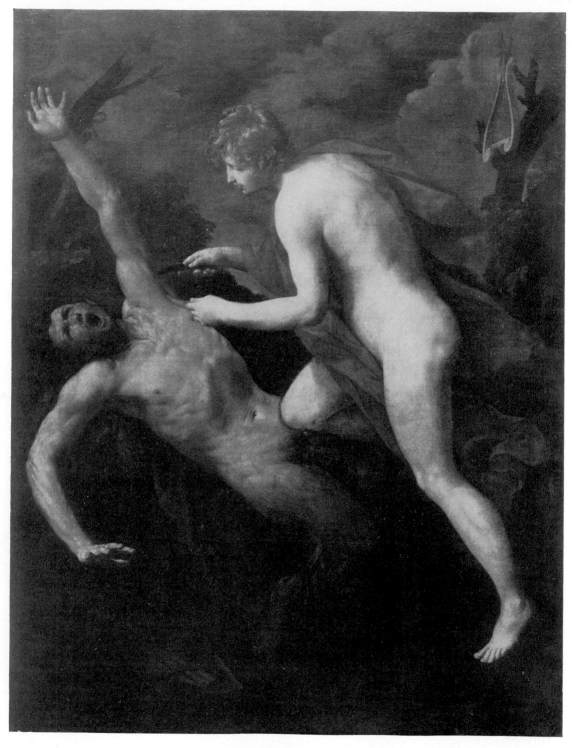

180. GUIDO RENI: *Apollo and Marsyas*. Alte Pinakothek, Munich

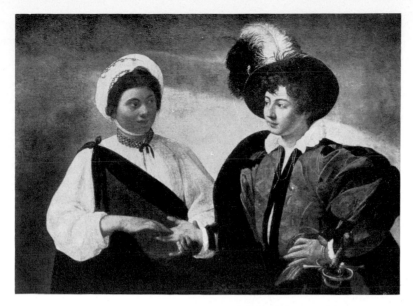

181. CARAVAGGIO: *Gipsy and Soldier*. Louvre, Paris

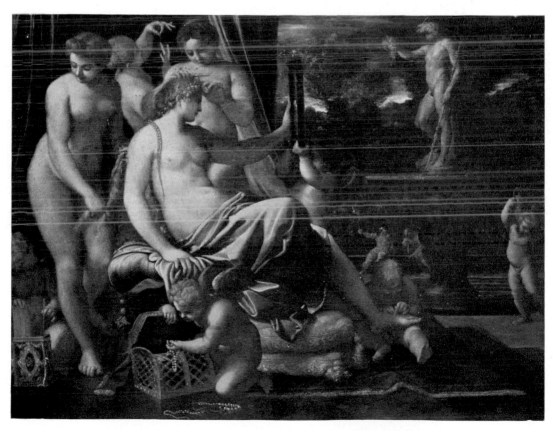

182. ANNIBALE CARRACCI: *Venus adorned by the Graces*. National Gallery of Art, Washington
(Kress Collection)

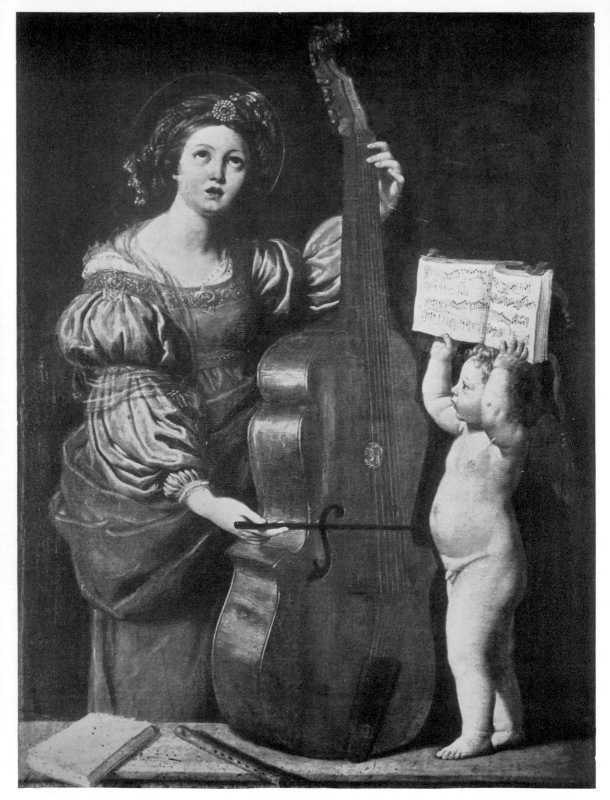

183. DOMENICHINO: *St. Cecilia*. Louvre, Paris

INDEX

ACKNOWLEDGEMENTS

We wish to record our gratitude to the following public and private collections for their courtesy in giving us permission to reproduce paintings in their possession:

The National Gallery of Art, Washington (Plates VIII, 11, 12, 22, 24, 25, 28, 57, 71, 93, 99, 100, 102, 104, 112, 124, 156, 167, 169, 172, 182); the Metropolitan Museum of Art, New York (Plate 150); the Frick Collection, New York (Plate 2); the Walters Art Gallery, Baltimore (Plate 81); the Museum of Fine Arts, Boston (Plate 101); the Isabella Stewart Gardner Museum, Boston (Plates 15, 62, 76); the Fogg Art Museum, Cambridge, Mass. (Plate 97); the John G. Johnson Collection, Philadelphia (Plate 96); the Museum of Art, Rhode Island School of Design, Providence, R.I. (Plate 141); the Worcester Art Museum, Worcester, Mass. (Plate 140); the National Gallery, London (Plates I, V, VI, VII, 14, 30, 43-5, 64, 77, 107, 108, 113, 143, 149, 151, 159, 171); the Art Gallery, Glasgow (Plate 49); the National Gallery of Ireland, Dublin (Plate 117); the Ashmolean Museum, Oxford (Plate 27); the National Gallery of Victoria, Melbourne (Plate 103); the Royal Museum of Fine Arts, Copenhagen (Plate 52); the Rijksmuseum, Amsterdam (Plate 145); the Kunsthistorisches Museum, Vienna (Plates 63, 174, 175); the Alte Pinakothek, Munich (Plates 129, 168, 180); the Thyssen Collection, Lugano (Plate 92); the Ateneum, Helsinki (Plate 98); the Museu de Arte de São Paulo, Brazil (Plate 118); M. Arthur Sachs, Paris (Plate 53).

INDEX

235